Shoji Hamada

Shoji Hamada

A Potter's Way and Work

Susan Peterson

 KODANSHA INTERNATIONAL LTD.

Distributors

United States: Harper & Row, Publishers, Inc.
10 East 53rd Street, New York, New York 10022

Canada: Fitzhenry & Whiteside Limited
150 Lesmill Road, Don Mills, Ontario

British Commonwealth (excluding Canada and the Far
East): TABS
51 Weymouth Street, London W1

Europe: Boxerbooks Inc.
Limmatstrasse 111, 8031 Zurich

Australia and New Zealand: Paul Flesch & Co. Pty. Ltd.
259 Collins Street, Melbourne 3000

The Far East: Japan Publications Trading Company
P.O. Box 5030, Tokyo International, Tokyo

Published by Kodansha International Ltd., 2–12–21
Otowa, Bunkyo-ku, Tokyo 112 and Kodansha International/
USA, Ltd., 10 East 53rd Street, New York, New York
10022 and 44 Montgomery Street, San Francisco, California
94104. Copyright in Japan 1974 by Kodansha Interna-
tional Ltd. All rights reserved. Printed in Japan.

LCC 74–77957
ISBN 0–87011–228–7
JBC 1072–784461–2361

First edition, 1974

to RMK

Contents

Acknowledgments

IT IS QUITE impossible to write in words my thanks for the privilege of having known Shoji Hamada, his way and work, or to thank him for his patience in continuing to show me a "living study" since we first met. I am grateful for our twenty-three years of association in Japan and America, and particularly for the four months in Mashiko during the fall of 1970, when I made the notes and photographs for this book from daily observation. The help and hospitality of the Hamada family members in residence during that busy autumn, Mr. Hamada, Mrs. Hamada, Shinsaku, his wife, Teruko, their sons Tomoo and Yuichi, Atsuya, and Hisako, overwhelmed and touched me. I hope this will truly acknowledge my gratitude for the warmth of these friendships.

Thanks must also be given to all the workers of the household and the pottery, particularly Oka-san, Uma-san, and Masao-san, and as well to the people of Mashiko village who silently encouraged. For the graciousness of their time, I thank the Mashiko potters Hamada asked me to interview in regard to their threads in his life, especially Tetsuzo Shimaoka, Totaro Sakuma, and Kiichiro Kenmoku. Also I must thank the personnel at the Tochigi Prefecture ceramic cooperative (the Mashiko *kumiai*) and Mr. Tsukamoto, its founder, for invaluable information; Mr. Eiji Kato, collector and restauranteur of Utsunomiya; my "family" at the Tozanso Inn in Mashiko; and the many other friends, acquaintances, and museum people throughout Japan who frequently provided assistance.

My special appreciation and gratitude to Deborah Smith, now of Pondicherry, for her several years of help to me prior to Mashiko and for her long hours there of translating Hamada's articles, and others, from the Japanese to English, and for interpreting at certain interviews—Hamada made the fine compliment that she is fifty percent

Japanese now—and for taking some of the black-and-white photographs. My thanks also to Mr. Kensuke Ueda, advisor of the U.S. consulate in Kobe, and to Mr. Ken Hongo of Okayama for their part in helping Deborah and me to travel to some places and to meet people in other parts of Japan involved with Hamada;

—to Dr. Robert Max Krone, without whom the work could not have concluded;

—to Bernard Leach for his foreword and to both Bernard and Janet for their unending assistance in so many ways;

—to my own family, my parents, Dr. and Mrs. Paul Harnly, and my children Jill, Jan, and Taäg Peterson for their patient help and suggestions;

—to my students and colleagues at the University of Southern California, Idyllwild School of Music and Art, and Hunter College;

—to all who have read and helped with the manuscript, but especial- to Marguerite Courtney and Dr. Margaret Dornish for their serious enthusiasm and analysis; Dr. Arthur Hald of Gustavsbergs Fabriker for several photographs, including the lovely one of Mrs. Hamada; Minnie Negoro for some special notes; Dan and Lillyan Rhodes, Masami Kuni, and Joan and Malcolm Watkins for encouragement;

—to Rose Slivka, editor of *Craft Horizons* magazine, and Aileen O. Webb, Chairman of the Board, and Dr. Donald Wyckoff, President, American Crafts Council, my affection for their unwavering assistance and consultation;

—to Edith Derolez and Joseph Lillis for typing the manuscript;

—to all of you my profound thanks.

A return to Mashiko in May 1974 has served to cement and re-emphasize my gratitude to all persons who have assisted in this endeavor since 1970.

Susan Harnly Peterson

New York, 1974

Comments

THIS BOOK about Hamada is written with warmth and familiarity. Susan Peterson has known Hamada for over twenty years, and, as a teacher of pottery and artist, knows her subject. She spent four months in the house and workshop in Mashiko, in preparation for this book.

Of all the men I have known, nobody has achieved such a balance between the faculties of heart, head, and hand as Hamada. Through Susan Peterson's eyes I have been able once again to watch the movement of those hands in the making of a pot, the flicker of his brush decorating its surface, the thoughtful organizing of the day, the week, the month, the year, of his many activities—all with unfailing good temper and warmth of speech that makes him acceptable to all.

My first contact with Hamada was a letter written by him in Kyoto to me in Soetsu Yanagi's country home at Abiko, twenty-five miles east of Tokyo. That was early in 1918. The English was pretty good, straightforward and unpretentious, but the handwriting was still better. This young man told me how he had intended to become a painter, but that the sight of Kenkichi Tomimoto's and my pots changed his mind. He said he was working at the Ceramic Testing Institute in Kyoto and that he would like to come and visit.

He arrived, and I believe we talked almost continuously for two days. We spoke half in English and half in Japanese, which we have continued to do to this day. He was the first person I had met who knew the chemical and technical approach to pots, as I did not. I had more practical and artistic experience. We became friends at once, and it was not long before he asked if there was any possibility of his coming to England, as my assistant, where I expected to return in a year or so. Eventually this was arranged with the generous people who had invited me to come and start a pottery in Cornwall.

As for the friendship between Hamada and myself, never can I recall any irritation or anger between us in half a century. Quite to the contrary, it has been a cause of deep joy to hear Hamada say, on more than one occasion, that he had never regretted that he came to St. Ives and stayed with us for three years, helping me to establish my pottery in my own land.

The outcome of the meeting and friendship between Hamada and myself has been unexpected, unplanned, but far-reaching. Indeed it seems in retrospect that some other Power played the chess moves, not only of our two lives, but of many other people's lives as well; foremost among them must be placed Soetsu Yanagi, for he was the thinker who gave the whole movement a Buddhist aesthetic.

We have travelled widely, talking, writing, demonstrating, and exhibiting, over the greater part of fifty years. A ripple has gone round the world, an exchange of inner values, like an engagement preceding marriage.

To read a corroboration of one's own experience in a given background is a delight; to extend this observation through the eyes of another adds to the pleasure, as in this book.

Quiet human relationships are brought to life, as is Hamada's unity of character. The roundness of the man—the harmony between him and all his surroundings even extends to the paddy fields and the hills behind Mashiko—the clay itself—not exactly sandy but noduled so that between thumb and forefinger its sandiness breaks down into characteristic plasticity. Hamada is affable; he seeks jokes and makes them, a wonderful mixture—so warm, so direct, and therefore approachable. For these things Susan has an instinct. She recognizes and conveys them.

The home is the hub. Without his wife how different Hamada's life would have been. I remember when I first met Mrs. Hamada many years ago when she was young. I told Hamada she looked like one of those gentle Suiko sculptures of the seventh century. I recall Hamada saying at St. Ives before he went back to Japan in 1923 that he was not anxious about Japanese marriage customs. He said he knew the type of girl whom he could marry happily, but that he also trusted his parents to choose for him wisely and well. So it has turned out. How

12

well she has served him in his life's work. In later years Mrs. Hamada has even travelled with her husband around the world. Their daughter Hisako, who before her marriage last year finished her education in San Francisco, where she was much helped by Susan Peterson, learned to speak English well, to weave, and to help her father with visitors and his English correspondence.

Susan describes with intimate observation how each one of Hamada's crew contributes to the whole flow of work. Shinsaku, for example, keeps accounts, does not concern himself very much with visitors, throws excellently, and is his father's right hand in the workshop.

Hamada's third son Atsuya spent some two years with me at St. Ives and is quite a linguist. He speaks and writes English with unusually good idiom. He also throws very well. His love of botany is so great as to make one wonder at times why he did not enter that field professionally; yet he is unquestionably a good potter.

Hamada's upper farmhouse is quite a museum; the treasures there he has collected with as unerring an eye as that of Yanagi. Whilst showing Susan this collection of crafts and commenting on the great admiration in Japan for the Korean bowl used for daily soup or rice from which the Japanese Tea Master derived his finest concept of the way of life called Tea, he pointed out that the lesson he learned in his own making of bowls was not to aim at Tea bowls any more than the simple Korean peasant had done. Susan quotes Hamada's report of Yanagi's division of the five sources from which the best Tea bowls had historically been chosen; also his separation of Tea drinkers into those he would or would not serve—with great incisiveness. Hamada appears to have wished that Susan Peterson, in writing this book, should not omit his own debts to old tradition in the West as well as in the East. He wanted her to make it clear that he had a great regard for the profound insights of Tea—and of its latest protagonist, Yanagi, with his overall philosophy of Buddhism. Of Western pots, he admired most those made in medieval England.

Apart from her impressions at Mashiko, I was pleased to find a description of Hamada's teaching in America at the University of Southern California workshop in 1963. The clays and glazes were made to resemble as closely as possible those he was accustomed to using in

13

Japan. More importantly, with the assistance of his second son Shinsaku, he demonstrated to students in America of a much more mechanized background how a professional hand potter should concentrate. He was, in fact, telling them that this involved long hours of repetitive heartfelt work without incurring the monotony attendant upon industry. This presentation alone, exemplifying what is essential to good potting, would justify this book.

<div style="text-align: right">Bernard Leach</div>

St. Ives, Cornwall, 1973

Here is a description of the way and the work of Shoji Hamada, leading potter of Japan, one whose life has been concentrated toward the perpetuation and achievement of fundamental, unchanging, and universal values and goals.

All black-and-white and color photographs, with the exception of the credits mentioned on page 10, were taken by the author during the autumn of 1970 in Mashiko.

Personal names have been used in the Western way, with given name first, instead of in the Japanese manner, with family name preceding the given name. The honorific *san* has been added to the workers' names in the Japanese manner because everyone called them in that way. However, I am using just first names for Hamada's family, in the Western manner, because that is what I always have done. I must add that yen revaluations and other factors have caused revisions in prices I stated for Hamada's work at the time of the initial writing.

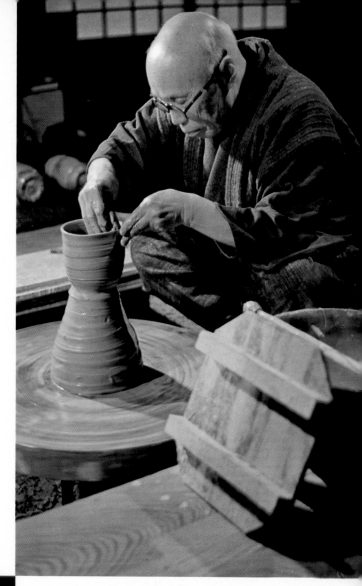

1. Hamada throwing tea ceremony bowls.

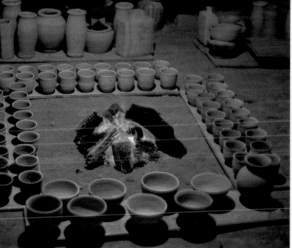

2. Tea bowls arranged around a charcoal fire to dry.

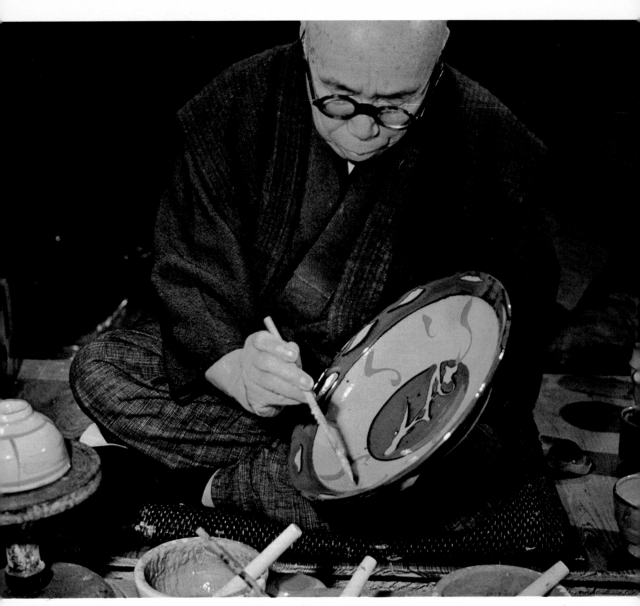

3. Hamada painting overglaze enamel.

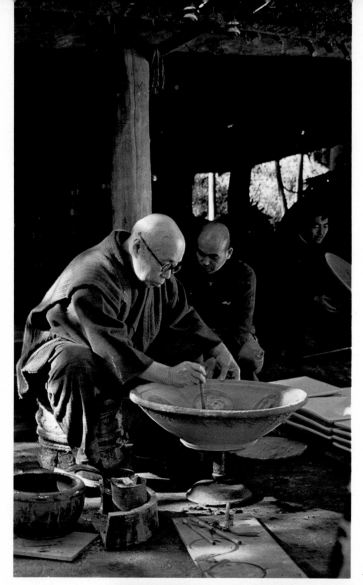

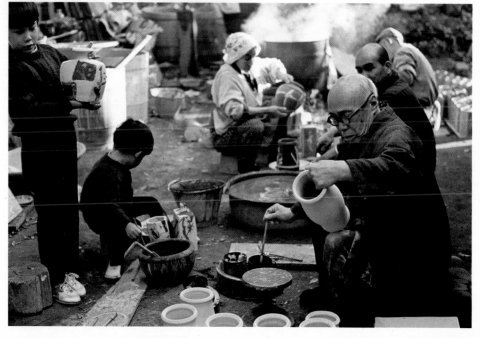

4, 5. Glazing.

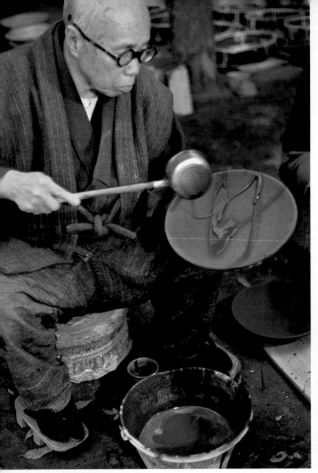

6. Ladle pouring glaze.

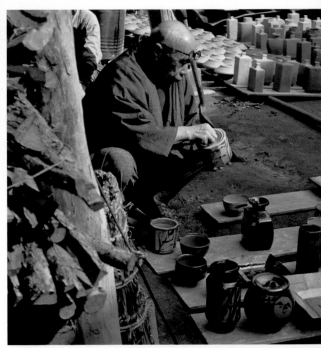

7. Hamada and fired enamel pieces.

8. Hamada, Sakuma, and Shimaoka after the glaze kiln opening.

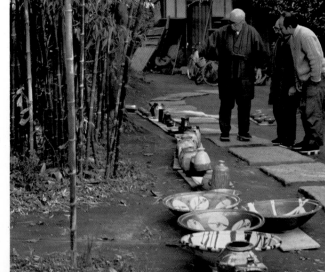

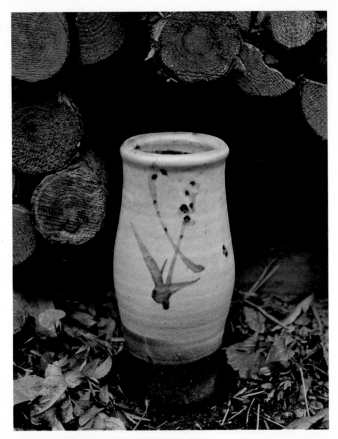

9–15. Ware from the autumn 1970 firing.

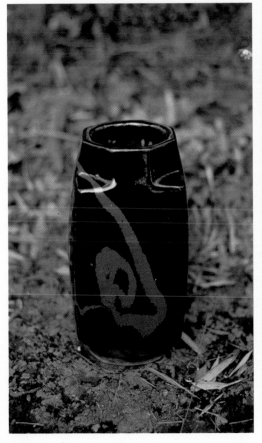

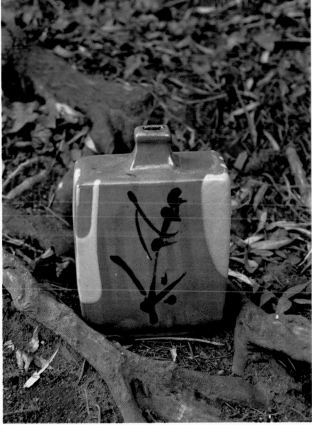

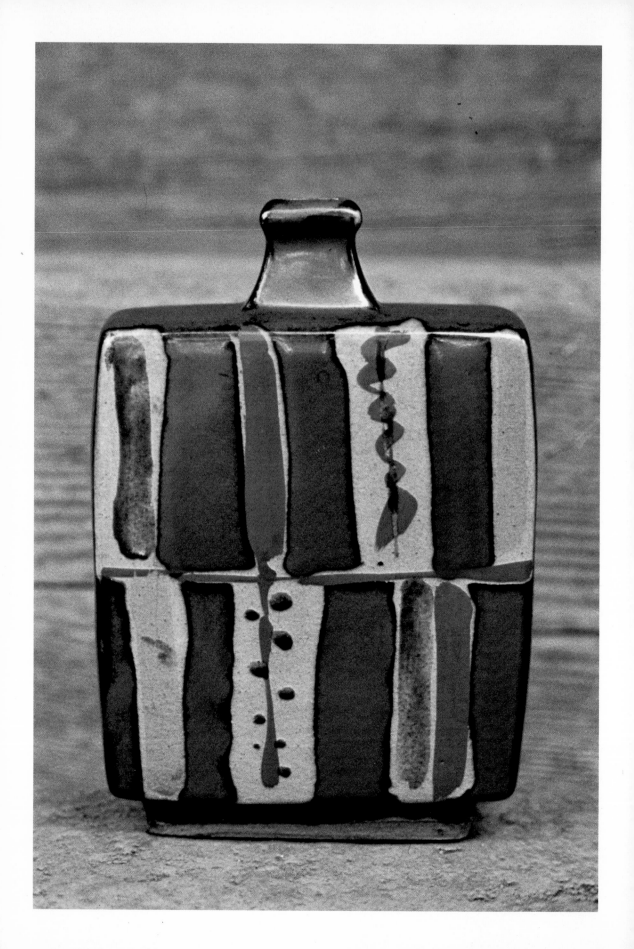

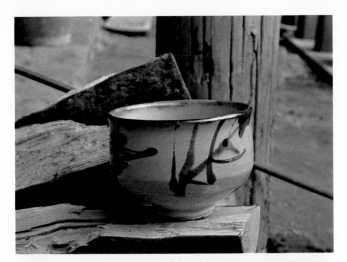

16–18. Pattern details.

The Setting

It is October 1970, and a clear crisp cool autumn in the town of Mashiko, Tochigi Prefecture, one hundred miles north of Tokyo on the eastern edge of the Shimotsuke plain. This is the village of Shoji Hamada. I have walked up the two miles through the town from the railroad station to his home at the foot of a hill. Turning, I can see the long stretch of valley across the rice fields and the town, smoke rising from the kilns of the village, haze on the hills, and the red and yellow colors of autumn mingling with the gray blues and earth greens.

It has been eight years since I have been here, and the street was not paved on the last visit. It is many years since my first meeting with Hamada on his initial trip to America in 1952. He came to this country with his English friend Bernard Leach, Europe's leading potter, and his Japanese friend Soetsu Yanagi, the founder of Japan's folk art movement. Their purpose was to do a three-week workshop arranged at Chouinard Art Institute where I was teaching, and to give demonstrations and talks at other institutions in and near Los Angeles as part of their extensive tour of the United States. Since then our paths have crossed many times in the West and the East. During one of those times, in 1967, Hamada had suggested that perhaps it was time to write down a few things about his work, although he himself was not a writer. Now three years later, having responded to this task, I feel both satisfaction and hesitancy.

Ahead is the white stucco gate house with shaped, fat green trees on either side. Beyond that lies the whole of Hamada's compound and the way of his work. The big wooden door is barred. I remember him telling me once that he would like to put a sign here to ward off visitors, saying: "Yesterday I was not in, today I am out, tomorrow I am going." I am aware, however, that he only closes the gate to visitors

for very important reasons, believing that one should give to visitors more than is expected. But today I sense that it is closed for him to have free time for me. Knowing another way to the workshop, I cross and walk the path to the right of the gate.

Hamada is there, rocking back and forth on his wooden *geta*, hands clasped inside his kimono sleeves, eyes twinkling, waiting for our greeting. He bows slightly when he sees me. His appearance is similar to the look of rural Japan, soft and mellow as the ochre straw in the fields, seasoned as the deep greens of the tea bushes, muddy as the blue grays of the neighboring trout pond. He wears a treasured old kimono vest, woven years ago by a friend, which tops the traditional country style trousers, which are cut fully, tied at the waist, and tight at the ankles.

His round head, almost completely bald but with thin tufts of gray hair at the neck, is dramatized by his magnificent Korean tortoiseshell glasses. The roundness of his body does not constrain his agility, for I know he can rise in one motion from a cross-legged position, run to the end of his workbench for a tool, and return in seconds to sit down again in one motion at his wheel. But it is Hamada's broad smile and sparkling eyes that command attention. With long acquaintance, however, his features in repose are perhaps most remembered, because it is in quiet times in his presence that one feels his indefinable, unforgettable central focus. The hands, the broad palms, the long fingers, the strong wrists, together with the whole physique give no hint of his 76 years. The life of clay, close to earth and things of earth, seems to have been able to preserve youth.

After our short greeting, he is ready to begin work. He suggests we do so over tea in the small European room where there are chairs around a lovely old English table. It is his custom to begin the entertaining of Western guests formally in this room. Hamada is eager to talk of the book, and says that each day we will meet here at teatime for discussion, otherwise I will be watching the rhythm of his work.

As if to write the first chapter in minutes, he begins to talk of key influences in his life that continue to maturate his work, of the old Japanese buildings he brought to this compound from other places so many years ago, of the growing and tending of plants, of his nearly

26

fifty years collecting the pottery and crafts of other cultures, of the pattern of life that flows here under his direction, and of the working of clay and the firing of kilns. As he speaks, my thoughts are that he has revitalized a tradition, transcending it for contemporary Japan. These influences in his life he is telling me about, which account for the extraordinary influence he himself has exerted in his time, are all based on his love and respect for the works of the hand, for the works of the heart, and most of all for the works flowing from people still working in living craft traditions.

In a current magazine he has just found some pictures of old English slipware pottery similar to a collection that he brought back from Europe in 1923. He thinks these pots are really early American though, not English, and he says that in twenty years of knowing something of the United States, he has changed his mind about that country having no history. Four hundred years have passed since Columbus, he says, and that is enough to develop a quite respectable tradition. I remember that he once made a special visit to the Pennsylvania Dutch country because of his interest in American ties with the older culture of Europe. Particularly he likes early American furniture, especially Shaker chairs, which are light and bright without intellectual coldness.

Wishing to illustrate a similar quality in another way, he brings out a small Persian bowl he bought for the equivalent of one dollar in an Osaka market. It has a swipe of rust red painting around the lip, but the line is not joined in one place where the potter's thumb had to hold the bowl. Hamada loves this piece. Quick brushes of cobalt and copper make a decoration in the center of the bowl, covering up some harsh stilt marks. The clay body is rough like Mashiko's, with specks of impurities showing through the glaze. "This is a good pot," he says. "Only those simple potters could make such a piece, refined potters could not."

"Ordinarily a collector places value on completing his sets of things and finding rare things and so on," Hamada reflects, "but I don't have much appreciation for matching everything perfectly or boasting of the scarcity and price. I am most captivated by things that touch me gently at the heart, or by things that leave me defeated, knowing that I could never match them."

27

"Myself, I would in an instant do without victory or defeat, and I have no use for most of what comes my way, but if I get hold of such a thing as this, it is as food for my body and soul that I must keep coming back to.

"It doesn't matter if it is unsymmetrical or if it is damaged, and whether other people think it is great or worthless is no cause for concern. If it is new instead of old and cheap rather than expensive, then I am all the happier."

He shows me some long Ainu mustache sticks he has bought, which are rare and old and full of intrinsic value for him because they were carved by Japanese aborigines on the island of Hokkaido long ago. Pleased when he can buy something difficult to find from a collector, he is proud of a Korean A-frame yoke he got recently for four hundred dollars, and he knows of only four of these in museums. This piece has woven straps and a wooden brace, and was made to be worn on the shoulders of a person carrying a heavy load, to distribute the weight. These everyday works are examples of the kind of heart and hand combination he values. He himself began with these things in mind.

As a young man he studied ceramic science in Tokyo and Kyoto, and learned to make hand pottery with his friend Kanjiro Kawai. Hamada remarks, reminiscing of that long friendship, "Soon in the potter's life various critical reviews appear and you come to recognize your own figure reflected in the mirror of the words. And if you are off your guard, you get so you yourself believe the image that others create for you, and in this there is the danger that you may fail to show even other outstanding qualities that you likely have. I feel it is good fortune that Kawai and I became mirrors for each other, and that thanks to that we were able to pursue our work with few mistakes."

One day in his youth Hamada found a small exhibition of pottery by Bernard Leach and Kenkichi Tomimoto, which impressed him so much that he took courage to meet them and thus forged a direction that was a turning point in his life. It was Bernard Leach who took him to England when he was twenty-five. For three years there, the young Hamada was influenced by European concepts, associating with a few good working artists who lived simple lives, built their own furniture, wove their own clothes, made shoes, and grew most of their own

food. Impressed and admiring, he decided to try to live in the same way when he returned to Japan. This steadfast attention to traditional ways, and his unwillingness to give them up in the face of outside change is inherent in his ideal of submerging self and of working without conciousness or false pride. Hamada's early decision was that these were good values, values worth keeping, and that societies would be better for perpetuating them.

The true significance of this first discussion was reinforced during the next weeks. Our talk that teatime left no doubt in my mind that he wanted the book to cover his early life abroad and at Mashiko, the influences on his work and philosophy, and the interrelationship of his pots, especially the tea ceremony bowls, with all of these things.

Hamada stood up, putting away some of the folk objects he had been showing, and gestured toward the main house adjoining this European room. The family house is the hub of all activity, the place to which everyone comes back. Its entrance is bordered by umbrellas, pots of plants, and vegetables hanging to dry. On one side is the open porch and on the other side is a long wall of shoji screens, which throw squares of light and shadow both on the ground outside and into the main room. Sliding open the weathered wooden door in the center, one sees the slate entryway covered with pairs of shoes. Also leaving our shoes in the entryway, we step up to the floor of polished hardwood and change into house slippers. The room can be seen at one glance: beautiful *tansu* chests with Hamada's pots all over them, baskets full of fruit, flowers, and dried grasses, the farm style kitchen off to one side, the long, heavy wood Western style dining table with two long benches of polished wood matching the planks of the floor, the wrought iron and paper light hanging above, and the open *robata*, a sunken fireplace that is an inseparable part of the life of this house.

The odor of the smoke is pungent. If you have sat very long in this room you can always recall its aroma. The wood being burned is Japanese cedar—cryptomeria—the same often used for incense at temples, which burns to a very fine ash that Hamada uses for his glazes. The robata contains a fire full of coals. Around the high, wide railing of polished wood are eight fat stools handmade of rope coils.

Steam from the iron kettle hanging over the fire gives warmth and

an air of mystery to the room. The robata is a place for guests, for conversation, sometimes for cooking, and always for family gatherings.

Mrs. Hamada is putting more wood with some dry twigs and needles on the fire. She welcomes me and remarks about the huge sequoia trees she saw in Yosemite on her first visit to America. Holding her arms out as wide as possible, she laughs because she cannot make a circle as big as the trees. We always communicate by sign language or voice inflection because neither of us speaks the other's language.

Atsuya Hamada, fourth child, third son, and Hisako Hamada, fifth child, second daughter, have been showing guests around the compound. Atsuya is an expert botanist who spends part of his time in the work of his father's studio. He is a world traveler, speaks many languages, and has lived and worked in Mexico, Scandinavia, and at the Leach Pottery in Cornwall.

Hisako, who spent several years in college and art school in California, helps her father in his English correspondence, screens inquiries, makes appointments, and assists her mother in managing the household. She is also a weaver and keeps an apartment in Tokyo where she goes when her father is away from Mashiko.

Shinsaku Hamada, second son, works all the time in his father's shop, and has done so all his life. He is able to throw all the different shapes of the work, and he supervises the ordering of materials. In 1968, after twenty-five years of working with his father, he felt it was time to hold his first exhibition in Tokyo, and now he spends part of his days making pots in his own style. A shy man, Shinsaku speaks only a little English and tries not to involve himself with the visitors; his work is that of the studio.

I have known each of the Hamadas for some years, and we greet each other now with individual reminiscences and anticipations of the coming months. Teruko, Shinsaku's beautiful young wife, is learning Mrs. Hamada's way of food preparation, and, together with their two young sons, this family is a joy for the whole household.

We have spent most of the day together; it is time to go, but Hamada suggests we walk around the compound. As in the case of some of the great ancient gardens in this country, the naturalness of everything in this Japanese rural setting is overpowering. One sees the organic

30

curves of the hill kilns built of handmade brick troweled over with a clay slurry into almost living forms and encounters the lick of flame of the various fires that leave a residue of ash in stoves, kilns, robatas, and outside in many places. The paths are dirt and so are the floors of the workshop and the storage rooms. The deeply thatched roofs of the houses soar upward in grand masses, green sprouts grow on the dark straw, the curve of each ridge line is subtle and striking against the clear sky. Round river pebbles are used for paths on the hill slopes, or log steps or flat textured rectangular stones mark the way from place to place. In this manner the walks are described and make decorative lines throughout the whole compound.

Everywhere one sees huge piles of wood for firing the kilns, the diameters of the logs exposed like so many spools, stacked to the eaves of the buildings, and smaller bundles of sticks and twigs in straw baskets or wrapped in woven straw blankets. Racks of small potted plants behind Shinsaku's house, or in front of Hamada's, are sometimes used for drying freshly thrown tea bowls, making both plant and pot a satisfying background for the other. Persimmons hang to dry, one on top of the other in a bamboo sling; stems of mountain potato are strung out along a window, dangling in the sun; mounds of rocks are kept beside wooden barrels for making the "one-year" pickles; trees and shrubs everywhere have tags of graftings or the branches are wire-wound in special shapes; and tall evergreen oaks are espaliered as a fire break on the path leading from the main house to the five-chamber kiln. Birds fly around in aviaries and small birds sun on the roofs. Stacks of fresh yellow chrysanthemum blossoms wait in baskets to be used for the night's tempura or pickles; mushrooms are drying in baskets. Food seems to be an integral part of the whole picture.

Here and there are piles of straw for the packing of pots, old glazed kiln shelves are used to make a wall, the textures of wooden geta and leather slippers at the various entrances mingle with Ainu straw mats or polished wood or tatami. We encounter the aroma of hot buckwheat noodles steaming in Hamada bowls nestled on black trays accompanied by burnt orange lacquered chopsticks, set outside on the weathered wood tables for the workers' tea.

Mounds of thatch straw are piled next to buildings for repairing

roofs, and mounds of leaves are raked away from the main walks. Pots are never out of sight. There are pots on the ground catching rain water for the animals, and neat stacks of broken pots, and freshly made wet clay pots in various stages of development. One can see bamboo ladles hanging beside handmade grass baskets used for winnowing or for carrying or in the fields. The natural harmony of the compound results from these combinations of texture and shape and color.

In addition there is the sound of soft dripping water for the birds in the aviaries, the play of shadows from gnarled old trees and soft young bamboos when the sun is high. Bushes and small trees are trimmed to follow the line of natural growth; the Okinawan stone lanterns, sarcophagi, and stone animals placed along the paths are nearly hidden in the vegetation.

The thatch roofs have swayback ridges rising at both ends to a kind of rounded point. The huge wooden beams supporting the thatch are almost black, with strong grain and cracks of varying depths and lengths. These blacks inside, and the dark gray of the thatch, contrast with the mouse gray of the long, weathered wood tables that stand outside for use at teatime or for airing the *futon*—Japanese quilt beds—every morning. The buildings are so tall, so wide, so high as to be overwhelming were it not for the grand scale of the landscape, the height of the big cedars, and the breadth of the espaliered trees that form ribbons of green and frame geometric spaces. Thin stalks of fresh yellow bamboo, heavier stalks of light green bamboo, give verticals to the broad horizontals of the thatch roofs. Woven straw mats, hatlike, cover whole plants or small trees for the coming winter, or sometimes portions of trees are bound up at the joints with ochre-colored dried grass.

There is no place I know of where one can see the whole of this compound at once; only small vistas unfold one after another as a path changes direction or moves around a building.

There is a separate pickle house where big rocks are used to weight down wooden lids fitting inside the old Mashiko stoneware clay jars and wood barrels, holding tight the contents of the condiments that Mrs. Hamada makes. Bamboo screens and various baskets are the warm color of straw or dried grass, handmade brooms hang against the

wooden sides of buildings, and brass-colored flashes are seen occasionally from a metal ladle or pan.

The gate houses have huge wooden doors with oversize iron hinges and bolts. In contrast, the delicate paper shoji filter small squares of light from behind at night, differently in daylight. The shoji of these buildings are marked off with thin wood strips in squares or in rectangles, broken at times by curved line shadows of a branch or a figure. Hamada's elegant Meiji period farmhouse halfway up a knoll of the hill has windows paned with thin white shell from the South Pacific, startling in beauty.

The ground here is covered with flat stone walks and round logs, or thick stones form steps on the inclines in the manner typical of Japanese gardens, with short bamboo fences tied back at the joint, confining the paths. The cutting gardens for starting new plants are sheltered, secluded spots containing many little red flower pots, wooden boxes, and larger jars with various plants such as cactus and succulents, assortments collected when the family travels. Taking the narrow way from the five-chamber kiln past this house, past the stacks of wood bundles and past the bamboo grove, one can climb to Hamada's hill at the top of the compound for a view across the valley of Mashiko to the hills beyond, over the roofs of his buildings. Many years he has cared for these ten old houses and the accessories of the compound that he struggled to bring to this place. He has come to think of them as indispensable to his life and work. "If they weren't here," he says, "it wouldn't do."

In 1922, in England, he knew what he wanted his work and his life to be. Influenced by those early experiences in England, and by his associations with Leach and Yanagi, the pattern of his clay work has developed in as steadfast a manner as the pattern of his compound. The culture of the West has become mixed and blended with his life in the East, yet the core of the man is his own. The atmosphere and routine of this household is unique, and most people who come to know it cannot help being influenced in turn.

A long day is ended. We have established how the time will go and something about the work, and what it is important to see. Hamada has arranged for me to sleep in the small inn in the village near the

railroad station, and I will spend every day at his compound. He knows I will develop a sign-language friendship with the vendors of the town as I walk to his place each morning.

From Hamada's to the inn, the main street, lined with paper and board stalls and small shops, is a bustle of people in country dress, school children in blue, bicycles, buses, and carts. The air is crisp in the autumn and gets very cold in winter, but the warmth of the village persists in these people. In the first weeks I will visit some of the potteries that are important in Hamada's relations with the village, some of the men who are Hamada's friends of his youth, and a few potters who were his students. But the work at Hamada's is my real reason for being here.

My landlord's family at the inn takes care of me in simple fashion, feeding me when I am there with the same menu as theirs, bringing hot coals to warm my cold room, which is exposed to the wind despite wooden shutters over the paper shoji, and keeping hot tea constantly at hand when I am working at night.

Deborah Smith, a friend and student of mine in pottery and a Stanford University graduate in Japanese language and culture, will join me at times to help with interpreting at the interviews, with translating the articles Hamada has written, and articles written about him that he feels are important background.

The pace of this village is similar to Hamada's own pace, steady and patterned, and each day is likely to reveal a previously unnoticed facet.

The Work

Hamada's workshop is barely visible from the gate house, up the road lined with trees and strewn with leaves. One has to know that the long, low, thatch-roofed building commanding the knoll is there, off to one side, away from the center of the whole compound. Pots made in the morning surround the shop, fresh clay wares brought out for the sun, lined up in rows drying on boards covering the graveled ground. Sun and shadows, lights and darks, play on the straw roof, bounce and glitter from the tall trees, patterning the ground, catching the pots.

The landscape is dark Japanese green any time of the year, but in autumn it is softly colored with yellow ochres and golds and warm greens. These are the colors most often seen also in glaze on the wares of Mashiko town. The scene is reminiscent of the hill and tree drawings on the teapots of Masu Minagawa, the famous Mashiko lady who painted her designs, it is said, a thousand times a day for forty years, becoming a symbol for Hamada of traditional country pottery and repetitive work. One of her teapots he used in his childhood was his own earliest link with the village of Mashiko. It is all of a piece, the valley, the town, and the ware.

The workshop building is sixty feet long, twenty-one feet wide, made of wood, plaster, and thatch, with half-timber verticals and white stucco walls at each end. It is an old farmhouse from Tochigi Perfecture, nailless in construction, bought and reassembled here forty years ago. Paper shoji facing the valley run the length of the building and divide in sections so that each worker at a wheel can open and frame his own view.

Seven throwing wheels face the sliding shoji, beginning at the far end with Hamada's hand wheel and continuing with six Korean style kick wheels. Each wheel is mounted in a pit and surrounded by a

35

wooden platform and bench. Pots of tools, pots of steaming water for throwing, and pillows covered with warp and weft dyed fabric are at each place. Incongrous in the simple workshop interior is an intercom attached to the wall by Hamada's wheel for communication to and from the main house.

Autumn and winter are cold, and the water in this workshop is always cold except when heated on the fire. Outside is a trough where bamboo screens are washed. Next to the shop the large barrels of glazes are sometimes iced over on top. Inside the air is cold and damp from the wetness of the clay and the use of water, but also because there is no heat and the shoji are paper. Bare electric light bulbs hang over the work areas, racks for plaster mold storage cover the walls, and shelves storing greenware are suspended from the smoke-blackened bamboo rafters. No space is wasted. The room is small for the amount of work they are doing, yet the feeling is open and movement is easy.

Pots are everywhere, bottles, bowls, cups, plates, being made and set down, picked up and moved. The workers walk barefoot or with wooden geta on the floor of hard packed dirt. There is a sunken firepit in the center of the room where a black iron kettle is kept full and steaming. Coals glow constantly in this robata, and surrounding it are small wooden seats, measuring about eight by four inches on four-inch legs, hardly more than stands to keep sitters' bottoms off the floor. Everyone sits on these tiny rests to get warm by the fire, to eat, to smoke, to pause between paces in the routine of the work.

Clay is piled at the back of the workshop in a huge mound about ten feet high, twenty feet long, eight feet deep, running half the length of this room. It has hardened a crust of clay on the outside but remains soft underneath, and is enough for a year's supply. A plastic sheet is kept at one end, covering the place where the clay is spaded off for working and made ready to be wedged. Potters who are younger, or as yet unestablished, cannot afford a huge mound of clay like the one in this workshop, which, aging as it does there for a year, improves in plasticity and workability. Most potters in Mashiko buy only a little at a time, always using the clay as it is freshly processed, while Hamada buys this great amount and can use his clay aged.

The Clay

Clay for the village is pickaxed from the side of the mountain at Kitagoya, beyond and behind Hamada's farm. The various clays of different colors occurring in this deposit are sorted and pounded by hand, spread out in piles to dry on the hill, carried to tanks dug deep in the ground, and mixed with water. Sand sinks to the bottom, the water rises, and impurities are removed as the fine liquid clay is screened very wet between two settling tanks. A woman stirs this pure clay mixture with a long wooden oar, and ladles and sieves it back and forth, perhaps for several days, then ladles it into shallow settling troughs made of hard clay. After a day or so of moisture evaporation, she scoops the clay slurry from these troughs into bisque pots for further drying to the plastic, workable stage.

The woman says that this is not woman's work, but it is the women of this farm who sort the clays from the mountain, rake the sun-hard chunks into the tanks, mix and screen the wet slip, and ladle the slurry into the drying pots. Even in the *kumiai*, the ceramic cooperative in the town, where clay is prepared commercially in machines, the ladling is done by women in the same fashion as at Kitagoya.

The strata in the mountainside contain different types of clay, which have different colors and textures. Some of the clays are coarse, some are fine, some are gray, some yellow or brown, which means they contain oxides that will mellow the color in firing. Hamada uses a white slip on his ware that comes from the same deposit but is finer and whiter and rarer than the stoneware clays there. Some potters mix the types, but Hamada likes to use the clay exactly as it comes from the mountain. He has it processed as it occurs, by the people who live on the land, and delivered to him about once a year. But it is a coarse sandy clay, and sometimes for special shapes, for big bowls and some plates, he has to mix it with clay from other regions for more plasticity.

Many times he has said that Mashiko clay is difficult, but that it is better to make a good pot from bad clay. I had not known before that the clay was so sandy. Roll a coil and it cracks, push two coils together and they disintegrate. The clay is deceptive because it is sticky, it looks fine and plastic but it begins to tear, dry, and crumble when it is

37

worked. Only by the end of my stay did I understand the immense care and the long repeated hours of preparation given this clay. In many different ways, beginning with the Kitagoya mountain families and countinuing in Hamada's workshop with further processing and hours of hand wedging, the clay is prepared so that it gains unusual strength and resilience.

The biggest lesson Shinsaku, Hamada's potter son, learned in America was about clay. Now that he can speak some English, he has been waiting to tell me about the lesson he learned when he was with me at the University of Southern California workshop in 1963. At that time, thinking he could build a bigger slab rectangular pot than he usually does, using the commercially mixed American clay that we get from machines, he worked as he usually did, with his Mashiko techniques. One by one the pieces all cracked. I remember those big pots breaking as they dried. Only now I realize our clay of inferior plasticity is due to our lack of understanding about the importance of time in preparation. It is the fault of our short experience, of not having the depth of tradition to understand and communicate with our materials, especially natural materials. Shinsaku eventually knew that our machine-mixed clay was not good for his kind of hand-building, but he had to think about why. And he explained in the following way:

"Americans don't comprehend clay, the long stages of preparation necessary to make raw clay plastic and strong so that it won't crack in drying or firing. Clay must be processed for days, as it is at Kitagoya, and wedged by hand very much. Americans and the English just do not use enough "arm." Working the clay over and over by hand can't be duplicated by machine." The hand-wedging at Hamada's is the same for all the throwing, about two hours more or less, depending on the consistency required, which is different depending on the kind of pot shapes to be made. Shinsaku wedges his own clay and most of his father's.

The scrap clay of this workshop is reused about two or three parts with new clay. When it has been used so much that it is no longer good because all the finest clay particles are gone, it is saved for bricks and kiln patching, or mixed with straw and given away to be used for the

walls of the Mashiko farmhouses, so really none is wasted. Shinsaku says he found our bungs of machine-processed clay hard on the outside and soft on the inside. It is better to keep a mountain of wet plastic clay as they do in his workshop, because that way a lot of clay ages together and remains homogenous. Hamada's method of long careful clay processing by hand is traditional to Japanese folk pottery, and similar to the care that the American Indian, for instance, takes with his clay, the care in finding it in the first place, then in mixing it. "Think of all the thin pot shapes you have seen, made by those people for centuries," says Shinsaku, drawing complicated graceful profiles in the air with his arms. "They had to have chosen and prepared the clay very carefully in order to be able to make those shapes."

WHEELS

Hamada likes to begin work early in the morning, setting a casual atmosphere for throwing by chatting with his sons and the workers in the studio. He slides open the shoji to the sun in the trees, and sits down cross-legged on the blue pillow in front of the Chinese type hand wheel he has had forty years. He is quiet, composed, aware, speaking of the weather to Shinsaku who is working on the kick wheel at his left, speaking of the typhoon that has turned itself away and is not coming, and of how nice it is that today the weather is warm.

Shinsaku's small boy is fussing with lumps of clay, and Hamada turns to show him how better to make a Mt. Fuji. He tells the child how to make a round ball and push his finger into the bottom to make it more hollow for firing, and pull a point at the other end for the mountain. Then Hamada is playing with the clay himself, rolling it into a ball. He takes the mountain the boy has made, puts a dent in it and adds his round ball on top. There is Fuji with the world on it, and the boy and his grandfather laugh together.

Hamada is turning his wheel, the beautiful chestnut hand wheel. Sitting cross-legged on the same level as his wheel, in a position impossible for most Westerners, he begins rotating the heavy wooden head clockwise with the fingers of his left hand, looking out at the cool morning across his land and the valley. As the wheel slows down,

39

Hamada picks up a long stick with its end carved round, and somehow finding one of the four brass-lined holes on the top of the wheel as it goes, he fits in the stick. Violent movements with his right arm make the wheel zing around. Laying down the stick, he clutches the clay with both hands to bring it to a cone. After several revolutions, the pressure of his hands on the clay slows the wheel, and he must reach quickly for the stick again.

Just making the wheel go around is very difficult physical work, but his body is quiet, steady, and centered. His hands, small with long fingers, caress the clay with strong rhythmic motions, in unison with the centrifugal force of the wheel. He begins by just squeezing the clay up and down, feeling its wants, deciding what to do.

Hamada is often referred to as *sensei*, the Japanese word for master, teacher, literally, "first born," and it is true that he teaches as he works. He has received the Cultural Order, his nation's highest honor, and has been designated the Holder of an Important, Intangible Cultural Property, the Skill of Folk Pottery, known commonly as a Living National Treasure. Offhandedly, as he throws now, he lectures to me about wheels. "Hardly anybody today uses a hand wheel. The potters of Kyushu in the south of Japan learned from the Koreans. They, and the potters of Kanazawa, where Kutani ware was made, use the Korean type kick wheel, which is smaller than the European type.

"Seto potters learned from the Chinese, and they use the hand wheel. Mashiko and Kyoto have a comparatively short history as potteries go, and they use a mixed tradition, the kick wheel for large things, the hand wheel for small things. The Korean wheel, kicked clockwise with both feet, came to Mashiko first, so today the potters kick clockwise. This was also true at Bizen. Differences came from the point of origin, but the hand wheel always goes clockwise. The Okinawan wheel moves the other way for throwing, but trimming goes clockwise, who knows why? Shinsaku uses the kick wheel because it is better for stronger things."

Shinsaku remarks that his father told him the right way to learn to throw on his Korean wheel was counterclockwise, the way Americans learn, so he learned that way. For large things, he has to kick constantly

on this type of wheel, moving the feet all the time or throwing will be off center, but Shinsaku says that for small things he does not have to kick all the time. An electric wheel would be out of place in this workshop because even the physical action of kicking or hand-turning a wheel is expressed in the pot.

Atsuya Hamada and all the others in the shop throw clockwise, in traditional fashion. The wheels are beautiful, with thick, round heads on a short shaft, then a small, thick wheel at the base for kicking, just big enough for both feet. The wheels are made of *keyaki* (zelkova) wood, the common hardwood in Japan. There is a saying that if you are able to make a fire of keyaki and then can keep it burning three years, you will go blind from the heavy smoke.

THROWING POTS

Hamada continues the laborious task of turning his hand wheel. "I should learn to use the kick wheel, but it would take about a month. I am too busy. I have no time. In the kick wheel the whole body moves. My hand wheel is slower and more gentle. My body is still, only the hands and arms work."

As he pulls up and opens the clay, shapes seem to arrive effortlessly. His hands, right one inside, left one outside, are almost parallel with his own middle. The clay cylinder goes up fast, then in, and the profile is drawn out into fullness. These are beginning bottom shapes for jars. Hamada will add coils later when the jars are stiff but not dry, and necks will be thrown from the added coils, a safer method for this difficult hand wheel than throwing the jar all at once.

"Some potters draw up a clay cone to a point, a perfect point. That's very good throwing when both sides draw evenly to a point. The old technique years ago for a very big jar was to lay over the top edge of a big cylinder twice to make the lip strong, and after that to widen and shape the big form. At Mashiko all potters used to do this. Now no one can do it. The way is lost. Only in the thirty-year-old film about Mashiko pottery I gave you can you see this method, but it is so important."

Hamada continues to throw and to talk. I have just come around the

world and we reminisce together about museums and his own last journey. The British have maybe the best, the most balanced collection of Oriental things, although the Louvre is good, too, but better for Near Eastern and Persian, he says. Stockholm is excellent for some things, prehistoric Chinese and certain phases, but it does not cover it all. Even the Oriental collection in London's British Museum is mostly in the storeroom, but they have had many fine scholars who have worked there in the field over the years. The Victoria and Albert in London, the same. In the USA the best museum for Oriental wares was in Kansas City, but now it is the Brundage Collection in the DeYoung Museum in San Francisco. The Freer in Washington, D.C., used to be good but it is old because much more material has been unearthed and no new additions have been made.

Museum collections show that European pottery concentrates on glazes, but Hamada says that the body is much more important. The glaze is only the clothes, but the body is the heart. "That's what made the Japanese people like Bernard Leach's work. The body or form of the pot is strong, and that is most important. Leach is a very humble man and never says he is the best. That the Japanese people like too," laughs Hamada, "because he is best." I say that the same modesty is true of Hamada, and he quips, with a glint in his eye, "Oh, no. Hamada always says that he is the best,"

I have been to see Hamada's retrospective exhibition from collections in this prefecture, at nearby Utsunomiya, and I ask if he thinks his style has changed over his fifty years' work.

"I didn't change my style. It changed naturally. When I look at all my work lined up, it all seems to be very *nigiyaka*, which means birds jumping around in a tree, or a lot of people talking at a party, or many people busy in the street. I made eight platters last night, I will make fifty tea bowls tonight—always a healthy variety, but tied together. You have to work when you are not aware of self. If you have a certain *kimochi*—feeling, disposition—as you work, your work will smell of that *kimochi*."

Many expressions do not translate well into English, and Hamada notes that Japanese has more nuances than English, especially in the area of aesthetics. For instance, in Japanese, *mono ga wakaru hito* means

42

a person who understands things, appreciates value, recognizes quality, both material and spiritual. Then there is the expression *mona o miru me*, meaning eyes that see things. One says in English, "He has an eye for things," but the meaning in Japanese is deeper. One not only sees the thing, he sees into it. Seeing things means that he communicates with these things. It is also so in throwing. To make a vase or bottle is to make the inside.

Hamada reminiscing about Europe, Leach, and his own style made me recall that he had studied painting in his youth, not ceramics, and I asked him how it was that he chose ceramics.

He replied, "From the time I was little what I liked most was drawing pictures. About the third year of middle school I realized that if I were going to become a painter, unless I was really a good painter, it would be meaningless. After all, I couldn't just go on painting so-so nice paintings, living off other people's favors. If I were a potter, since people would use my work in some way or another, since it would be useful, I could have a little clearer conscience perhaps. Among all the crafts, the wondrous strange quality of ceramic glaze captured my fancy. Thinking back, there was a particular glaze, *namako* glaze, I liked on an ordinary pottery hibachi, so I chose ceramics.

"One of my teachers in technical school invited me to visit him any-time at home to talk. One time I noticed that the earthen teapot displayed on one of his shelves was the same kind that they used to serve lunchtime tea in at my grammar school. When I asked him where it had been made, he answered that he knew that they were still making those teapots in Mashiko in Tochigi Prefecture. Later this teapot, made by Masu Minagawa, was the connection that resulted in my coming to Mashiko.

"It was so beautiful in the early days in Mashiko to see the shapes drying in the yards, when everyone was making hundreds of the same large pottery shapes. Women wedged the clay bungs, fifty in the morning and fifty in the afternoon, wedging the clay with children on their backs. That was beautiful too. Now women workers don't do throwing or wedging, but they are very skillful with glazing, with balancing pots on their fingers. They put a little glaze in and swish it around very quickly," and Hamada makes a fast gesture with his

43

hands. He is sad that whole families do not seem to work together in the potteries anymore.

In Mashiko in 1924, when Hamada came, there were about seven thousand residents, and forty kilns with a one-hundred-year tradition of making hot water bottles, water jars, grinding bowls, saké warmers, and large water containers for all kinds of uses, from big ones for storage to small ones for washing the eyes. And long before, in Neolithic, Jomon times, earthenware was made here too, because farmers often unearth such shards.

About fifteen years ago Mashiko people stopped making the traditional useful things. Hamada feels that the general level of pottery now as it exists in the many shops in Mashiko, coming from the town's 105 kilns, is not very good and the people who buy it have not very good eyes.

"In about twenty more years American pottery will get better, and Japanese pottery will go down," Hamada jokes. "Mashiko will eventually see that it was better before, years ago when they were learning to make this kind of ware. Then they were trying to find out and make what people needed. Now they just make anything, and it sells.

"It is very regrettable that no one makes the big pots here anymore. They were making such fine pots, and I wish at least one house was still doing it. Up until five years ago there was still one house doing big pots, but they, too, quit. It was apparently very difficult to make those big pots, and they couldn't make money at it any more. The government should support one house doing this. The government does support the ancient potteries.

"But the Mashiko people who knew how to do that sort of thing are now sixty or seventy years old and very tired. In Onda, a pottery village in Kyushu, for instance, the government gives support, but in Mashiko the traditional big pot making has already disappeared and probably couldn't be revived.

"It's not only that, but the usefulness of these pots has disappeared. In the old kitchens they used to use them as water storage jars, but now there is running water in the kitchens."

Hamada says that his being in Mashiko making a different kind of ware did not hamper the work of these old potters. The usefulness of these big pots simply disappeared, first in the cities, then in the country.

Conveniences came first to the city, then to the country. Slowly, since the war, the big storage jars could not be sold anymore.

I ask about the big pots that I know are still being made at the Otani kiln on Shikoku island. "In the case of Otani, those large pots had been made as acid jars in the old days, and then the acid factories found better materials for containers and those clay pots couldn't be sold any more either. The potters were really in trouble and they looked for something else. Then they hit upon making planters and garden containers and said to the people please use our pots for other purposes."

Hamada continues throwing, looking out through the shoji opening at the day beyond, cutting pots off the wheel and setting them aside one after the other. I remark that in the case of Mashiko, Hamada was here and that he saved the potteries. Hamada frowned, grew abstracted, smiled enigmatically. "No, I did not. Let's talk more about it later," he said, implying that it is too early for me to understand.

The Workers

The other work of the shop has been going on as we talk. Clay slabs are being pressed into molds for the square jars and bottles and for the traditional tableware, and various shapes are being thrown on the other five wheels. One person alone could not begin to accomplish the scope and variety of this work. It is the mark of this studio, and Hamada's way, that the group is an extension of the man.

The workers of the studio are a more or less permanent group of seven, plus Hamada. Each member is important, and the team functions as one. Sometimes there is a larger team, neighboring workers called in to help with heavy work demands like glazing and firing, and other jobs that do not occur every day.

Shinsaku, the first potter-son, has lived all his life in his father's work, went with his father to America in 1963 and home again around the world, now makes his own wares for exhibition in addition to those of the studio. Atsuya Hamada, the second potter-son, is especially good at cups and pitchers, has lived and done pottery in Denmark and with Bernard Leach in Cornwall, but is also a botanist. Oka-san, eleven-

year *deshi*—which really means more than a student of the master—
is an integral part of the flow of the shop and responsible for the kiln
firings, but he will go away in the spring to build his own pottery.
Uma-san has been here thirty-one years, came from grammar school
first as a servant boy, worked the clay, tended fireplaces, learned the
molds, then learned throwing, went to war, and returned. He throws
the large bowls and other shapes very well, and can be considered a
right hand to Hamada. Masao-san has been here twenty-eight years
full time, and he is the best one at pressing the large rectangular
bottles and big platters in the molds Hamada himself has made.
Mitsuko, the only woman of the team, began as a maid in the household
but became the best at pressing the small molds in the workshop.

Each worker has his own place in the studio, facing the shoji.
Mitsuko is at the far corner with her clay and molds, then Uma-san,
then Atsuya, and on the other side of the door, left as one enters, is
Masao-san, then Shinsaku, then Hamada. In addition there is one
very young boy who tends Hamada's wheel, and one very old man
who has been here a long while serving Hamada in various ways in the
compound, who now is learning to start the firing of the kilns.

Oka-san's *deshi* relationship involves more than a European type of
apprenticeship. A true deshi training such as Oka-san has received is very
difficult and not as common a way to learn in Japan as it used to be,
although Hamada regards it as the best system. To learn as a deshi
means to submit one's self to the master, to leave one's own self, to
become "in" the master. This "surrender" to the master does not
mean just blind imitation, but gives a spiritual discipline and the
opportunity to absorb a skill into one's bones. Oka-san has given
eleven years of his life to this master, although the usual deshi period
is three years.

Oka-san was born eight minutes' walk from where Hamada was
born. His father was the doctor for the Hamada household, and the
families had a close relationship. His eldest brother went first to
Hamada's to be deshi, but was refused because of the hard times that
followed the war—there was not enough food. This brother later married
Hamada's older daughter. Oka-san went to the university and studied
design for the purpose of broadening his view of art (his maternal

46

grandfather was one of Japan's most famous modern painters), but also with the intention of becoming a potter.

He had never met Hamada, but he came with his mother and father after graduation to ask to become deshi. He waited about three weeks for an answer and then received a postcard saying, "You may come." He came immediately. A deshi usually stays three years, but Oka-san's father had asked Hamada to keep his son ten years. Oka-san did not know this at the time and says that for him it just developed naturally to stay so long.

When Oka-san recalls his first days in the Hamada household and the first aspects of his deshi life, one strong impression was how much the whole Hamada family, but especially Hamada himself, enjoyed food, and how many different kinds of food there were. In the same way as his penchant for food, Hamada's desire for antiques surprised Oka-san. Hamada was always coming home with something new from far away for his collection, quite different from Oka-san's father, who brought home mostly Japanese things. Hamada at that time was collecting mainly Korean Yi dynasty pottery, and the big museum house was full of Yi dynasty ware on display. Oka-san first saw the ware with his own eyes, then learned to appreciate it through Hamada's eyes.

Oka-san could feel through Hamada's work how much Hamada was studying the Yi ware. Hamada was also interested in old Chinese wares, and medieval English pitchers, and studied these quite seriously as well. Oka-san slept for several years in that house with the collection. But his eleven-year stay with Hamada constitutes the learning. Hamada does not teach in the usual way.

Oka-san started in the workshop kneading clay. After two months he received his own wheel and his own place to work. In the next kiln his first wheel-thrown pieces went into the fire but only as his own work, not yet as products of the studio. His family and friends began to see that he was really going to be a potter. Always he learned by watching, but if he had a question Hamada would answer. It is not so much the teacher who teaches but the student who learns. As a deshi you learn with your body, meaning your flesh as well as your senses—your total awareness

Oka-san made two to four hundred tea cups per firing for the first year. These were sold as *nami-mono*, the ordinary ware of the kiln. Hamada never complimented his work. When some aspect of a thing was especially bad, he would correct, saying make this a little taller or this a little bigger, and so forth.

Little by little Hamada graduated Oka-san to other shapes, from tea cups to small bowls to a flat dish, always having him make hundreds at a time for practice. As soon as he could produce the shapes properly, they would go into the ordinary production of the workshop. Making hundreds of shapes all alike was an important aspect of Hamada's way of working and teaching.

Oka-san says that present-day artists think in terms of each piece being an individual work, but Hamada is different. Practice was not only for learning technique, but more for the deshi to learn a way of life. It was not the practice of making hundreds of shapes in order to be able to make one good shape, but rather the practice of hundreds of shapes in order to make hundreds of good pieces. It was not just technical training, but spiritual training as well. This is Oka-san's way of looking at it, although he knows that Hamada would probably not speak about the process in this way.

As deshi, Oka-san did not get any money until the third year, when he began to be paid a small sum monthly. Later, when Hamada's workers formed a group in order to exhibit and sell their own things, Oka-san found that his work was good and would sell, and at the present time his income is comfortable, though not large.

He knows that it is unique in Japan today to be an eleven-year deshi, but he knows that he really knows pottery. For a long time he has supervised every kiln that has been fired, with full responsibility for the three thousand pieces in it. As deshi you have to throw yourself away, and Oka-san knows that in giving himself away for these eleven years, potting has become, as he says, a part of his bones.

Oka-san has been speaking in Japanese. He remarks about a small but very important language point. Deborah, translating and questioning him as he speaks, has been using the Japanese word *sakuhin*, which means a "work" or "creation" of an artist. This word is not in the vocabulary at Hamada's. Instead, the Japanese word *shinamono*,

meaning articles, things, or goods, is his word for what he makes. Hamada works as a craftsman works, making hundreds of pieces at a time. Artists are possessive of their own creations, says Oka-san, but one does not find that at Hamada's.

Oka-san will leave in the spring to establish his own pottery. He will work in the way of Hamada, but also in his own way.

THE HOUSEHOLD

The running of this household is accomplished in the same careful manner as the managing of the pottery. Mrs. Hamada's deshi, as her husband likes to call them, are their daughter Hisako, and Shinsaku's wife, Teruko. Three girls help in the house, and there are workers for the jobs of the farm. The fields are planted, the cuttings and grafts made, the produce gathered, under Mrs. Hamada's care. One day I noticed that the whole field next to the house was newly planted, with small shoots of green coming up in short bunches in the black furrows, where only a few days before the same field was a jumble of chrysanthemum flowers.

I asked Hamada what the new planting was, and he said he did not know, how does it look? I described it; he laughed and said, "That's Mrs. Hamada's favorite grass." As he looked at the sample I brought, with his eye glasses up on his forehead, he said, "We'd better ask Atsuya, he's the botanist in the family." Then Hamada pulled apart a small kernel at the end of the green shoot and said, "Oh, now I know, it's barley."

So the planting goes, and the harvest time, and the drying or putting up of the various produce. Sometimes there is too much, and Mrs. Hamada goes with baskets of fresh vegetables to the neighbors, or to Tokyo to her first son's family. The girls of the kitchen and the two daughters are always experimenting with new ways of cooking and with the continuing abundance and variety of produce that is grown or bought or sometimes comes as presents.

Almost every day vendors come with something special, citrons, or fish, or persimmons, or other things are sent to the household from all over Japan as gifts from friends. Hisako says they wait all year for the

special times when the delicious persimmons ripen, different times at different places, and they receive samples.

Each year it is the same. Hamada has developed a pattern for living, a rhythm for his daily life that is like the never-ending flow of the kiln, with crescendos of special festival or holiday food preparation and climaxes of unusual events, coupled with new insights gleaned from the trips abroad or something a guest may bring or tell. In this way the simple routine is broadened out in a quite genuine way, from the structure of the strongly rooted base he has so conciously built. All the family participates, each one subordinating himself to the whole. Hisako, speaking of a new kimono a seamstress was making for her, and how long it would be before she could have it, remarked, "In Japan we always have to wait, we learn to wait."

Finishing Pots

For several days the work of the studio has been moving steadily toward completion of the three thousand pots that are being made for the next kiln. Hamada's annual Tokyo exhibition is approaching, and there is tension in the air and pressure for time.

Mitsuko is pressing oval bowls in flat molds, Masao-san is making square bottles with great precision, Uma-san throws large cylindrical jars. Shinsaku has made seventy-five tea cups in the last hour; the water by the wheel is steaming more because the air is colder, and his breath is visible as he stoops to dip some of the cups in ochre slip. Atsuya is throwing coffee cups. Pots are everywhere, waiting to be trimmed, arrayed on wooden pallets lying on the ground or stacked on boards racked overhead on the thick, smoke-blackened timbers of the roof. Pots are drying in the workshop or drying outside, row after row in the cold sunshine, literally hundreds of pots in and around the small shop, with only a free space on the dirt floor around the robata where the workers rest and have tea.

On this day Hamada came late in the afternoon to the workshop. As usual his wheel had been kept ready all day by the young boy who saw to the heat of the kettle at the robata, who kept Hamada's throwing pot filled with steaming water, the heavy wooden wheel head moisten-

ed, the pillow plumped up, and who was always rechecking the moisture of the ready wedged mounds of clay under the plastic to be certain they were in exact shape for working, but Hamada did not come.

Now he is here, after the workers, his sons, and the boy are gone, to finish the jars that he had previously thrown. I knew he would come, that he had to finish these pieces before they got dry, while they were in just the right stage of dampness.

He gets to work immediately, nodding to me, thumping the sides of pots, using his thumb and fingers at edges to test the stiffness, smoothing, caressing, patting some he likes, smiling, frowning. He puts a spot of clay on some of them, reminding himself of ones to be coated with yellow ochre, gives another bop with a plaster bat to an ovaled bottle, and undoes the plastic on eight jars sitting on the ground beside his wheel. We look at these pieces together, remarking that soft leather-hard clay is the nicest stage, looking at the sheen, the mellow lights and darks on each form. I am struck by the difference and life of each piece.

He takes time and care and gives studied attention. The pots are checked for rough trimming spots, or tool gouges, or nicks where the shoulder of a vase rested upside-down on a trimming chuck. Perhaps an hour is spent in the detailed finishing of these shapes.

He carves facets on the side of an open-necked jar with a large, sharp knife. Hamada says this kind of knife must be rusty; a new stainless steel knife would not do. No, it must be old and worn, preferably made in Okinawa, preferably a fisherman's knife that some grandmothers have been gutting fish with for generations. Now Hamada is using the strong old blade of such a knife to slash downward against a big round pot, making eight perfect vertical facets, each beveled with eight other facets; this second cutting makes a shadow pattern on the form.

I remember, as I sit watching him in the twilight here, the other time I had watched him late in the evenings, hours after the students were gone, as we sat in the USC pottery studio in Los Angeles. In 1963 I planned a workshop for Hamada at the University of Southern California. He had been willing to take time from his work in Japan

51

for this trip in order to arrange for a period of American study for his second daughter, Hisako, and because he really wanted to show some American potters the way of the work in Mashiko. He brought along Shinsaku, who did not speak any English at that time and who had spent all his life working in his father's studio. During the weeks of this workshop, these two proceeded with the daily making of shapes, using our prepared clay, throwing, trimming, attaching necks, making handles and lids, faceting bottles, applying slip, working each day in the same manner as they worked at home, out of the life experience of many years, from what Hamada calls his taproot. This has been the only time Hamada showed Westerners the whole rhythm and progression of the way he works in Japan.

On the first day of the USC workshop, while the students were assembling and waiting, he said, "Show me the glazes." He had written to me several times, telling me to try to make what I had seen in Mashiko. As a matter of fact, he had sent me a detailed diagram of how to burn a pile of rice husks for ash, if I could find some for his special glaze. Naturally I could not. We use similar types of glazes for our stoneware fire, but we make them from much different materials. I showed him fired tests of what I had prepared. He asked only one or two brief questions for each test: does it run? how thick should it be? And the work began. Here in Mashiko I have become more aware of what an astonishing feat this was, to take glazes that were not his own and use them without prior knowledge, as if they were his own. The raw glazes at his pottery, which are made of ash and impure materials, are nothing at all like the refined, American counterparts in consistency, condition, or application.

For those at the university who watched the workshop, it was a time of fascination. He and Shinsaku worked steadily and smoothly each day in silence, but Hamada talked once or twice a day to the group in English. For me it was another time of daily attendance to his wishes, of hanging up his outer kimono in my office each morning, keeping it locked up because he had one-hundred-dollar bills pinned all over the inside ("It's only paper," he said), of answering the many phone calls, and making a few appointments, especially for press interviews.

After the students left the studio, at four or five o'clock each day,

Hamada and Shinsaku continued throwing, finishing, trimming, making clay, keeping up the rhythm until eleven or twelve midnight, when they would be ready for some dinner or sightseeing. During that time I saw the same care as he is taking now, the same patience, the same practiced eye glancing over the work, rejecting, accepting, filling in, adding where necessary, until the whole is perfection, doing the same thing in my American university pottery as he is dong in his own studio on this hillside in Japan.

Suddenly the intercom asks for him to come to the main house. We walk down the path on the slippery clay-mud steps, each one cut from the earth and secured with a log. Hamada shines the big red torch for light, pointing out some trees and flowers as we go.

I have been here some days now, and we have not had a chance for more than a few of his proposed sit-down three o'clock teas. I have seen and talked with people in Mashiko that he asked me to see. I have been watching, I have some questions, and I ask him for some discussion time.

Abruptly he replies: "I leave tonight, a little after eight, for Utsunomiya by car, then take the train to Tokyo and change trains to Osaka. Arriving there perhaps five hours later, I have fifty-five minutes before taking the train to Kurashiki. Someone from the Osaka Daimaru department store will meet me to take the Okinawa enamels I will be carrying from these kilns we have just fired; fifty-five minutes, plenty of time for that. Then to Kurashiki. Next morning I will give a speech at the opening of the new Ohara Gallery, the interior of which has been designed by Keisuke Serizawa, my old friend the silk screen artist, for the Chinese and Korean pottery collection. Then I will go back to Osaka. We will stay up all the remaining night installing the Osaka exhibition, Sunday. Monday there will be many festivities celebrating the thirty years of the Kurashiki museum.

"Monday evening, Osaka again, and up all that night installing. Many people will come for the memorial for the president of Daimaru, my old friend with whom I used to paint, who died. We will use some Leach drawings just arrived for the exhibition. That president was very fond of Leach. All day Tuesday I will be at the opening ceremonies. I return from Osaka Wednesday the 11th, perhaps by 4:00 P.M.

53

Thursday we will pack a bisque kiln here to get ready for the glazing, and I still have maybe fifty tea bowls to make for this kiln.''

He was laying down the pattern. I was at the moment not part of it, and I knew I would have to watch and still wait.

Cups of hot tea and plates of fruit are placed on the railing of the robata in the main house when we arrive. Mrs. Hamada stirs the coals and the charred wood as she always does so that the sweet-smelling cedar smoke mingles with the steam from the hanging iron kettle. We warm our cold hands over the steam, and our eyes water from the smoke. Hamada says he can do one-half hour's more work in the shop before preparing to go to Utsunomiya. A soft rain has begun, and he notes that this will make his clay pots dry more slowly. It is nearly seven o'clock and he must leave a little after eight.

Suddenly a stranger joins us at the robata for tea. He has come from Tokyo by train to buy a pot, has chosen it in the last hour with Atsuya, and is waiting for it to be wrapped. Hamada, who has come to eat and wants to work another half hour before catching his train, sits quietly and makes conversation with the new guest. Suddenly lightning and thunder starts, and it is raining hard; we can hear it on the roof and see it through the shoji in the firelight. Hamada says his Tochigi Prefecture is well known for violent thunderstorms.

A maid announces that our taxi is at the gate, Hamada procrastinates a little longer with conversation, then hands each of us a parchment umbrella and puts on his geta. As if forgetting his recent discourse on the pressure of his time, he takes an umbrella for himself and walks down the square stone plaques that line the slick path, carrying the red torch. The gate house light has not been working for several days, and rain is pouring down. Helping us into the waiting taxi, Hamada takes our wet umbrellas, folds them under his arm while holding his own umbrella and shines the flashlight, waving it goodbye, moving the light in a big circle until we can no longer see it.

This is as much a part of his pattern and orderliness as everything he has said he is going to do. The torch, the farewell, the memorial exhibition in Osaka, and the opening in Kurashiki, the big and little events alike are part of the never-ending scheme in which everything has a place, scheduled or not.

REMINISCING

His Western clothes dangling from a bamboo pole, airing in the sun, told me he was home. I saw him sitting cross-legged on the porch, taking the sun himself, looking out at the grandeur of his vista, the valley's yellow fields, the town, the blue gray hills beyond. "Today is closed," he announces with a chuckle, referring to the barred wooden doors at the gate house. I know. I had just seen him politely but firmly turn away a young visitor wandering up the path.

Hamada has been away three days at the Osaka and Kurashiki exhibitions. He is twinkling with pleasure: "So many people at the exhibition; eighty percent of my works sold the first day. Munakata's scroll paintings at this show were very expensive. Now that he has received the cultural order, the galleries want his prices up, but he is so expensive that only three sold. Serizawa's dyeings were very expensive too. My largest bowl is two thousand dollars, not so expensive for Japan. Of course I realize that is very expensive in America for a pot." Hamada seems almost to savor the English word "pot" as he says it.

"Serizawa was so tired from designing the new installation for early Chinese wares, T'ang and Han, at the Ohara Gallery in Kurashiki, but it is a wonderful interior. Of course the DeYoung Museum in San Francisco is very fine in this area too."

In a talkative mood, Hamada sits on the porch railing, dangling his feet and swinging them ever so lightly. He has already decided that this is to be a sit-down day, and I realize that he is preparing to honor my request of the rainy night before he left. He calls for tea to be prepared and lays out pillows for us to sit on the low wood table in front of the house. This is the gray weathered wood table of many uses, the table on which the *futon* quilts are aired in the morning, or sometimes packages are wrapped for guests, or flowers arranged, or fruits and vegetables from the garden are piled and sorted.

Tea in hand, Hamada speaks of his Mashiko beginnings. Of course he owns this property, twenty thousand *tsubo*, which he thinks might be equivalent to twenty acres, as one tsubo is 3.95 square yards. He motions with his arm to include the whole of his land, the big tree on the other side of the five-chamber kiln, the fields across the road, up the

hill past Shinsaku's house and Hamada's museum house, to the eight-chamber kiln and the salt kiln at the top of the property.

The idea for this compound had come to him in 1921, in Ditchling, Sussex, during the time that he and Bernard Leach were setting up the pottery in Cornwall and Hamada was building the kilns. The two had gone as pilgrims to see Mrs. Ethyl Mairet, a weaver whose work they had seen and admired. Hamada had bought her book on vegetable dyeing in the Maruzen bookstore in Tokyo. At Mrs. Mairet's they had met Eric Gill, the British sculptor and designer, and then stayed at his home nearby. Hamada was very impressed by the life these artists led, making their own beer, cheese, bread, and doing their own weaving, building their own furniture, pursuing an existence different from others around them.

So it was in Ditchling, when he was twenty-six, that Hamada knew he had found his destiny. He wanted to live in this same way. He knew that his painter friends might have exhibits and they might get rich and become famous, but he knew that he had made a true discovery. It would be a long road, but he knew what he wanted to do. He resolved to start immediately when he got home.

After returning from England to Japan by ship in 1924, he stopped to see Kanjiro Kawai, his good friend and colleague from Ceramic Institute days. He found that Soetsu Yanagi had moved to Kyoto too, after the Tokyo earthquake of 1923. He wanted his two friends Yanagi and Kawai to meet, so he got them together by having Yanagi come to see his English slipware collection. This began the close association of these three men, who would eventually coin the term and philosophy of *mingei* (folkcraft) and establish museums of folk art, changing the image of much that was made then and what is made now in present-day Japan, and influencing the world.

Having brought Yanagi and Kawai together, Hamada went off to the village of Mashiko where he had decided to live and establish his kiln. Typically understating, he said he expected Mashiko to be hard and it was not nearly as hard as he had expected. He came to Mashiko to learn from the people and he did learn from them.

"In the beginning, when I first came to Mashiko, the people thought I was a communist. My big leather trunk had only English letters on

it and English things in it, and sometimes they would send police to see what I was doing. People who traveled were suspect, and besides, even my work clothes were different. They had never seen this kind of clothing," and he points to his baggy overall pants and kimono top, which are something like the ones he used to wear. "The traditional garb of this village was *mompei*—full-cut country work trousers—of a particular type, but my clothes then were even more rural, and from a different area of Japan. Many people in Mashiko didn't even wear work trousers then; they wore kimono tied between the legs."

He experienced the same kind of resentment when he visited Okinawa in 1924, but the island people were inclined to be more friendly than the Mashiko villagers, perhaps because they were so isolated. Still Hamada found it very hard in the beginning to be accepted in Okinawa, when he went to do traditional pottery, because even there they were wary and afraid of him.

In Mashiko he worked first at the Otsuka kiln, not the one that is the oldest kiln in Mashiko but of the same family. He was only allowed to stay there about two months because the wife said it was too hard to have another mouth to feed.

He had made friends with a young boy named Sakuma, who seemed impressed with Hamada's worldly knowledge, and the two began a lifelong relationship. He was given a tiny spot to rent at Sakuma's father's pottery, where traditional domestic wares and big jars were being made. At Sakuma's he paid according to what he made, even for failures in the kiln, but he used their glazes and learned their regional materials. "That first year I couldn't sell anything, nobody wanted it, but also I didn't want to sell. That would have made the people even more suspicious of me, so I just gave what I made to my friends and mostly my relatives."

"For a long time the Mashiko people still thought I might be a communist. Sometimes they sent police. When I tried to get a room, nobody would rent. Or if I did, I could only live for a short time in one place, usually in an outside hallway with a borrowed wheel. Even after I already had two children, I had to move to a new place every year.

"Yanagi came to visit me after I had been two months in Mashiko,

liked my work, and liked me being here. He wrote about me in a big Tokyo newspaper, but of course Mashiko people only read the local news. Then the next year my relatives, to whom I had given my first pots, thought they would try to sell them for me in the Ginza, and they did, knowing they could get more gifts from Hamada," he says with a twinkle. He remarks that talking of himself in the third person, as he usually does, is the Japanese custom.

His marriage was arranged toward the end of that first year in Mashiko. The Japanese word is *miai* for an arranged marriage, and it is arranged by a *nakodo*, a go-between. Hamada thinks the idea of a go-between is good; he thought so then and he still thinks so. The custom of having some well-informed objective person look for both people and plan the characteristics that will be suitable for each, helping each choose a compatible mate, is the best way, he said.

Before he married Mrs. Hamada, he had a man he knew judge her to see if she was a good match. He explains that there is an old Chinese discipline whereby one may be trained in this sort of intuitive judgement, a very serious discipline. At that time, when he wanted to marry, he knew a man who had studied this art and could accurately judge a person by seeing his face. That man looked at Mrs. Hamada and said she would make him a good wife. Hamada is telling this story in English, but his wife, who is sitting with us, has felt what he has said and smiles. Mrs. Hamada's family also sent people to research him, to see what he was doing in Mashiko. They found him living alone, getting thrown out of one place and another, so the go-between concluded that he could take care of himself, he must be all right, Hamada jokes about himself.

The marriage was decided after one meeting. The go-between suggested December 21 as the best day to be married because it is the shortest day of the year, so every day after that will be longer. One starts with nothing and good fortune grows.

"Even after marrying, the people of Mashiko didn't trust me. During those next years we lived in different rented places, always having a small sleeping room, but sometimes for the kitchen and pottery we used the hall. We had no money to buy a place. A few years later though, a workshop closed, and I was able to buy six wheels for nine

yen and some saké. At that time two yen equalled one dollar. I am still using two of these wheels, and one I took to Okinawa."

After six years in Mashiko, Hamada went again to England, this time with Yanagi. He had an exhibition in the Paterson Gallery, at 5 Old Bond Street, where all the walls were hung with Spanish velvet. George Eumorfopoulos, then the most famous collector of ceramics in the world, was the first customer at this exhibit. A. L. Hetherington and W. W. Winkworth of the Victoria and Albert Museum in London, experts and writers on ceramics, and Robert L. Hobson of the British Museum, all came to this exhibition and bought his work.

"Yanagi told me, don't buy anything, send all the money to Mrs. Hamada. So I did, then I bought this house."

Returning from England in 1929, having had a successful exhibition, having again met with Eric Gill and his other artist friends like Mrs. Mairet, Hamada found that he could now appreciate Mashiko more for what it really was—a way of life. It was not just that the clay materials were here, or the pottery techniques, but the other aspects as well—the people, the countryside—and he knew it was right to make his work here.

"The easiest way to gain a place to live seemed to be to move a house house to my land, not to build new. We had seen this old house, in a place away from Mashiko, belonging to a man who had many debts and who drank too much. After returning from England the second time and having the money from that exhibit, I went to see this man. He was still drinking, had been drinking for three days, and he said I could have his house if I paid his brother and if I would take everything in it the way it was.

"I agreed and arranged the move. I brought twenty people and three carts for carrying the huge beams. We moved it in pieces, no nails, and reassembled it on the ground here in Mashiko. The longest beam was sixty-six feet. When we came with all these people and carts to get the house, the man was sitting in the kitchen drunk. My friend advised me not to pay the man while he was drunk, for he would only want more and more money later. So we all waited there, horses, helpers, carts, most of the day until the man sobered up enough to make the transaction. Originally, when I wanted to buy this house and learned that the owner was very much in debt and needed to sell,

my problem was to find out how much in debt he was and offer him that price. Then I'd know I'd made the best possible deal.

"Eventually I bought ten old buildings, each one a sixty to one-hundred-year-old house. We carried them here on horse carts, all had very big beams, and we piled them around the place until I could get to putting them back together. Funny things always happened when I bought the houses.

"Another time I went to see a man about buying his house, and there he was sitting on the porch looking down the barrel of his gun at anyone who came around. Everybody was afraid to talk to him. I asked him what he was doing. 'Just cleaning my gun,' he said. And I bought the house. There is still one of the ten that we haven't rebuilt. I hope it will be the beginning of my museum."

With a wave of his hand he invites us up from our cushions and into the house to the robata. He did not move inside earlier, saying he wanted to avoid getting too warm because he still expects to go the workshop. But it is cooler now, and he wants us to eat some new foods.

We were served Japanese pickles prepared with grated white Japanese radish and soy sauce, then radish with sweet red bean paste, which Teruko had made. "The radish is too hot this time of year, and it will taste better when the weather is colder, but we are making this for special festivals." We ate delicious thin slices of fresh citron dipped in fine ground sugar, and *sushi* made with special raw tuna fish wrapped in pickled persimmon leaf, then homemade buckwheat noodles with seaweed and green onion.

When Mrs. Hamada came to sit at the robata, one could see that rare feeling of grace that develops between people who have lived and worked together for a long time. Watching Hamada and his wife today, I felt the tremendous understanding they have of each other even when they are sitting separately and speaking different languages.

Hamada reminisces about this small space, the nucleus of the compound, this room where he and his family have lived forty years, and the cherry wood robata, the heart of that core. The black iron kettle he bought years ago for seven yen steams over the fire. He liked the shape of the kettle because it resembled a persimmon, the fat round fruit for which the *kaki* glaze is named; he likes the wide lid and kaki

leaf design. The beautiful shiny floor of this room, and the dining table made of rich, dark keyaki wood gleam from years of polishing every day by hand. Hamada made the wrought iron lamp hanging from the beams and designed the long table and its benches, which a carpenter built for twenty-five yen. Big as this table is, it takes three shifts to feed everyone at each mealtime. "You understand why we can't entertain you all the time, there are too many shifts at the table now."

An ornate old tansu chest with iron hinges and handles stands as a focal point in this room. "I look at the decoration and think that it must be the Jomon in us that makes us do such things. The Jomon strain in our ancestral heritage, the elaborate strain, as opposed to Yayoi, which is the more plain; it's a kind of yin-yang." Leaving this thought in the air, he explains that he was trading his pots in the old days to pay for the chests he wanted. Now the pots are generally more valuable than the things he would want to trade for.

When he came back from England the second time and began to build this compound, Hamada had hopes of establishing a center where many crafts could be carried on at once, not only pottery, but furniture making, iron work, weaving, and glass blowing. This is still a wistful dream for him, not yet fulfilled.

He used to put a crucible of glass to melt at the end of the kiln after the last chamber was finished, so he could blow glass while the kiln cooled. He was so tired after firing the kiln that he pursued this for only a few years and found that he had to concentrate on the clay. He has designed and made some other furnishings, like those of this room, and the interior of Shimaoka's house next door, but there has never been time or energy to establish the craft community.

"For twenty years the Mashiko people laughed at me, didn't understand, and now don't understand, can't really. Maybe they still laugh at me, but if they do, it is just like Mashiko people, it is just their way.

"If I had not been here maybe only ten percent of the kilns would be still going, making tableware, but maybe that's all that should be going. My bad influence has been to make the town too proud, proud before they were ready. Proud of me and proud of themselves for their own success at this thing I started here.

61

"So that's why I plan to build a permanent showroom to keep my collection open always to any Mashiko potter who wants to see it. Maybe only one or two out of a hundred will want to see, but even that is worthwhile. Now I will let the pots do the teaching. Perhaps the pots themselves will correct the mistake Hamada has made. Maybe no one will understand even if he does see, maybe only one or two in a hundred, but still that's something, that's enough."

Sitting back after speaking so seriously, certain of the worth and the direction of his life, he laughs, "That's why whatever Susan writes will be OK, for it is the pots that live on beyond and carry the true message."

In Mashiko his presence was upsetting to a community of established potters making traditional wares for daily needs. When Hamada arrived there in his twenties, Mashiko was a traditional world. It no longer is. His own problem of having played a part in the changing of the early pottery of this village keeps him working to preserve the tradition of the way of the work he has developed these forty-eight years. Hamada made wares using the Mashiko technique traditions, but he made his own wares. He held exhibitions, and his work sold for much more than the village pottery. His fame brought new ideas to Mashiko potters when society no longer needed their traditional wares. Then they changed their work to a way that was not inherently theirs.

His feelings about the erosion of tradition in this village and in Japan, and his inability to hold back the obsolescense of these traditional potteries, Hamada refers to as his Mashiko problem. His Mashiko problem is a miniature example of overall societal trends. It has given impetus to his purchase of vast amounts of works made over the world by unsophisticated peoples of all times, as legacy for the future. He has raised money for five museums for the perpetuation of folk art, and uses his good eye and insight to direct the collections.

Hamada has bridged two value systems, two cultures—the two attitudes of work and art. More successfully than any other craftsman in his time he has done this unique thing, has known he had to do it since his earliest years, and has made fantastic energy expenditures toward this end. Hamada has devoted very little time to writing about himself. He is too busy doing the work, and living it. He has spent

eleven years training one true deshi, and kept with him two sons in the way of his work, though they are of a later Japanese generation and do not have strong roots in the traditional world.

His taking on of traditional ways is imbedded in Hamada's ideal of submersing self, of working without consciousness and without false pride. He considers that the only persons who really achieved this were the anonymous folk craftsmen of the ages who produced things of beauty without being conscious of doing so.

The fact of Hamada's benefitting Mashiko through both preservation of the traditional pottery techniques and stimulation of other Mashiko potters to maintain and increase their kilns, and the failure of Mashiko to fully appreciate or understand Hamada's way or even keep to their own ways, has been a lifelong dilemma for him. In solving this problem for himself, it seems to me that he has given the germ for solving it to Mashiko. Mashiko pottery as a whole has made the bridges between old and new values. The kilns of Mashiko now number 105, whereas there were forty when Hamada arrived. Mashiko potters are producing without government subsidies in the 150-year-old traditional manner using local natural materials and hill kilns while living the Japanese rural life. This has occurred at a time when other traditional family type pottery areas in Japan, such as Arita, Seto, Kanazawa, and Kyoto no longer function at anywhere close to the scale of the past. Some Mashiko ceramic ware is very good and some is not so good, but the important thing is that the town is alive and working.

Mrs. Hamada has brought some more varieties of food for us to sample, and some cups of fresh yogurt, thirty of which are made here every day from the culture the Bulgarian embassy gave them a few months ago. Everyone delights in trying the yogurt with different sweets, including the heather honey sent for this purpose by the youngest son, who is studying glassblowing in England.

Hamada remarks that his wife has a wonderful ability to cook. When they were first married he would come home and tell her what food to make, because he ate differently from what was her custom. He would describe a favorite dish, and it was always very difficult to create a flavor from a verbal description, but she was good at it.

63

Hisako, joining us at the fire, tells the story of Hamada asking her mother to make a special stuffed meat pastry he had eaten the first time he lived in England, and she had made it all those years according to his description. Many times she tried to make it with many trials and corrections until she finally got it the way he liked it. The family ate this same food together on their recent trip abroad, and all agreed that Mrs. Hamada's version was better than the original.

Mrs. Hamada had not really wanted to go to America in 1966, but people talked about travel, so she finally decided to go. She did not take a special kimono, just her ordinary ones. She decided chopsticks were "more delicious" than eating with a knife and fork, and when she first slept in a bed, she was afraid of falling out. At Farmer's Market in Los Angeles, where we had gone to investigate food, she was disappointed in the cucumber, her favorite thing to eat, because the American one was big and flavorless compared with the fresh, clean, cool taste of the Japanese variety. Remembering this trip, I smilingly remind her of her goodbye telephone call from New York, when they were ready to fly to Europe, she speaking Japanese to me and I talking English, and both of us understanding.

Has she ever used a potter's wheel? "Once while we were in Okinawa when Hamada was gone from the workshop, I tried five or six different times. I always cleaned up after myself very carefully so he wouldn't know, but finally he noticed something different about the swipe marks left by my cleaning rags, different from his own style. I had given myself away. He scolded me for trying, and I didn't anymore. That was the only time."

But Hamada had wanted her to do weaving. It was customary in Japan for country women to weave the common fabrics for the family clothing, as well as to sew them. Hamada designed the main room of this house originally with a chimney fireplace so that the balcony area above, which he intended for the loom, would not get the smoke from the open fire. The robata was built later when he found that Mrs. Hamada had no time for weaving because she was busy taking care of visitors and children. All she could manage was to make the clothing.

For all those years, up until the war was over, she had no place of her own, no place to be, as she calls it, and no time of her own to

travel or to take a rest. Even at New Year, the precious three-day holiday of rest in Japan, even then they entertained the workers and servants who had helped them all year long, and she had to make food for them and be busy. It is customary for Japanese wives to slave for thirty or forty years without a rest. Translated literally from the Japanese, her words say that the wife is supposed "to kill herself for her husband," which means that the wife is supposed to submit her spirit to her husband. There is a Japanese saying about women, says Mrs. Hamada, that when you are young you obey your parents, later you obey your husband, and when you are older you must obey your children.

From the earliest days, Hamada worked at night on his pots, because even then there were guests. Before the war they used to keep as many as ten guests a night. Entertaining guests did not just mean tea, but an overnight stay. Mrs. Hamada and their youngest boy slept in the small room off the living area, the older boys slept on the raised area by the robata, and the girls in the kitchen. Until after the war there were guests every night.

The first train came to Mashiko at six in the morning, and it is a half hour walk from the station to the compound. She got so she knew in her bones just when to open the door. The other train came at ten in the evening. If guests arrived in the evening, they would stay overnight talking until very late, and Hamada would work after they went to bed. If they came in the morning, they stayed all day. So from the very beginning the only pottery time has been late at night or early in the morning before breakfast.

Now most people come by car, and there are more frequent trains, so people do not stay so long, but there are even more visitors than before. Mrs. Hamada says that one of the reasons she came to Mashiko to be married was that she liked flowers and country rather than meeting people or business. Hamada was good for her because he did not sell anything, he only made things, she thought.

"My wife says she doesn't like people," Hamada laughs, "But all people like my wife."

Abruptly and seriously, Hamada folds his hands together and leans forward. "I would never be proud of my work. There is always so much

more to learn. I don't want to float on top of things, I just want to sink down to the bottom, to go down deeper right where I am. Some people want to play on the water, swim around on the surface, diving a little and coming up again, sticking their heads out, but now I've gotten so that I just want to go down deep. Sometimes I think I don't want to see any more visitors, but then I know, after all, without the people it would be lonely."

Hamada has not made any pots on this day, but he has talked with his workers and seen some visitors. It is a tribute to his kindness and generosity that he gives so much of his time to the many visitors who come; this is also part of the showing of his work. But it is impossible not to speculate about how many of them come just to say they have been here, or because he has been given the highest awards in the land. Many people who come have such superficial knowledge of him, or his work, or ceramics in general that they seem unworthy of the visit. Still his time is awarded to all alike, with possible differences according to the interest expressed in conversation, or, in the case of foreigners, if they have the ability to speak Japanese, or according to the kind of introduction the guest bears or the person from whom he comes.

The pattern of giving, doing, reviewing, repeating, reflects the devotion to the ideal for which he has lived these years in this place, and of which he has been talking these last hours. It is like a teacher's need to tell, but it is more: he likes what he is and is what he lives, which implies that he cannot do otherwise with the guests. He does not remember the names or faces, but entertains the endless stream in the course of his duty to help them see. If only a few are touched, well, that is enough.

He has spent all afternoon with his family, Deborah, and me, first outside, then in the house. For a long time he had not wanted to go inside because he said he was planning to go to the workshop again. But the work was not done. He has seemed happy, pleased with his family circle, glad to have fit these hours into the scheme, conscious of what it means to the girls at the big table making rice cakes for festival time, the grandsons playing nearby, to us, and to his own revitalization.

The only possible inference of nervousness, that he would like to be somewhere else, is the twisting of his fingers together, and the touching

of one palm with the other, over and over, as the fire burns in the robata. This gesture is one that he employs just before he is getting ready to throw, sitting cross-legged and quiet on the pillow in front of his wheel in the workshop, working his fingers back and forth in a ritual before touching the clay. Now by the fire, watching him chuckle and reminisce, telling sories and calling for the different foods for us to try, I see his hands twist over and over in this gesture of getting ready to work, reminding me of the great gift, his time, that he is giving.

ENAMEL OVERGLAZE PAINTING

Whenever he can, when the weather is fine and the light is good, Hamada sets up for enamel painting on the open porch of the main house, facing the vista of the valley. From here he can look across the rice fields to the hills of Mashiko, the colors of gray and green and ochre. Every few days he sits here painting about thirty already glazed and fired pots with low temperature enamel pigments, which will need a third firing in a special kiln.

Certain of the pots of each load were made in Okinawa, where he has gone some weeks of each year for many years to work. He enjoys the different look of that clay, the warm white slip, and the glaze made and fired there from coral and rice ash. The pots are flown back to Mashiko, highly prized because not many are made, and they are used only for overglaze enamel painting. In this group also to be painted are glazed stoneware pots of his own kiln, with especially designed clear glaze areas ready to frame the enamel patterns.

His pillow is placed on the porch, surrounded by the pots to be decorated, his brushes are here, and the mortars and pestals containing the enamels are clustered around. The colors he uses are grass green, rich amber, and the characteristic Kutani red.

Hamada sits down to paint, cross-legged as usual, and puts a pot up on his banding wheel. He works two pots at a time, planning the next while looking at this, setting one down, picking up the other, adding a stroke. The action is both deliberate and spontaneous. He goes over the piece with his eyes, moves his thumb in the air, or waves the brush, then bounds to the pot with the tip of the brush full of color, ready to

67

make a stroke. Suddenly he may decide not to do anything, and put that pot down to contemplate another.

To paint chalky wet enamel pigment on the hard glassy surface of a glazed, fired pot is a difficult chore; both glaze surface and liquid do not want to adhere to each other, either wet or dry. Enamel tends to remain slightly raised on the first glaze because it is fired at a low temperature, just above red heat, to retain the brilliant color. Its character is sometimes more like paint than like glaze. In any case, enamel is a great challenge.

"I have no names for the patterns. There is no need to name them." he replies when I ask him about a repeat star pattern outlined in red and filled in with green enamel, which I had not seen before. His patterns have been assimilated by his body and seem to belong to these pots, although enamel painting juts out of the surface by virtue of its color, like the bright changes of a patchwork quilt.

Picking up larger pots, he holds them a bit longer. Up go the tortoiseshell glasses onto his forehead, or down before his eyes; it does not seem to matter where they are. As Hamada holds a plate or a vase, the brush comes down and the line is made as if it already knew the way it would go. Enamel is forever, each stroke counts. No melding of glaze will soften the line, no accidents of firing or blush of wood ash will mellow the surface.

Finished colors fired on top of the first glaze stand out in brilliance and texture. The unfired enamel colors are much more dull and chalky now than they will be after firing. As Hamada paints, he must relate the way the finished intensity of color will be to the chalky way it is now. He must see it in his mind's eye as it will look after the firing on the gray and tan glazed pots he is painting. There is no other potter who can match Hamada's finesse in this technique.

As each pot is finished, he stacks it someplace around him, enameled places not touching or the unfired pigment will rub off. The pots are not taken away, because he is still looking at them. Most of the brush designs are familiar patterns that I have seen many times, until he puts a geometric pattern on a square plate. In answer to the question that I am not asking, he smiles and says, "It is inspired by your Indians."

Tea is the medium for suspending the enamel and helping it adhere

to the pot's glossy surface. He stirs the pigments occasionally with a pestle in the porcelain mortar, sometimes adding a drop of tea to improve the viscosity and suspension. When the pots are painted with one color, he lets them dry before adding the next color. He alternates shapes, picking up larger pots or smaller, choosing different forms, and the sequence of shapes gives rhythm to the painting. It is another example of patterning the movements and setting a rhythm to the time, transforming the whole.

Every potter has a different secret for enamels. Hamada's colors are commercially made to his specification, ground for him, but sometimes he changes them and grinds more. Porcelain overglaze enamels must be extraordinarily fine grained in order to fire on smoothly. They are generally ground for a very long time by machine, perhaps three months; stoneware enamels need only three or four days. Cobalt blue is the hardest color to fine down. In the old days, cobalt was ground by hand about three years, Hamada says, usually by a blind old woman who had nothing else to do. The cobalt would be ground continuously, and when some was used, it was replaced. In this way new and old were together, forever, the same as old wine. Hamada remarks now that in Okinawa there are some Chinese wines that are three hundred years old.

"Most enamels are made in Kyoto today, but only a few people make good ones; mostly people are making fakes. My overglaze red is from the best red I know in Kyoto. Recently I saw a very good new color sample—you know there are many different Kutani reds— which had a little yellow ochre added, and it made a good red. I should try it." The fact that he says he should try it of course means he probably will not, for that would disturb years of development already so carefully drawn.

When the red enamel on these pots has dried later tonight, he will finish by adding the green or amber enamels where he wants them, and tomorrow the small kiln will be packed with these pieces and fired to 1470° F. (800° C.) in one day. He paces this with other work, with throwing and trimming pots and seeing visitors and going somewhere on the train. It all fits. An hour of time here, thirty pots painted, two kiln loads, one day for each to fire in the simple updraft kiln to fuse

69

on this color. When these are finished, he will paint another group, and another, repeating what has been repeated all these years, gaining from the repetition each time.

The enamel kiln is two updraught bottle kilns together, built with a common wall, but only one chamber is used. The inner pot for stacking the ware will hold about sixteen pieces. One of Hamada's large bisque bowls with its foot cut out is inverted on top to close the kiln. This little kiln is also used for bisquing greenware when Hamada has not yet made all his tea bowls and the glaze kiln is ready to be fired.

Next day the enamel firing was begun at 10:00 A.M. and finished at 3:00 P.M. The old man fires the kiln, sitting in his auto seat flat on the ground, never leaving it the whole time, watching the smoke, checking the color of the flames, throwing the red pine continuously into the firebox. "Old-man" is the name I coined—I never heard him addressed by his real name. We have been friends since the day he offered me the unusual privilege of sitting in his auto seat. He has been here for years, doing a variety of odd jobs, and now he is being allowed to start the firings in the large five-chamber kiln. He has already learned to do this small enamel firing, and he does the whole kiln, proud and conscious of the responsibility Hamada gives him.

Draw trials, small clay pieces with enamels painted on them for glaze tests, are pulled from the fire when the kiln is cherry red and taken to Hamada until he says the color is just right. Then the old man shuts down his fire. Next day, when the kiln is cool, he is more eager than anyone to see the results.

The seventeen pots from this firing are laid out on the ground on pallet boards in the sun, to stay for the morning for everyone who is around to see. Hamada surveys the lot, rocking slightly on his geta, hands behind his back, glasses on his nose. Then he crouches down quickly beside a pot he wants to see closer. Up go the tortoise rims onto his round forehead; he holds the pot in his hands, turning it, feeling the rise of the enamel with his thumb, looking at the quality of surface. Kinetic as well as visual feel is part of any ceramic surface and must be memorized and put into the potter's subconsciousness, to come out again by itself later. This is why very much time must be spent in just looking at, and feeling, the finished ware from every kiln, no matter

how many years of doing so have passed. It is a necessary, continuous refueling.

The cycle of work in the studio is ending. Teapots, tableware bearing the seal of the kiln, the various styles of rectangular bottles, square platters, large thrown jars, plates, bottles, the huge open bowl shapes, and the tea bowls, form the body of work.

For several days the continuous rhythm of the process has been culminating. Pots made, pots finished, some slip-dipped, are always being moved from one place to another, drying on the gravel in front of the workshop, drying on pallet boards in back of the workshop, drying under the filtered shade of the tall espaliered trees that line the walks everywhere and form dividing lines of the compound.

The Bisque Kiln

It has taken nearly a month to make three thousand pieces, and most things are finished. But it is hard to realize that the tea bowls are still coming, that none of them have been made. Nor do I yet understand that they will still be coming over the next few weeks continuously until the last chamber of the glaze kiln is loaded and closed.

In the workshop, Masao-san presses the last rectangular slab bottles in the plaster molds. These are the staple ware of the workshop, and he is a genius at making them. He cuts patterns with a sharp point from slabs of clay for the various sized bottles, like cutting a dress. Placing the clay in each half of the mold, he uses one slab for the large side, and the shorter one for the narrow side, separate slabs for the neck, and large coils for the joints. He places the clay in each part of the mold, joins the seams, reinforces with coils, and adds the foot. The separate plaster shapes with the clay in them are placed firmly together, squashing the clay joints, attaching the sides like a puzzle. Pieces of the mold are tied together until the clay bottle inside has dried. Masao-san works four large bottle molds at a time, then he rests.

The pieces dry in the molds until just the right time for removal. Left too long, they will crack. Masao-san does the whole exacting process so well that there are no accidents. He has made hundreds of the various molded bottles during these past weeks; now he is finishing

71

the last ones. Oka-san is wedging clay for throwing more platters. Shinsaku is making teapots again; Uma-san is also throwing. A last-minute hustle is going on, the end of the work for this kiln.

For several days the workers have carried pots for the bisque firing, two or three at a time from the workshop on the hill to the five-chamber kiln below, down through the autumn leaves, over the stone paths, over slippery straw mats placed on the mud, past the long wet grasses, and under clumps of tall, dripping bamboo.

It is a lull in the symphony. Another way of getting three thousand pots down the hill from the workshop could be managed, but it is better to take this way, walking the paths, carrying the pots, this rest of several days between the physical work of making and the physical work of firing that is to come.

For days the men have been talking at the robata or at tea of the schedule, of when the bisque fire will be, but the dates set have each been postponed because more ware is still needed to fill the kiln.

Now it seems really time to pack the bisque, the first firing of the pots that will take several days and nights of continuous stoking, watching, and waiting. It will be a long slow water-smoking fire, to drive out the physically combined moisture in the clay. Then the temperature will be raised slowly, avoiding thermal shock, to about 1800° F. (1000° C.), which makes the ware dense enough to handle and decorate but porous enough to absorb the coats of raw liquid glaze that will be applied next. Later the glazed pots will be packed in the kiln again for a second, higher temperature firing. The mystery of chemical change causes the chalky glaze materials to become glassy and brilliant, full of polished rich color, hard and dense after the roaring fire has gone to 2300° F. (1300° C.) and the wares are cooled.

The five-chamber kiln really looks like a dragon, as writers have often described the ancient design of the Oriental climbing kiln. There is a huge fire mouth at the base of the kiln, from which a series of elongated igloos, the chambers for the ware, climb the hill at a thirty-degree angle. The outside surface undulates with the rising curve of each chamber. The kiln is plastered smooth over the buff firebricks, and there are holes toward the top of each arch where fire and smoke will spit out.

72

The stacking chambers are each about thirty feet across, from the door on one side to the opposite stoking side, fifteen feet wide, and almost tall enough inside for a man to stand. The interior walls are covered with shiny ash glaze from the years of burning wood fuel. Each chamber has an opening in the side, which will be bricked up when the kiln is filled. The kiln length is about one hundred feet from the firebox up the hill to the flue.

Hamada also has a much larger eight-chamber kiln, which holds about eight thousand pieces, up the hill behind the workshop. This he built in 1943 as a challenge to himself when he had perfected the use of the five-chamber kiln. His idea is that whenever you have mastered one thing, it is wise to go on to another, in that way you are always studying. This larger kiln is seldom fired now, perhaps once a year if there is a big special order to do, because it takes too long to fill. It is better to fire the smaller kiln and the two-chamber salt kiln more frequently, along with many enamel firings, for a faster rhythm of work.

The kiln climbs the hill, and clay wares are piled all around on the narrow dirt path and beside the kiln until there is no room for walking. Some chambers are partly stacked with clay shelves, and pots are being placed inside now. The workers pass the pots up the hill chain fashion, handing them in to Uma-san and Masao-san, who crouch inside loading. An area of open space inside on the dirt floor the length of each chamber is left empty to make a place for throwing logs in during the firing.

For several days the kiln is casually loaded because pots are still being finished in the shop and brought down. Then the pace increases. Everybody works at packing the hundreds of pieces into these chambers. There is a constant movement of pots up and down hill into the proper places in the kiln, workers stooping and passing, bending, picking up or putting·down. The way of packing seems unstructured but in fact it is silently scheduled and carefully worked out according to what is known from experience about the heat of each chamber.

The first chamber is loaded and boarded up, though the others are not, and a small warming fire is lit at the mouth of the kiln. Dry autumn leaves are raked from all around, from the top of the hill down, dragged

in large slings to the fire mouth, where the fire that is building is fanned out to make coals. Leaves make just the right kind of slow smoke necessary to dry the wet pots in the kiln. The workers pick up rakes and begin combing the bamboo grove for more leaves, carrying them to the kiln in reed baskets.

Loading of the other chambers continues as the warming fire crackles. Perhaps a hundred tall jars are placed together at the top of one chamber, rice bowls are stacked lip to lip; all others are set singly, except some pots that are used to support other shapes. Openness is necessary so the moisture can evaporate easily. Smoke comes from the second and third chamber holes. The kiln is full, the men find bricks to close the openings of each chamber. Sand, sifted and shoveled to the base of each door, is mixed with water and the workers hurry to seal the brick doors with this mud.

The day is cold and crisp. The young boy fanning the coals at the fire mouth takes a damp towel, holds it in the fire, wrings the hot towel out and wipes his face and hands with its warmth. Then he moves up and down the side of the kiln, looking at the smoke of each chamber, gauging when to add more leaves to the fire.

The workers, in procession, bring bundles of wood on their backs from the top hill of the compound, where it has been stored. At the kiln they drop the wood in piles and go for more, returning to deposit the right number of bundles for the fire at each chamber. The heaviest logs are brought down by truck, and a tall fort is made of them at the mouth of the kiln. All the wood at each place will be used up in the firing process. Smoke belches from the ports of the first three chambers. The boy tending the fire watches the smoke and adds some dry cedar needles. Smoke is mixed with steam from the wet clay and the wet kiln and billows up in the air, enveloping the thatched roof covering and surrounding the area in moisture and blackness. The first chamber beyond the fire mouth is warm, everything else is still cold. Kiln preheating is one more delicate and difficult job in the whole of the clay cycle.

All workers have gone to lunch, but not the boy, who takes the water hose and begins to dampen the hill dirt and the leaves. He sprays the road twenty feet below with water until the dirt and the gravel stones

74

are muddy wet, and the leaves, grass, and tree trunks in the opposite field are wet too. This is done from the neighbor's house next to the kiln down to Hamada's gate house, a long swipe of road to wet, for the possibility of fire in the dry autumn makes this necessary.

Today and tonight the bisque kiln will warm slowly, will be fired hotter tomorrow and tomorrow night, and cool on the third day. Hamada says it takes three or four days after that to glaze the pots, and the next firing will take two more days. This is the schedule, but by now I know that these are short-term goals to be set for the need of setting and that they are not always followed, depending on the flow of life in between.

On the second day of the bisque firing, the blazing fire at the mouth is sealed off. The first chamber has achieved red heat, and it is time to fire it up to temperature, about 1800° F. (1000° C.). Two men take up positions on either side of the kiln, thirty feet away from each other, the kiln inbetween. Unable to see each other, but in absolute unison, which is very important, they begin to heave six-foot logs into the chamber from each side. Sparks and leaping flames from the fire burn all the way across inside the kiln chamber, not touching the pots directly. Every ten minutes the two-man team throws in about fifty split logs. The fire inside the chamber is burning briskly, and now there is no smoke. The front of the fire mouth is still warm to the touch and glowing with red coals inside.

The old man sits on his automobile seat at the mouth of the kiln smoking his pipe. The log fort is gone now, used up by the man and the boy in firing this part, and now the two-man teams work furiously to bring the next chambers, one after the other, to the desired temperature.

At the end of the kiln, the flue holes are steaming with moist warm air. Fire flows out of the port holes all along the kiln, red licks against the buff brick. The kiln undulates in sculptural form, red hot at the bottom, still dark cold at the top. The sand sealing the doors of the two top chambers is still wet, indicating the extreme difference in temperature from the bottom to the top of this kiln. The problems of this kind of multichamber wood firing are immense and beyond the experience of most Western potters.

Old-man is continuously pulling out plugs and peering into the chambers, watching the fire. He has discarded one of the specially made round plugs for closing the stoking holes. First he finds a chipped bisque tea bowl of Hamada's and sticks it foot side forward into the hole. Then he changes that to an old broken bisque plug, and the next time puts in an irregular brick, which falls out, so he begins all over again. Is he playing a game for himself or does he really want just a tiny bit of air coming in at this lower hole? Questions such as this are never answered, indicative of the importance of the individual threads that weave through the process.

The roof of the kiln, where the undulations dip between chambers, is strewn with various broken pots. Now the old man rummages through this, picking and trying pieces in the same stoking hole. Then he moves to a pile of broken rectangular brick by the kiln, carefully choosing, holding one up, looking for another one that somehow may fit into this round hole, seeming to relish the importance of this strange search.

The sound of logs being heaved into the chamber, fifty at a time every ten minutes, and the crackling of the fire at the times it is fed mix with intervals of quiet, with the rustle of the swaying bamboo stalks overhead. The day is moist and cool without much sun. The ground is still wet all around the kiln, and there are small piles of wet leaves on the ground, left from yesterday when the fire was begun. Men come and go quietly, watching and waiting turns to take over the difficult physical work of stoking the chambers.

When the wind blows, the leaves drop. The thatch roof of the shed of this kiln is like a humped animal covering the caterpillar. Each chamber is stoked continuously for one and one-half hours, looked into constantly, sealed up when it is determined that it is finished, and the men move to begin the next one. At 5:30 on this second day the whole firing is accomplished and by 8:00 P.M. the kiln is cold to the touch. The hard work is over, but there is no celebration. This is only the beginning, the days of glazing are to come, and the longer and more crucial firing of the glaze kiln to a higher temperature with much more at stake. The men nod to each other and leave.

The next day is Sunday. The kiln should be cold enough to open

and unstack. At 10:00 A.M. there is absolutely no activity around the kiln. The area is quiet, still damp, with wet leaves falling. The flues at the top expell warm air, but the skin of the big dragon is cold to the touch. The kiln has been cooling about eighteen hours, but I know that perhaps opening the bottom chamber this soon to unload the kiln might cause too much cold air to come in and crack the pots. Then I remember that rest is a part of the rhythm here. Besides, this is a special Japanese holiday. The workers are with their families on this day, Hamada is in Kyoto for the wedding of Kanjiro Kawai's granddaughter, and there is no pressing need to unpack this kiln. Nevertheless it is a stark contrast to the routine bustle of work of every other day I have seen.

Glazing and Firing

Monday morning the kiln is unbricked and hundreds of bisque-fired pots are carried out. The swirling activity has begun again. The team unloads the pots and the big, heavy jars of powdered volcanic stone, which was calcined in this kiln for the kaki glaze. Oka-san and Masao-san and the old man make a chain line from the doors of the kiln to the bottom of the hill, handing pots to each other and returning for more.

Two people are flapping dusters hard against the bisque pieces, picking pots up as fast as they are placed on the boards at the bottom of the hill. Wood ash has deposited on the ware during firing. Tough and sticky, it must be dusted and scraped off the bisque pieces by hand with a whisk made of torn strips of cloth tied to a bamboo stick. Flailing the duster and scraping each piece with the bamboo handle, Mitsuko moves the short stump of wood on which her bottom rests, squat-hopping from one pallet to the next as if she were playing a game, picking up the pots and dusting them in a noisy rhythm.

Mixing the Glaze

The men build a big fire and heat a fifty-gallon drum of water. By the side of the cliff overlooking the road are two large oak barrels into which water is run from a hose to keep down the puffs of dust as the large pots of powdery ash are dumped. Nevertheless clouds of red orange dust engulf us all, and Masao-san mixes with a shovel. Boiling and steaming water, which is better for mixing, is ladled from the great iron bucket above the coals into the barrels of ash. This is the arduous beginning of mixing *kaki*, the tenmoku type saturated iron glaze for which Hamada and Mashiko are famous. Making a glaze from hard volcanic stone impressed me as being incredibly difficult,

78

considering that most Western potters buy materials ready to use. But to Hamada and his workers this is routine; the rock is ground fine by machine in town at the cooperative, and the resultant powder is calcined in the traditional way. The dust of this volcanic ash poofs in the air all around as it is dumped into water and shovel-mixed and screened from one barrel to the other. This goes on several days. Even then the glaze does not stay in suspension—it hardens quickly and must be remixed constantly during use.

When fired, this famous Mashiko kaki glaze is a shiny rich magenta brown, with a luster that is hard to describe. The name and its color come from the look of ripe persimmons, which are said to be ripest and have the best color on the twenty-fourth day of November. Mashiko potters have made and used this glaze from local rock for years, and it is one way of always indentifying Mashiko ware. Hamada improved the look of the kaki by using a limestone clear glaze underneath, and now other potters do the same.

All the glazes are difficult. *Nuka*, the rice ash glaze, is made from rice husks burned in the field, broken up and ground, washed of impurities, and still it resists mixing with water. Some glazes, left from last time, hard and dry, are carried from storage in the studio down to the kiln area, chopped into fine granules and shoveled with hot water. It takes immense preparation to make all these impure organic materials into usable glazes. Essentially Hamada uses only five natural materials for his glazes: ash from the hardwoods burned in the fireplaces, volcanic stone, rice husk ash, and an impure quartz. In different mixtures these materials yield several kinds of clear milky translucent, and opaque white glazes; with iron and manganese additions he makes black, and with copper added he has a turquoise color.

While the men are mixing the new glazes and getting the old ones out of storage and preparing the kiln for loading, Hamada says he will make tea ceremony bowls. This is one of the events of the cycle that cannot be precisely scheduled. It seems he delights in doing this work out of sequence of the overall work cycle, waiting to make these new clay pots after everything else is bisqued and being readied for the glaze fire. Tea bowls have special Japanese historical and cultural meaning as well as an extremely personal significance for Hamada.

79

Still, for this kiln, none has been made yet. The prefiring preparation continues; the workers search for ways to keep busy. Everyone is aware that the process is suspended as they wait for Hamada to feel like making tea bowls.

MAKING TEA CEREMONY BOWLS

Suddenly one morning Hamada says he will make tea bowls.

He knows that for several weeks I have waited for this. On many days he has mentioned that today he would probably make tea bowls. The hot water at his wheel was always ready, the clay always prepared, but his mood was not right or he was too busy or there were other things on his mind. Once he had said he would be wanting to make them when he returned from a trip to Osaka. Shinsaku heard that and said he would call me at the inn if Hamada threw during the night, but it did not happen.

In pacing himself he tries to know the best time of day for him to do different work. For instance, late at night or very early morning for tea bowls; for glazing, late afternoon, after the rhythm of the day has been established. "These are the best pots, if they can be done at the best times." The tea bowl is a very important part of his work, and he has saved its making to the last.

Making a tea bowl means not thinking of making a tea bowl. He begins by thinking of something else. First we go out to watch the man who is thatching the roof of Hamada's house. A whole new roof is necessary about every sixty years, repairs about once in ten. Two men have spent several hours thatching and carrying the long bamboo and pine boards for the scaffold. They have tied the scaffold with ropes at the joints, climbing up as they build. Thatch grass lies in bundles on the ground. The special grass for repairing roofs is grown at the back of the compound, where we have walked to look at a small house he had built for a sick friend to stay. Hamada wonders if we have the same purple flowers in America as are on this path. I do not think so. Walking off the path in the leaf-piled garden, we examine a tree grafted carefully in three places. Without realizing it, we have come to the workshop. He sits down at the wheel quietly, talking of Oka-san's

father who has had a stroke, and ponders to himself if he will take another deshi when Oka-san leaves; probably not.

The young helper has spent about one hour wedging a long roll of clay, pushing it in small pieces with his palm, rolling it out in a huge fat coil a yard long, pulling each end of the clay up toward the middle and pressing again, palms down toward the wooden platform. Finally the clay is ready to be divided into individual lumps for the wheel, rolled like cinnamon rolls into beehive cones ready for throwing.

Hamada sits cross-legged in front of his wheel. Then he is up, saying he forgot something: he must choose some bowls to take to Tokyo. His short legs reach for the floor, his feet for the geta, and he is off with the young boy. Returning several hours later, of course too long to have just chosen the pots for Tokyo, he comes back bringing visitors to watch him throw.

He twirls the wheel with his stick and gets six revolutions before it slows down. The cone of clay comes up irregularly, but he wants that, and he opens a shape at the top of the hump with his left hand. As the tea bowl bells out, he tends to throw it a bit off, raising an uneven spiral. Now and then he puts a flat palm and two fingers on the left side of the clay, pushing gently, throwing the bowl off center, making a wobble or causing an unevenness at the top.

Hamada jokes with the boy and talks for the visitors, explaining how he uses his hands. When they leave, he is quieter and speaks in a different tone about his friend Kanjiro Kawai and the poetry he wrote, and about the things they used to do together. The bowls just seem to come up from the clay anyway, without thinking, which is how he always says they should come.

The tea bowl, and the philosophy he has built around it, is important to him and has been a vital part of his potting. In the same manner as the little Persian bowl he showed me when I first came—made spontaneously and unconsciously—the only way to make a tea bowl is to make it the way Koreans made bowls before they knew about tea ceremony, or the way a potter in a foreign country who knows nothing about tea makes a bowl. Hamada tries not to think as a Japanese making a bowl for tea when he is making a tea ceremony bowl. What he tries to do is think as those other potters.

SHOJI HAMADA

YANAGI'S SCROLL

Soetsu Yanagi, old friend, mentor, founder with Hamada and Kawai years ago of the Japanese folkcraft movement, has written many important things about tea bowls. Hamada explains that, for instance, Yanagi says there are five kinds of tea bowls. One is a Korean bowl made by a Korean potter, these are good ones; two, those made by a good potter but designed by a bad tea master, like the first generation raku potters who made about five good bowls, now the fifteenth generation makes no good ones at all; three, bowls ordered from Korea or China, where the people do not know that they are making tea bowls; four, a European or South Sea bowl but chosen by a master, that is, a bowl made in a foreign country for some other use and found later by a tea master; five, Hamada's tea bowl. What is Hamada's tea bowl? Yanagi said that there are some good ones and some bad ones.

Once Yanagi wrote a scroll, and presented it to the Folkcraft Museum in Tokyo, about the people he would serve tea to and the ones to whom he would not. Hamada recited this scroll from memory, though he was interrupted several times by other visitors or by telephone calls, returning to our conversation with the exact word where he had been distracted:

"Yanagi Soetsu, in serving tea from the heart, would serve one cup to an ascetic priest, a pilgrim coming to the temple for meditation, a clear-hearted priest, a Buddhist layman seeking for truth, a destitute fellow traveler, a beautiful woman grown old, a naive youth, a kind-hearted young girl, a man who doesn't use flattery, and a frugal man from the country.

"Yanagi would serve no tea to a man proud of his money, a sham master (a teacher), a pallid tea server, a neophyte at tea who boasts of his skill, a tea ceremony addict, a person crazy about things with no eye for them, a snobbish scholar, an extravagant wife, a greedy merchant, or a flatterer."

Hamada remarks that Kawai, his early dear friend in pottery, used to say that Hamada has three legs, enabling him to stand straight and firm, and that the saying describes his tea bowls.

By 6:30, when he is called on the intercom for dinner, he has thrown

fifteen bowls, but really worked at the wheel only about one hour this day.

Early next morning he is working again. Off one hump of clay he gets ten bowls, each one different, Drawing up the cone takes several pulls, and he restarts the wheel many times with the stick. He opens a hole at the top of the cone and expands the first bowl, working directly in front of himself, left fingers palm-side against the clay, his right hand expanding the bowl toward the left from inside as he turns the wheel clockwise, using finally the wood rib to make a line on the profile. Hamada sometimes uses the flat of his hand in throwing, where a Westerner would use the side of a finger.

Finishing the thin lip is done with a limp cloth, folded in his finger-tips, pressing gently on the clay as the wheel turns. Cutting the base with a corded silk thread, he lifts the bowl off the hump with bamboo strips, causing the wet pot to deform. He drops it with a visible drop onto a board. Later he will straighten it out just before it stiffens, but it will always be off-round.

Some bowls are tall and cylindrical, some low and wide, some turn in at the top, some flare slightly, some are comfortable to cup between your hands, some are pleasant to hold at the foot, some full, some slender, but all have a fine sense of volume and life. While he is throwing, we have been speaking about the general significance of tea bowls. Hamada muses that tea bowls are not the most important thing, but tea is popular, so among people who like tea there is appreciation for that kind of pottery. He is reluctant to make any more emphasis than that. He says he likes tea himself so he spends much time making tea bowls, "but other people make flower vases and would appreciate the flower vase more."

Several times at this sitting I have remarked that tea bowls seem very important. Hamada defers again. Yes, he likes tea bowls. Americans do not really understand tea, so maybe they cannot understand tea bowls. It really depends on whether or not you like tea. He is being patient with my wanting him to verbalize what he does not want to and he has already told me about the importance of tea bowls yesterday.

Deborah asks if she were Japanese and wanted to buy something from

the master, would it not be a tea bowl that would be considered to have most the feeling of the spirit of the master? Not necessarily, says Hamada. Would not that be the thing that would have the intangible spirit of the master? Not necessarily, he says again, and I know he means this depends on the master. Deborah says she thinks that most Japanese people have an indescribable feeling of awe about a tea bowl. Hamada is still sparring, "Maybe it's just because they have any awe at all for it that makes it seem so unusual, that so many people who like tea have so much awe for a tea bowl."

Hamada says that for him a tea bowl is a symbol, as it was to Yanagi—remember his scroll? Hamada tries to make all his pots unconsciously, so they just "are." Yet with tea bowls this spirit is more profound. "But if you talk about it, it cannot be so much."

READYING THE KILN

The first small pieces of tableware are being glazed in the little area under the shed near the kiln. Even though it is raining hard, the mixing of large quantities of glaze is also taking place. Preparation time for mixing glaze encompasses several days and was included in the schedule Hamada forecast the other day. Bisque ware is piled up efficiently in small spaces rather than strewn around the ground. People cluster under the one light bulb, out of the rain. Glaze buckets stand in the rain, covered with boards. There is a steady downpour, but the little group huddles on the muddy hillside by the kiln trying to work at mixing glaze or glazing.

Glazing these three thousand pieces is a spectacular performance. Movements seem effortless but constant from one job to the next. When one pallet is full someone is there to pick it up and take it to the stacking chamber, or to the top of the kiln to be stored until a place is ready. The work is steady for a time, then relaxed by the fire. As Shinsaku says, it really is continuous work, there is no time for vacations and you cannot leave.

This afternoon two men are dismantling the shelves in the chambers, scraping posts, and restacking the shelves to make them absolutely stable. Great attention is paid to cleaning up the kiln prior to each new

firing, not after the previous one. Hamada is a member of the glazing team. There is still a heavy, steady rain, which slows the pace. Bisque pots are porous anyway, but these pots are wet from the rain. Glazes do not dry on them now, and the over-dips and poured patterns characteristic of Hamada's decoration are hard for him to accomplish.

Shinsaku has a good fire going and is attempting to dry the first coats of glaze. Hamada's big jars on four pallet boards are being turned and moved by the fire, keeping the warmth of each pot even, so that it does not split from thermal shock. Shinsaku, directing the drying, now and then picks up a pot, feels it, looks at it, and either sets it back by the fire or hands it over to be decorated or glazed with another coat.

The black ash glaze has been mixed in a low washtub about two feet in diameter and is being stirred by hand and with a sharp pointed tool. Two barrels of kaki are being rained in, but it does not matter because the solids have settled to a hard layer at the bottom, the liquid glaze having been ladled off into other containers. In the workshop on the hill wet glazes are blended into new combinations by ladle measures and carried down to the workers. The process seems interminable and tedious, yet it is accomplished with the finesse of a fully rehearsed performance. The team stops intermittently and sits around the big fire, warming hands and feet in the steam from the fifty-gallon drum. Teatime, a different kind of time, also breaks each day with a ceremony of food, drink, and talk, always at the wooden table on the grass in front of the main house, unless it is raining.

While the others are glazing, Mrs. Hamada has her own work. She packs wooden boxes for shipping, sorts large baskets of Western pears and *nashi*, the crisp Japanese pears that are mainstays of this household at this season and seem to appear replenished to the top of the baskets every day. She fondles the pears, looking at their colors, placing them in special baskets, choosing the ones to be eaten first, certain ones for family, others for guests. Her two grandsons are drawing with brush and water on white paper, then holding the paper so that the firelight shines through in the pattern of the brushstrokes. Only the men are involved in the pottery. The women of this house and the children see to the needs of the men.

When the black glaze is ready after half an hour of mixing by two men, Masao-san dips pots. Shinsaku has melted the hardened paraffin in a can on the coals, warming and melting it to make wax resist bands for decorating his own things.

Inside the kiln, crouched down in a tiny space, Uma-san is working at the laborious task of fixing the shelves, of chipping the supports clean, and replacing new pads of clay, tapping gently to make the joint steady, checking with a long wooden level to be certain they are all straight, building the decks with meticulous care. As a worker crawls in to help, his shoulder touches the last finished shelf, toppling the whole thing, and one realizes how unsteady it is until the clay pads have dried. Now this work must be done again. The supports are narrow carborundum columns for the higher shelves, wide clay ones for the lower decks, the men being careful to line them up with joints mitered, slab after slab in each thirty-foot chamber. The shelf structure must be very straight and sturdy, with the clay pads gluing post and shelf at each juncture into a monolithic whole before the pots are loaded.

Masao-san, as he is dipping and pouring, mixes two glazes together in an almost empty bowl, intuitively judging what is left and how much to ladle from each of the large tubs of base glaze to repeat the combination color. Rain comes steadily, making slippery mud and puddles in the path by the kiln. As each big jar is finished, the bottom is scraped and sponged and any small imperfections are touched up with a finger of glaze. The young boy tucks the jars one at a time under his belly, arms folded around the pot, shielding it with the bend of his body. He darts across the open space from the kiln shed to the storeroom, hurrying to put the pot out of the rain, where it will wait for Hamada's painting.

The wind blows wet leaves down to the ground from the autumn-gold trees. Pallets of old broken pots kept from the last kiln are strewn with piles of colored leaves that have blown onto them. The steady shush of the duster continues as workers whack it against the bisque pots to remove the wood ash. Someone is almost always dusting bisque during the whole glazing process because there are so many pieces to do. But that person changes with others doing other jobs, silently and without prearrangement, so that no one works too long at any one job.

Yet somehow it is all planned. The organization is too smooth to have happened accidentally. One realizes again that effortless spontaneity is truly the result of years of training under the hand of a master. In this case it is a continuous growth, an evolution, from strong beginnings made stronger over the years by this man who always knew where he was going.

Hamada tries to do all his work in blocks, for rhythm. Of course it is no good, he says, to do just one or two things at a time. Even if one has been doing the same things for over fifty years, still one needs the stimulus of pace and sequence of movement that work-of-a-kind done at one time can give. He rations time for himself, each day planning the hour or so that he can have for himself for working in clay, as opposed to the myriad of other activities that occupy him. So it was during the glazing time that he was still throwing tea bowls, about twenty at once from clay that had been especially prepared and hand-wedged by Shinsaku.

Sitting down to make more tea bowls, moistening the head of his wheel as it goes around, he takes delight in watching the concentric pattern of moisture against the grain of the broad surface of the thick wheel head. Turned with his hand, then with the stick, the wheel revolves rapidly, accelerates, and once again the clay shapes expand and emerge.

Suddenly it is a sunny, warm, gloriously beautiful day, clean from the rain. Drops of water still drip everywhere from the bamboo. At the glazing area, Mitsuko is waxing the bottoms of bowls, Oka-san the rims of plates, and Masao-san is dipping three square plates at a time, setting them on boards to be carried away. Some tea bowls have been bisqued and are in the storehouse waiting to be glazed.

TRIMMING TEA CEREMONY BOWLS

In the studio Hamada trims the tea bowls he has been throwing. Turning the outside profile first, he carves the foot in a very few motions. He taps gently at the side and center of the foot to hear how thick it is, picks it up, holds it, feels the weight as he cups the bowl carefully in his hands. It is not necessary to spend much time at this because he has

87

practiced so many years. "A bowl for tea must be light and well balanced. Tea masters don't like it heavy."

He has been waiting for me to come before making these last tea bowls, "That's why I'm behind again," he laughs. He tells me that his tea bowls sell for around two hundred thousand yen, something like six hundred fifty dollars, and they are cheaper than those of many other tea bowl masters. Some people have said he should keep his prices at the top, but he refuses to do so.

He has been trimming these tea bowls upside down, supported on one of the bowls, which he trims last. The tool he uses is sharp and worn to a fine shape; it needs only to touch the clay slightly and the cut is made, giving a roughness to this clay and emphasizing its real character. The ochre slip that he ladles on some of the bowls is screened so many times that its texture is satin and the application is very smooth.

This morning, while trimming, he speaks about his sons, about the kindness of Shinsaku, and how Atsuya is a good teacher and would like to have been a botanist, but that it is not so easy to make a living that way as with pottery, especially if your name is Hamada. He chats on as he picks up each bowl, eyeing the interior, feeling it with his hand, bulging the pliant clay with his fingers inside, working against his palm outside. He strengthens a curve with a swipe of his hand, and turns the pot upside down on the wheel to trim.

Astonishingly, he is almost alone. The shutters on the workshop shojis are closed. The young boy and Shinsaku sit by the fire, moving tea bowls around in a rectangle by the robata, trying to dry them quickly. The enamel kiln is warming, waiting to bisque fire these tea bowls. The process must be slow, because wet clay is likely to shrink unevenly and crack with too rapid drying. Intuitive knowledge and long experience with the limitations of his material allow Hamada and his workers to press the limit. Too close to the fire would warp or deform or crack these wet pieces, but the boy watches and turns each bowl around as he sees the color change that indicates one place is drier than another.

Hamada uses a damp cloth hard on the outside of some of the taller bowl shapes, raising the grain, roughing the surface. The single light

bulb above his head casts strong darks and lights on the piece, and I wonder if this is not the real reason for the bare light bulbs so often used above wheels in potteries in Japan. The form is so much easier to read, delineated by the sharp highlights, halftones, and shadows.

The fact that the hand wheel moves fast for only five or six revolutions affects the crispness of cut at the foot of the bowl. Each time Hamada begins the motion again with the stick, or just pushes the wheel with his fingers, the line change is always sharp and immediate. Trimmed shavings come off large and in one piece, direct and precise.

Hamada has trimmed and finished fifty tea bowls in about one and one-half hours, and some of them he has dipped or poured in ochre slip. Each pallet of finished bowls, ten on a board, is carried outside for preliminary air drying, then brought again to the workshop to dry at the fire.

Several hours later, and after each bowl has been turned so all sides have faced the fire, the wet colors, the rich dark gray of the raw clay and the rich yellow brown of the slip decoration, have changed to a chalky gray and light tan. The steaming has stopped, but the foot of each piece is still damp. The bowls are moved to floor level and set on bricks closer to the fire. Wood fuel makes this kind of rapid drying more possible and less dangerous to the ware than fuels that generate moisture, such as gas or oil. So only a few hours after the tea bowls were made, they were placed in the warm enamel kiln for bisquing.

Using this small kiln while the team of workers are doing preliminary glazing at the big kiln allows Hamada to work on continuously at his own pace. Blocking out each day, he fits himself and his potting into the general scheme, just as the rhythm of the worker's pace also revolves around his rhythm.

He is trimming more tea bowls, carving and talking about his father who ran many small businesses and was too busy, and his mother who died very young. His father married again ten years later. His father had wanted to be a painter but could not make a living at it, so he became a brush maker, which helped Hamada later, he laughs. He thinks his father retired too young, at about forty, but he had enough money from these businesses. He did not become a great painter, but enough to satisfy himself, after too late a start.

His father lived at Hamada's here in Mashiko until after he was eighty, very healthily. Everybody is healthy in Mashiko, says Hamada. He hopes to be like his father, who "died walking."

Glazing the Big Bowls

Today Hamada announces he is going to paint the big bowls; these are the bowls that sell for approximately two thousand dollars. Some important guests have been invited to watch this part of the glazing.

About 2:00 P.M. all is in readiness: a sagger with a folded blanket for Hamada to sit on, pots of iron and iron manganese, each with a ladle and two brushes in it, also pots of copper oxide and of black pigment. A big basin of kaki glaze has been mixed continuously about one hour, even though it had been mixed off and on for days. The paraffin in the pot on hot charcoal is melted, ready for use in making resist patterns, and a banding wheel for decorating is placed on the ground on the same level as the blanket seat.

The visitors have come, and everybody is waiting for Hamada to do three of the large bowls. These are important guests, and they are seated, waiting. How did they know he is doing this special thing? Of course someone has programmed it and invited the special people.

Oka-san says the glazes waiting in the pots by Hamada's stool are the black, clear, and the white ash glazes plus the six-percent copper turquoise. The brushes for wax are commercially bought, but brushes for painting, laid out on boards, are those that Hamada has made himself. The bristle clumps are fat at the top, round like the beginning of a teardrop, but narrower where they start at the ferrule, getting longer and thinner toward the end. The brush drips into its own gentle shape when he lifts it from the glaze.

I remember him explaining to me in America, in my studio, how to lay out the bristles one by one in the desired shape, and pick them up together without losing the pattern, tie them, and put them into a bamboo handle. This can be done of course, from any kind of bristle, but Hamada uses mainly hair from the ruff of the neck of the Akita dog.

The kaki glaze must be stirred continuously. If it settles, it may be a

90

twenty minute job to activate its suspension again. Even so, the bottom of the basin is coated deep with coagulated ash, and one of the workers is always tending this job.

Everything is set, but we wait for Hamada all afternoon at the place where the big bowls are ready. He is entertaining some "people up from Hiroshima all night on the train" and other groups of unscheduled visitors are led past us as he shows them the glazing area and then takes them to his museum. Hisako and Oka-san bring more groups. We are still waiting. At five o'clock the workers put everything that was ready for the big bowl glazing away under the shed and these guests go for tea. Nothing was glazed, but part of the show has gone on. A lot of people have seen the beginning of getting ready to glaze the big bowls.

At the house Hamada patters down to the gate on the stone walk with the last people to leave. He stops when he sees me, apologetically, and says "I am so sorry," and I say, " I am so sorry for you." Then I reflect that really, he likes this. The bowls can be painted any time, later tonight or tomorrow morning, but the feeling of giving himself to the different groups of visitors is important too. So he will leave the bowl painting until another tomorrow.

HAMADA'S PATTERNS

Hamada decorates every one of the pots for this kiln himself, even though he did not make each one. His painting of patterns is the same over the years. With a few exceptions the patterns depend on whether he uses the brush, a ladle, or his fingers, to dip, pour, or paint. The most familiar brush patterns are of bamboo and sugarcane, generally done in iron pigment over or under a glaze, but sometimes in wax resist with another glaze put over.

"It's my painting and I never grow tired of it even though I repeat it. It belongs to me, so it's all right. It's different with people who take someone else's idea and repeat it over and over. That's not all right."

He continues: "There was a Buddhist monk in the Tokugawa period. Disciples used to come to him and ask, 'What is the Buddha?' And he used to answer with the same simple phrase every time: 'Not yet born.'

91

He got to be an old man and he said, 'All my life I have taught only these words: not yet born. No matter how much I repeat them I never grow tired of saying them again. Some people who hear them understand and others are bewildered. Not yet born means never die.'

"It's the same with Hamada, he's always being born," says Hamada, "Yanagi once wrote an article about me and my painting. 'There's Hamada,' he wrote, 'painting the same simple painting over and over and over exactly the same year after year. Can't he think of anything else? Really, he can't help it. The painting has become part of his hand.'"

Hamada says that at a recent Utsunomiya retrospective show of his work someone told him that the earlier pieces he had decorated in sugarcane pattern had more leaves. He answered, "You see it's just like the plant, the older it is the more leaves it has." Then he said, "It is Hamada's variation on the same theme, the variety of sameness"

Now he plays with the color, with a brush, a pour, or a dip, using juxtaposition and contrast to articulate forms. Color is the same tool for the painter, but the painter can see exactly the hues as he goes along putting them down, seeing the result at the same time. The potter can only feel color or think it, out of his experience of putting it down, because he cannot see until after the firing how it really looks, although he previsualizes from his experience.

The potter must always work intuitively, no matter if he has worked for forty years. Unfired glaze pigment in the raw state is never the same color it will be after it is fired. Many raw glazes are even white or gray and thus no color at all until the fire. Almost all liquid unfired glazes are in the same value range, no matter what color, and they give no contrast when applied.

The surface of raw glaze is chalky and dry, resembling not in the slightest the way it will look out of the kiln. In no other art is the mystery of result kept secret until the very last, until after the trial of firing. Even then a wrong glaze ingredient or a change of atmosphere can yield an unintentional variation or a happy new thing that cannot be repeated. Hamada says that the potter is an interior artist working from inside out, as nearly at one with his materials as he knows how to be.

92

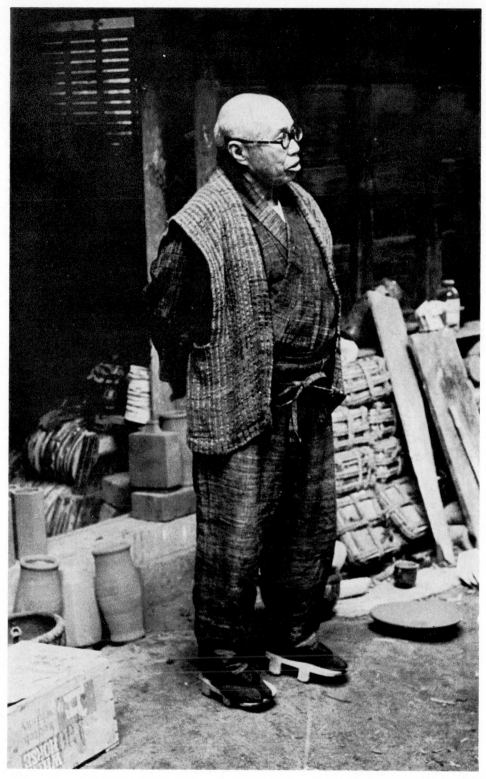

19. Shoji Hamada.

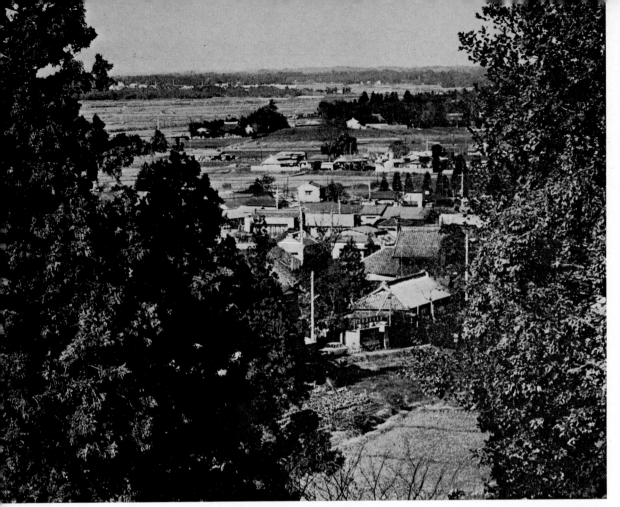

20. Mashiko, the valley of the town.
21. The gate house of Hamada's compound.

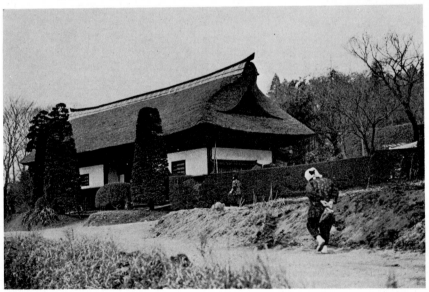

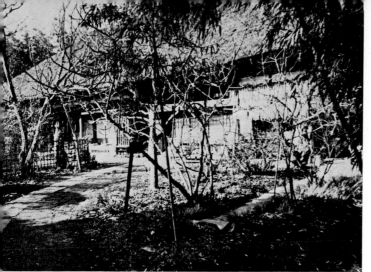

22–25. The family house:
from the gate house path;
the thatched roof; main en-
trance; robata.

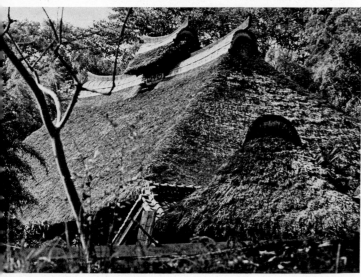

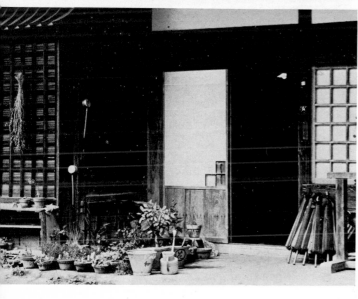

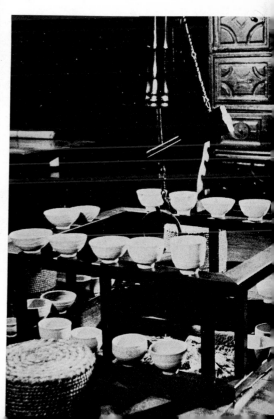

26. Paths are bordered with trimmed bushes and stone carvings.

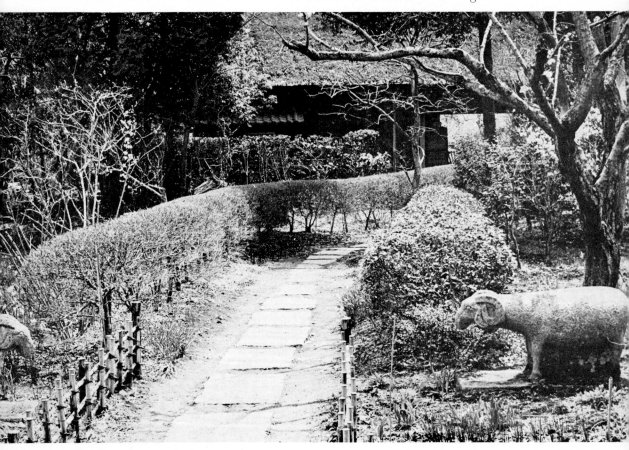

27–29. The old museum house: the roof gable; interior, collected pieces stored in boxes; part of Hamada's chair collection.

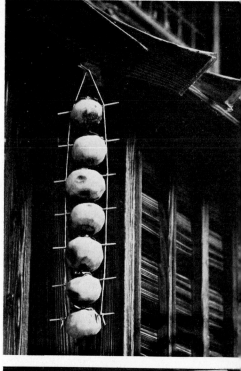

30–34. Details of the compound: a window of the museum house; drying mountain potato stems; persimmons drying; the shell-paned window of the museum house; pebble path and bamboo fence.

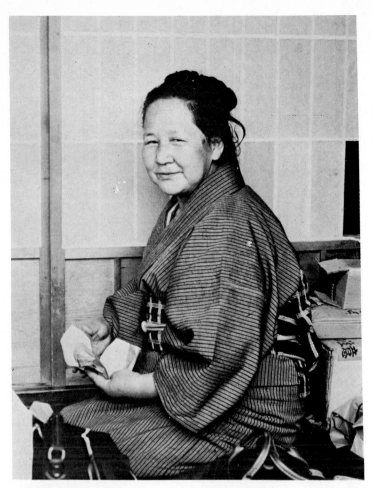

35–37. Mrs. Shoji Hamada; Teruko Hamada, Shinsaku's wife, serves festival rice; workers at tea.

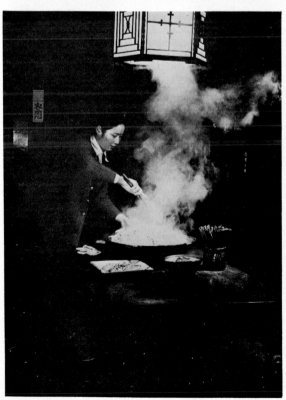

38–40. Path covered with straw mats on a rainy day; the five-chamber kiln; firewood fills the shed of the eight-chamber kiln.

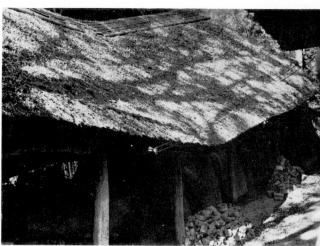

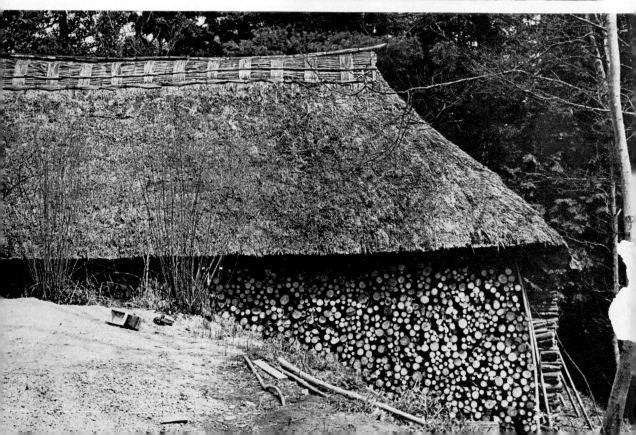

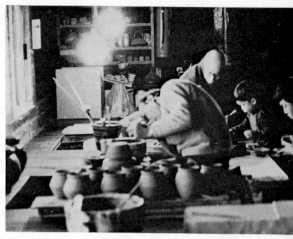

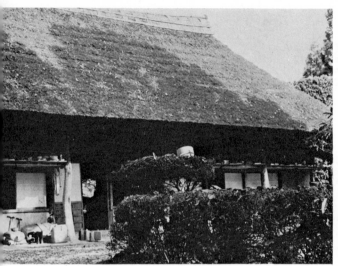

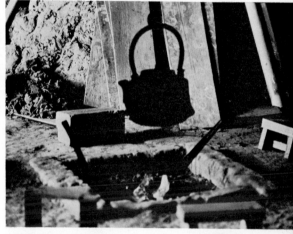

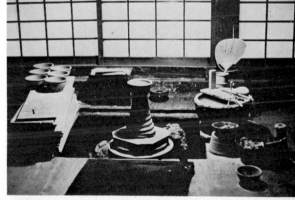

41–45. The workshop: the front entrance;
part of the wheel area on the south side;
robata; Oka-san's wheel; pots drying in the
sun.

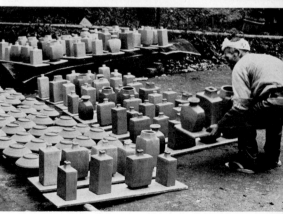

 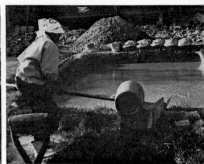

46–50. Clay preparation: natural raw clay at Kitagoya;
the Kitagoya settling tanks; drying trough and bats with
drying clay slurry; foot-wedging; pug mill.

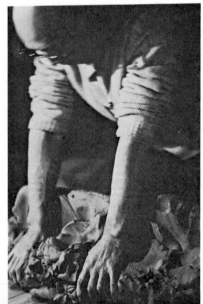

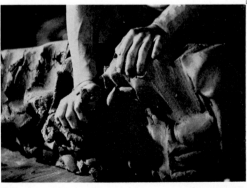

102

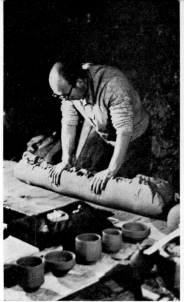

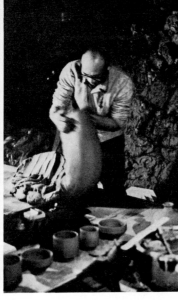

51–59. Wedging: Shinsaku Hamada kneads and twists a large amount of clay then spiral-wedges individual bungs for the wheel.

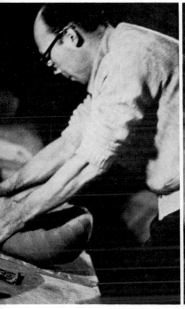

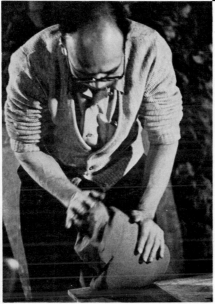

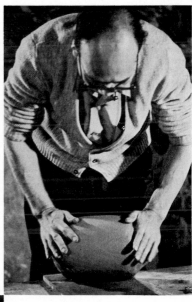

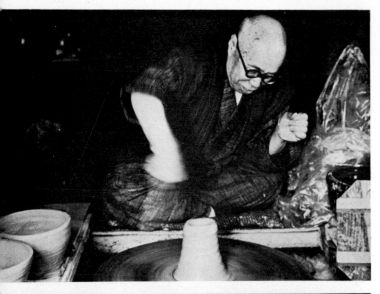

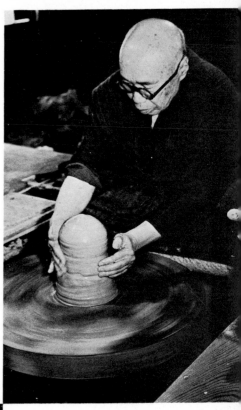

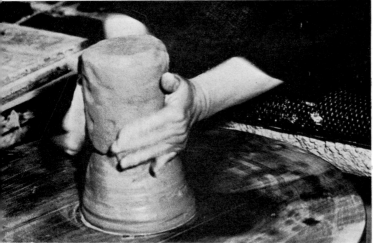

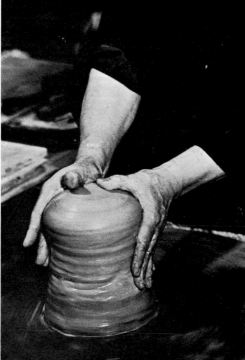

60–64. Hamada centering clay on his hand wheel.

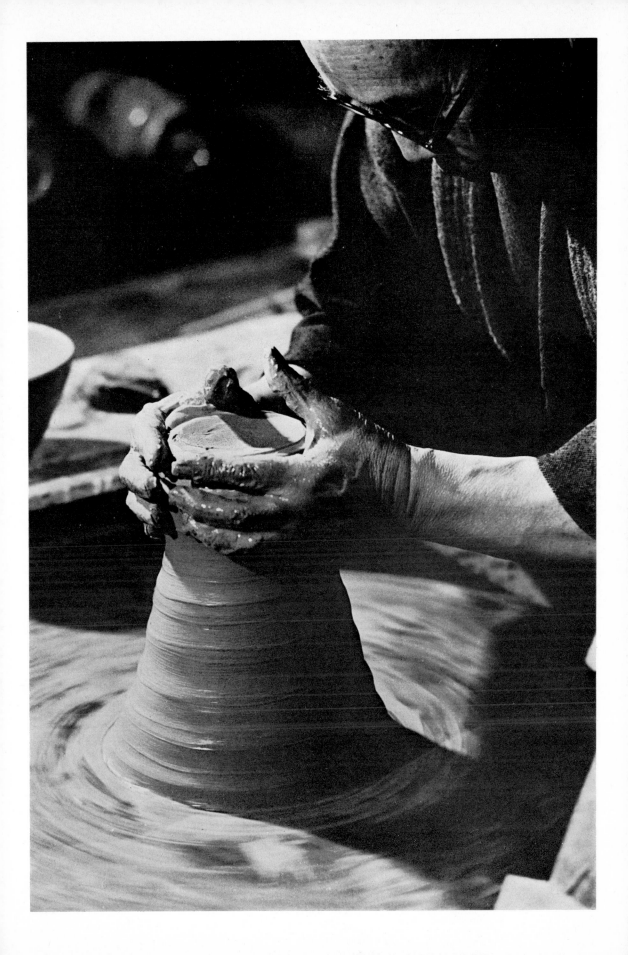

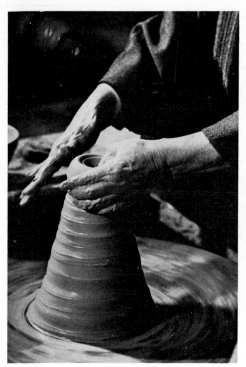

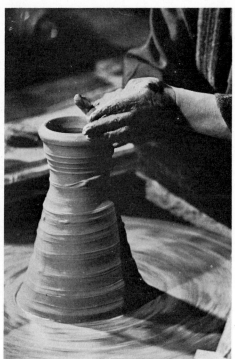

65–70. About six bowls are thrown from one hump of clay.

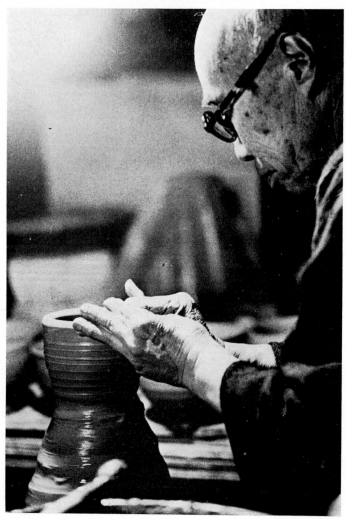

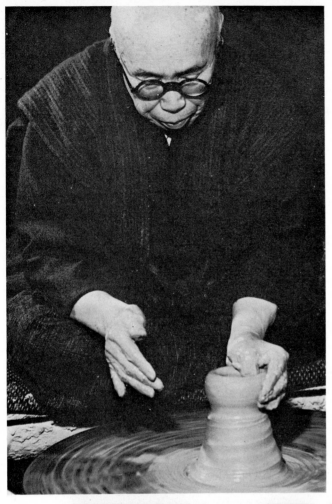

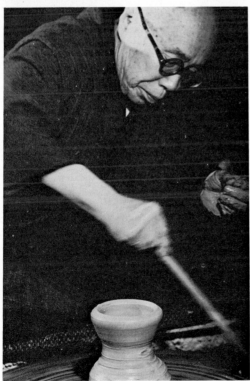

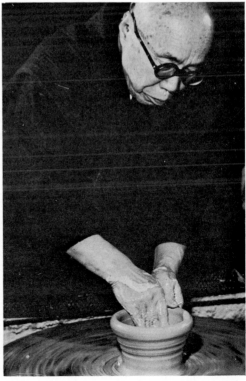

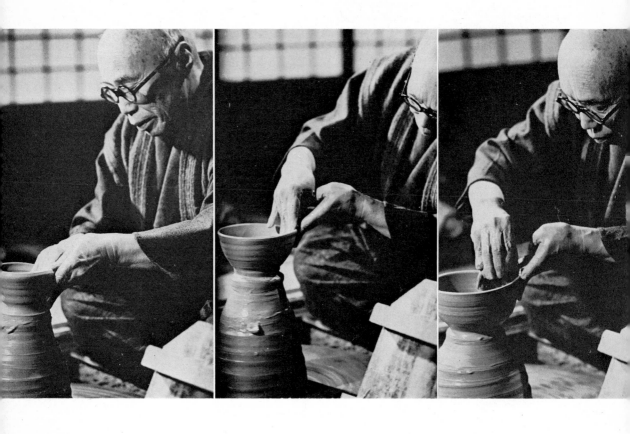

71–76. Throwing a tea ceremony bowl.

108

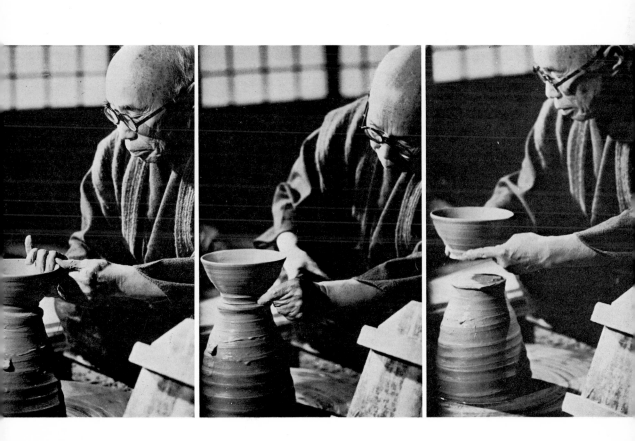

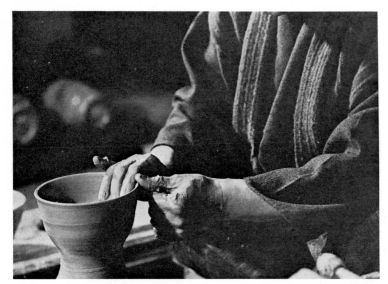

77–79. No two tea bowls are alike.

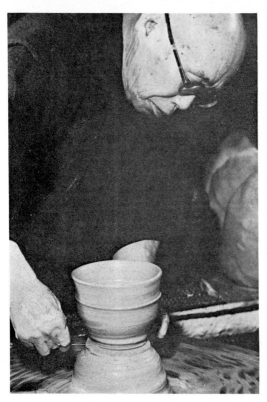

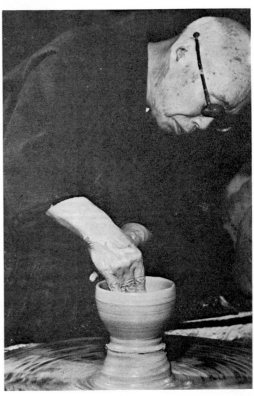

110

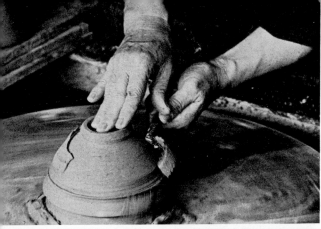

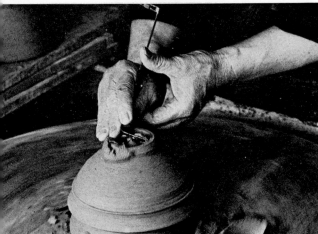

80–84. Trimming the contour and foot rim of the tea bowl; 85. Hamada taps the trimmed bowl to judge its thickness.

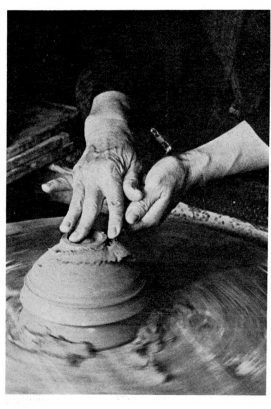

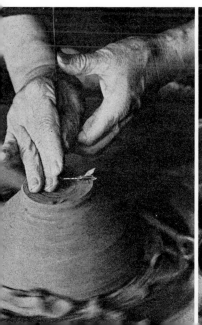

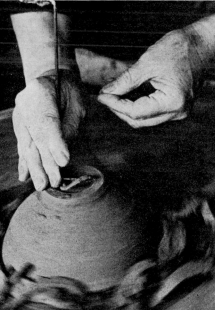

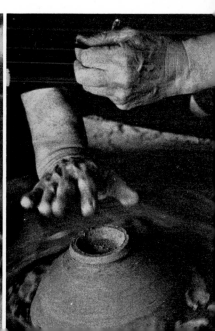

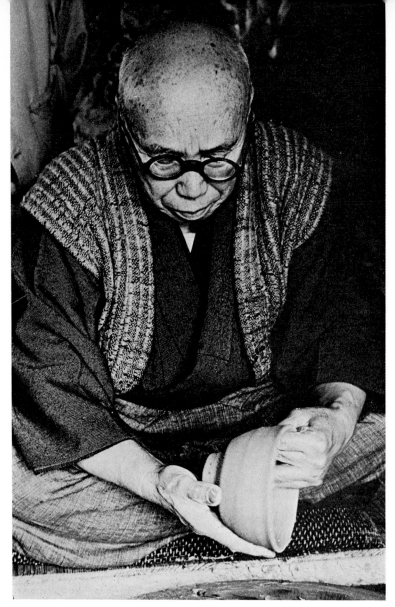

86–88. An important aspect of a tea bowl is how it feels.

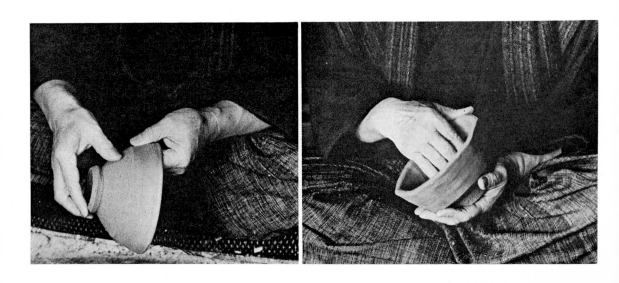

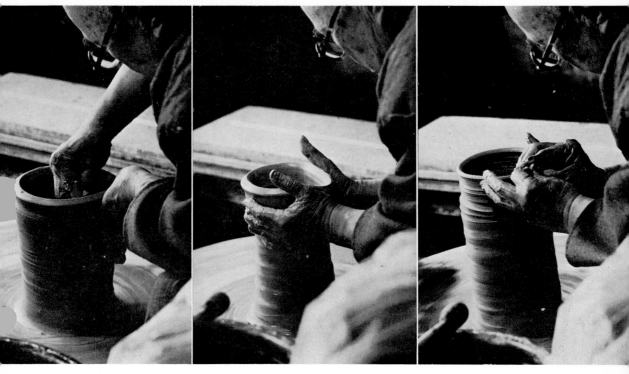

89–94. Throwing a cylindrical shape.

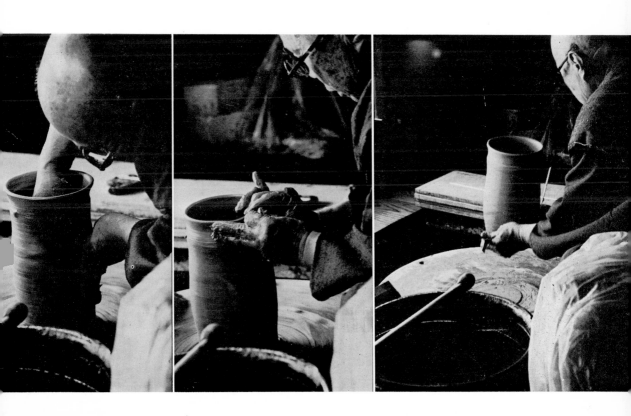

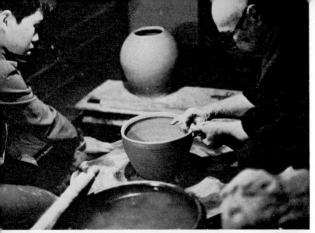

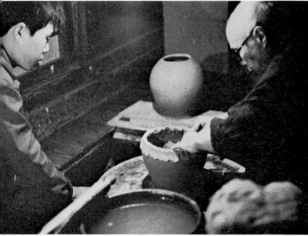

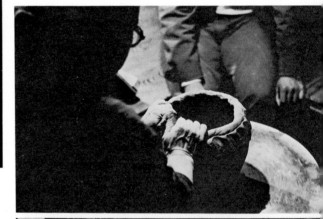

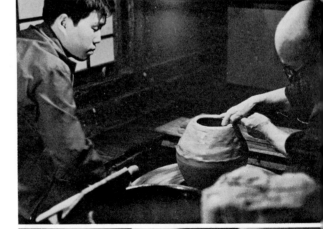

95–99. Making a large jar by the coil-
and-throw technique.

114

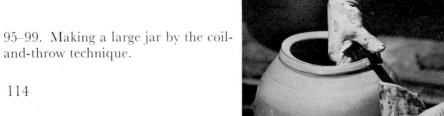

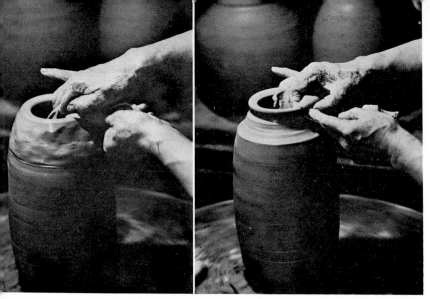

100–105. Coil-and-throw used for tall forms:
a jar (100, 101) and a bottle.

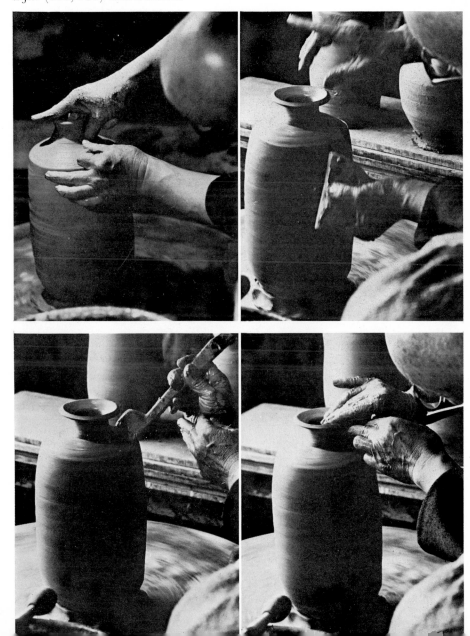

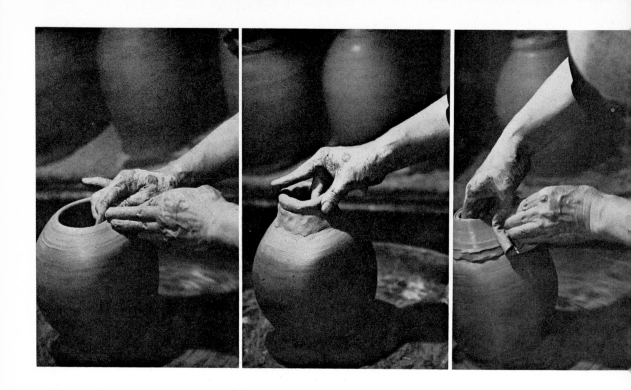

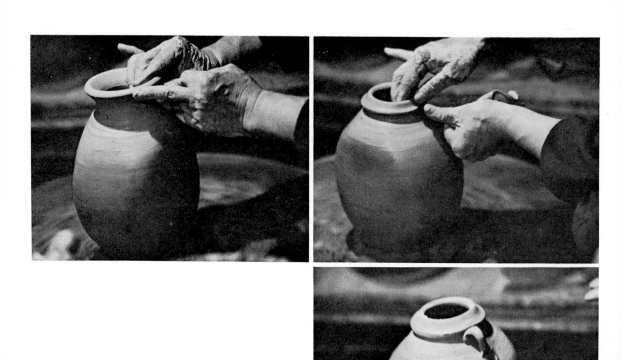

106–111. Adding neck and handles
to a paddled form.

116

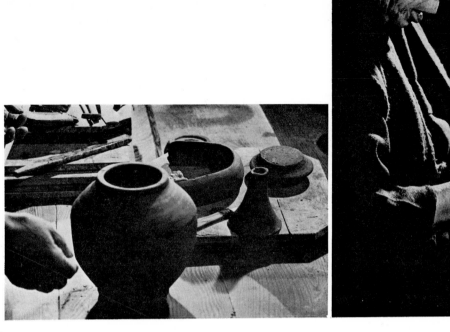

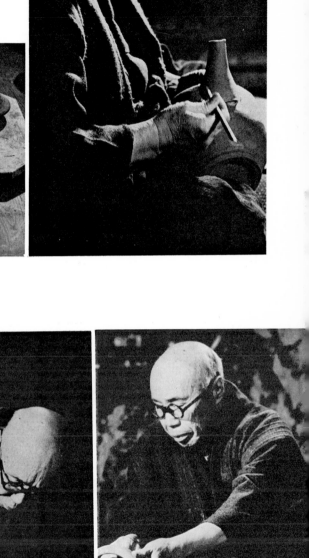

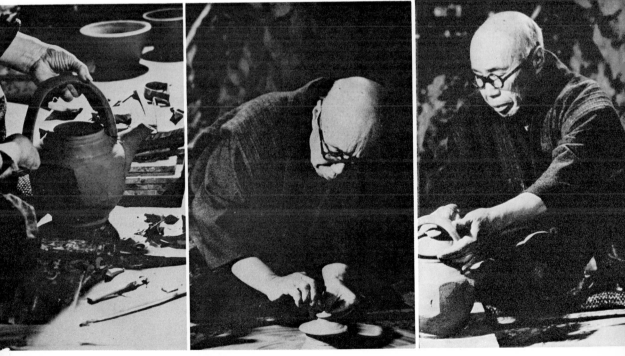

112–116. Adding handle, spout, and lid to a faceted teapot.

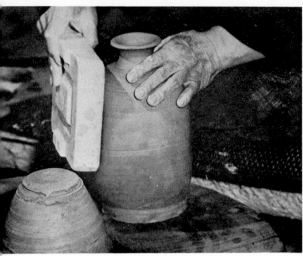

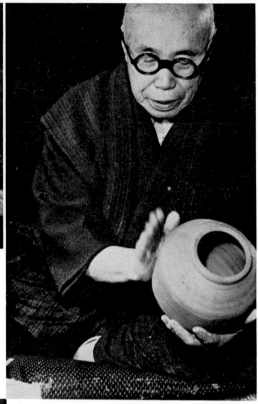

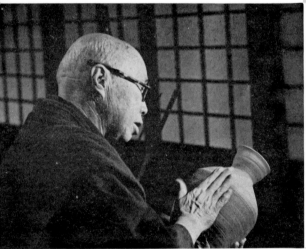

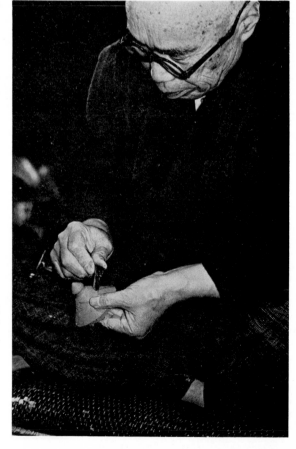

117–119. Paddling round forms with a plaster bat or by hand into oval or square shapes; 120. Incising decoration.

118

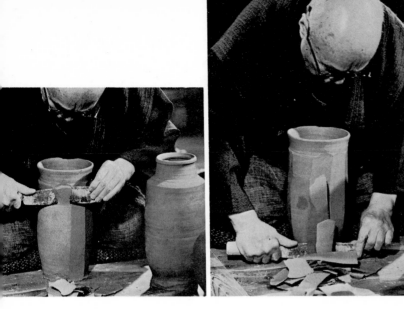

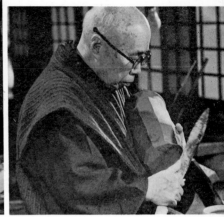

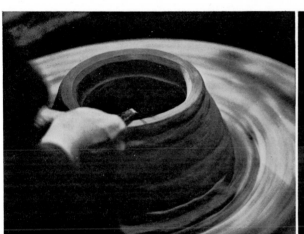

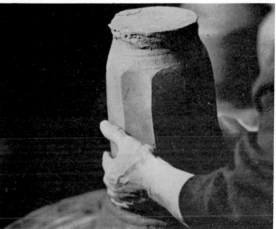

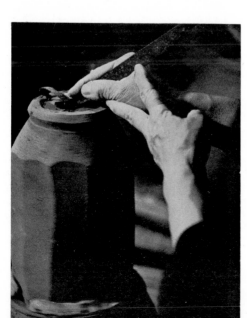

121–126. Faceting and trimming a cylindrical jar.

119

127–132. Hamada's tools: outside measures; shaping tools and bamboo sticks for lifting; inside and height measures; knives for faceting; paddles; handmade brushes.

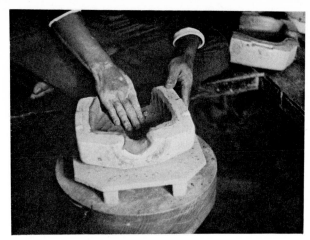

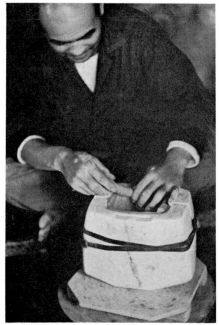

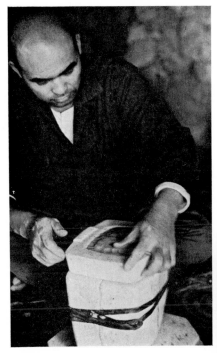

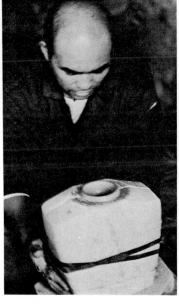

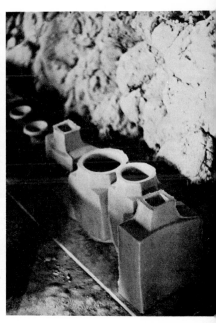

133–137. Pressing slabs in
a plaster mold.

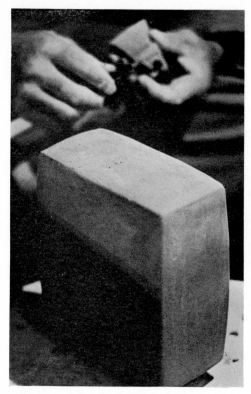

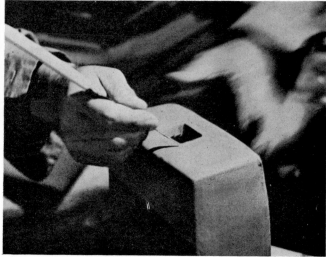

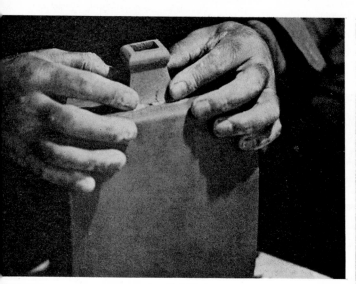

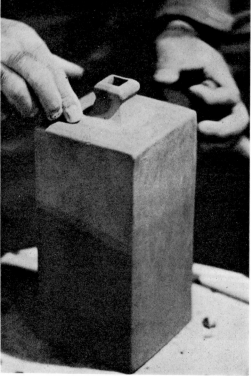

138–141. Some small-necked bottles have
the neck and body molded separately.

122

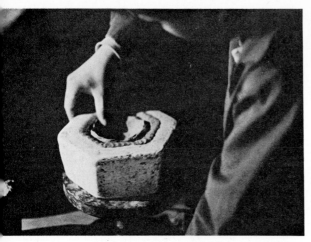

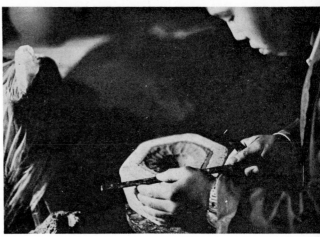

142–147. Pressing other mold forms: dishes and standard tableware of the kiln.

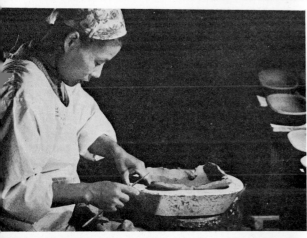

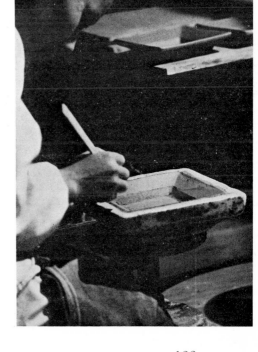

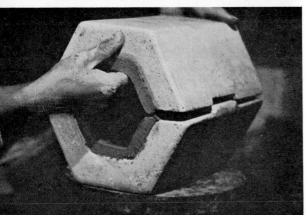

123

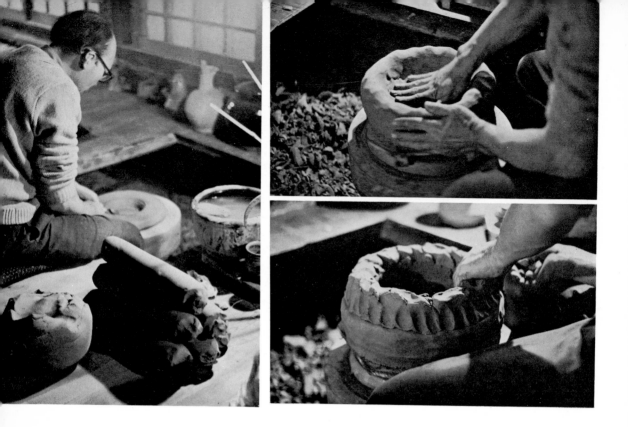

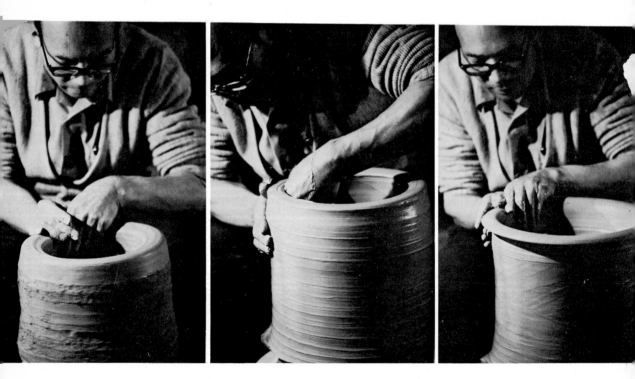

148–159. Shinsaku Hamada throwing the large bowl form.

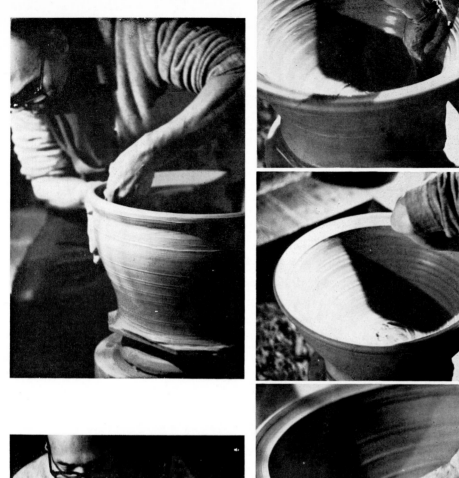

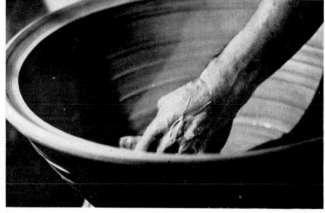

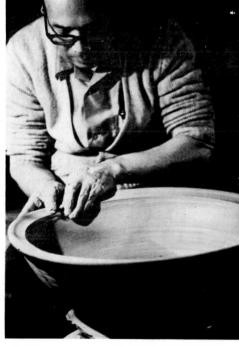

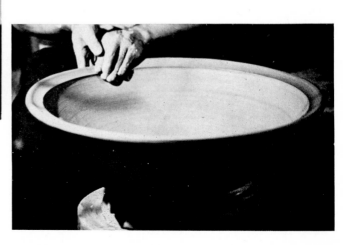

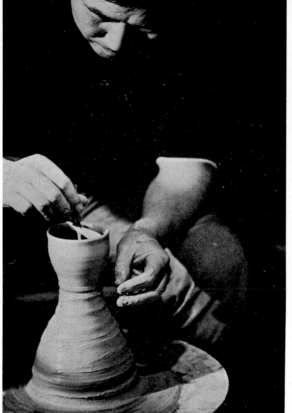

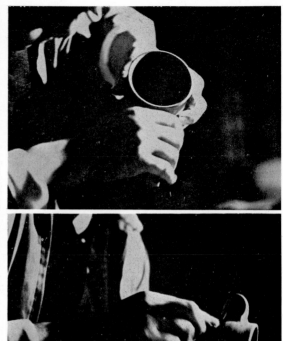

160–162. Atsuya Hamada making coffee cups.

163–165. Uma-san throwing and trimming a plate.

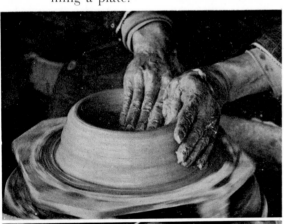

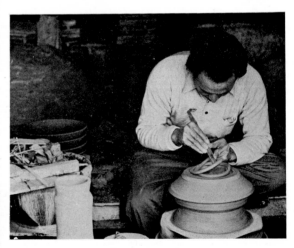

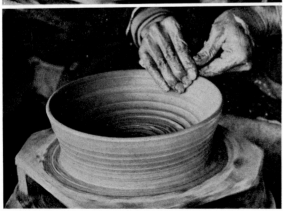

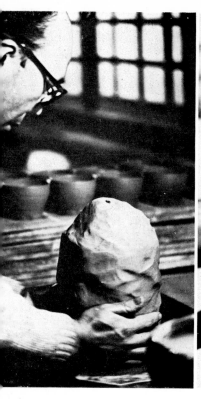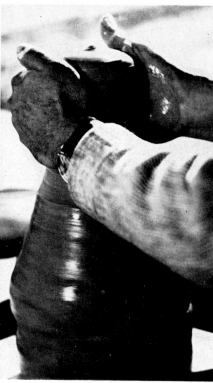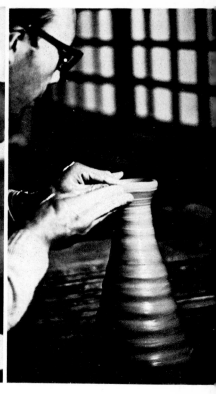

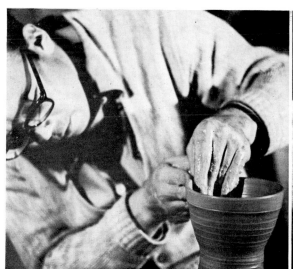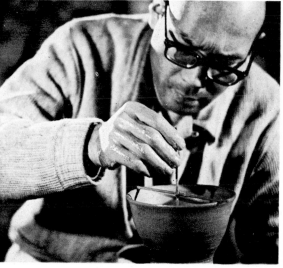

166–170. Shinsaku throwing tea cups.

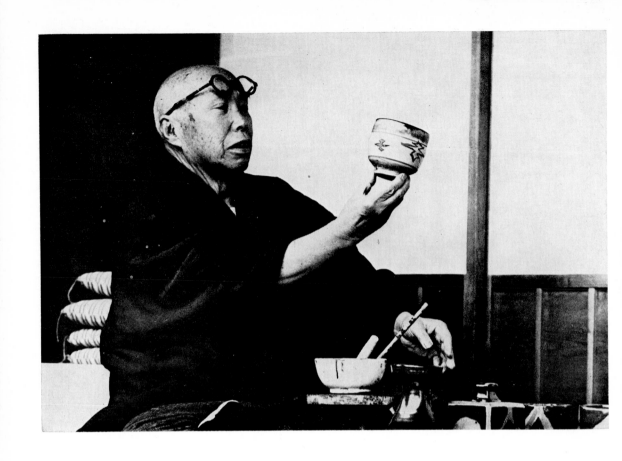

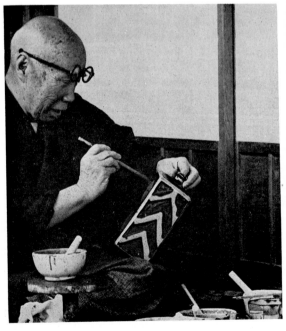

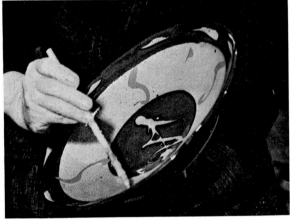

171–173. Hamada painting overglaze enamel.

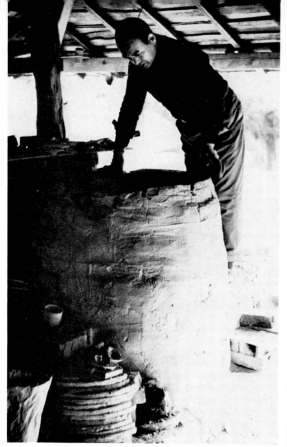

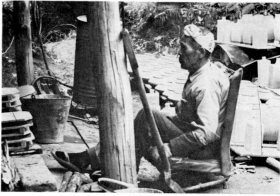

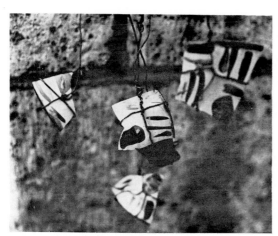

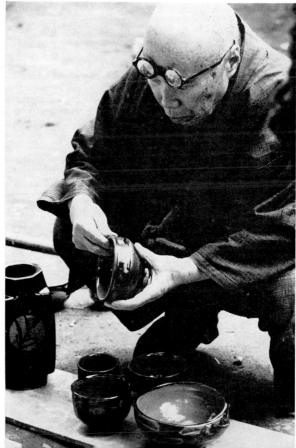

174–178. The enamel firing: the kiln and its lid; watching the fire; test pieces; Hamada inspecting the enameled pots.

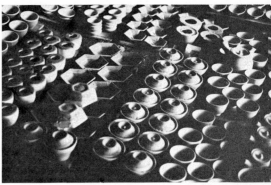
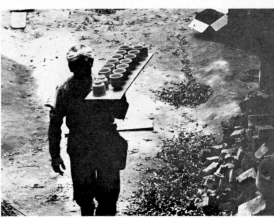
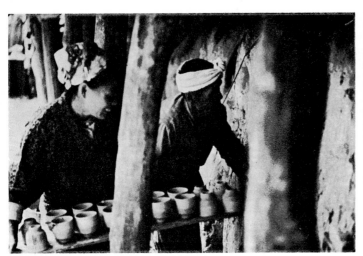
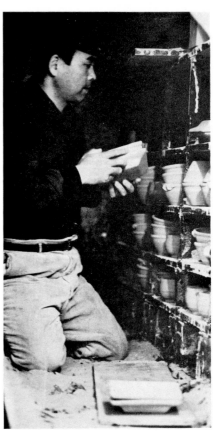

179–183. Packing the bisque kiln: carrying the large pieces; greenware ready for stacking; carrying small pieces to the kiln loader; Masao-san loading the kiln.

130

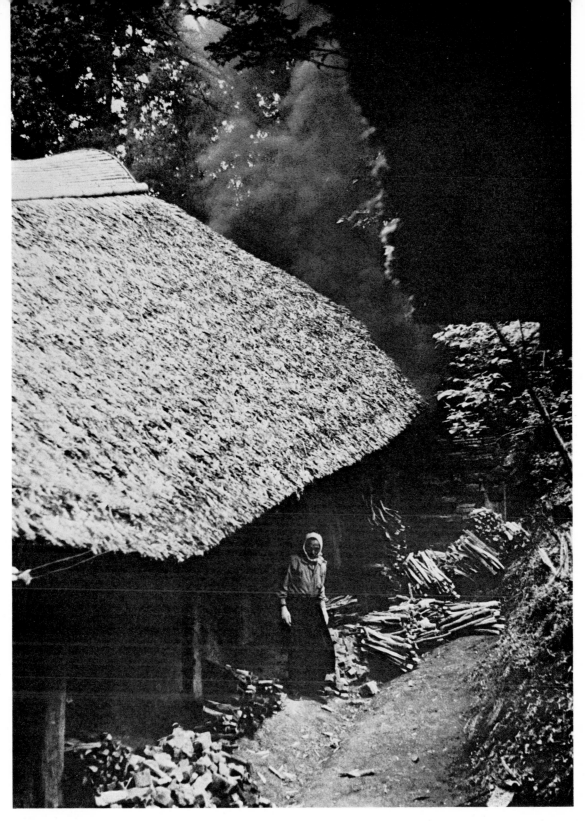

184. The bisque firing of the five-chamber kiln.

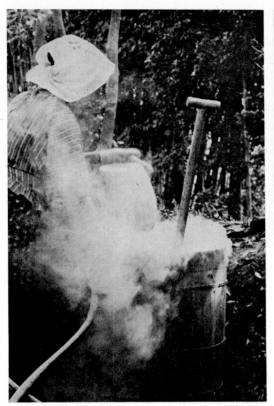

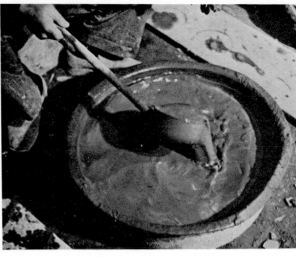

185–191. Glazing: preparing the kaki glaze; the kaki glaze mixture must be stirred constantly; dipping and ladle pouring different shapes.

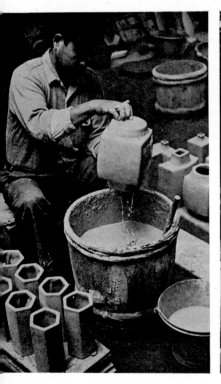

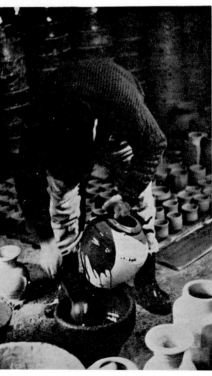

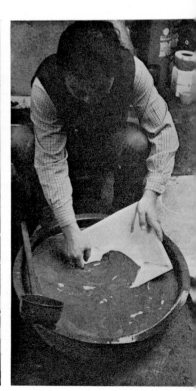

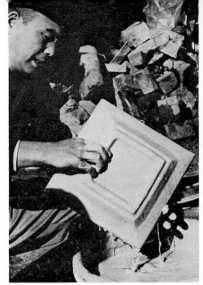

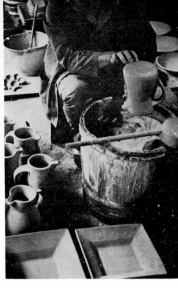

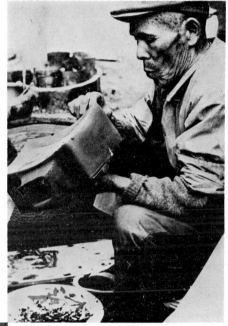

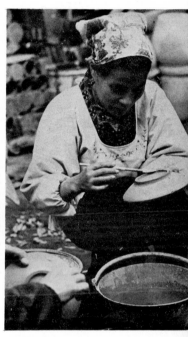

192–195. G l a z i n g : cleaning the foot; painting alumina on the foot rims; dipping a wax resist pattern; stacking glazed plates in saggers.

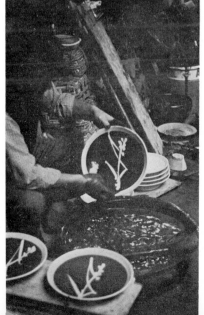

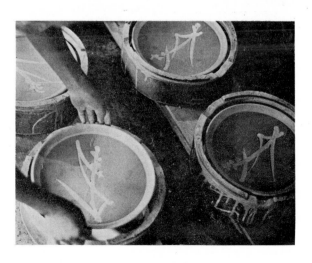

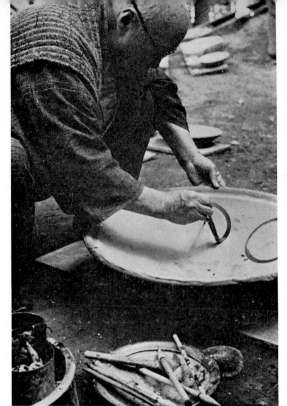

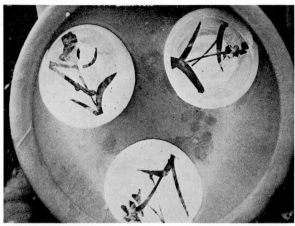

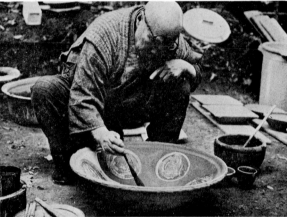

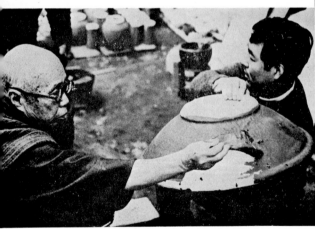

196–203. Glazing the large bowls.

134

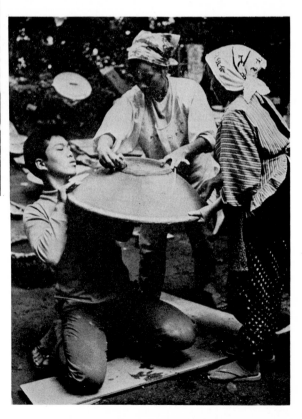

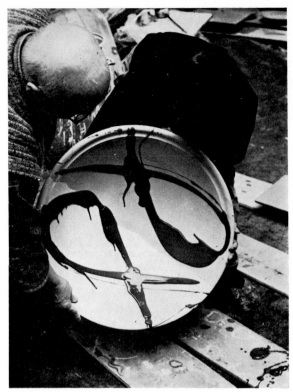
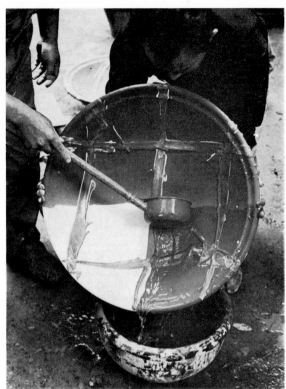
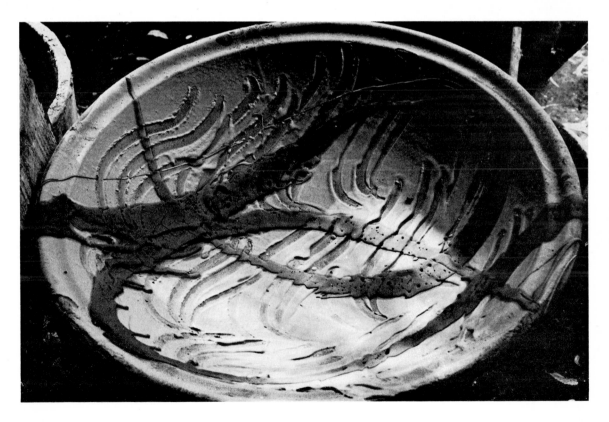

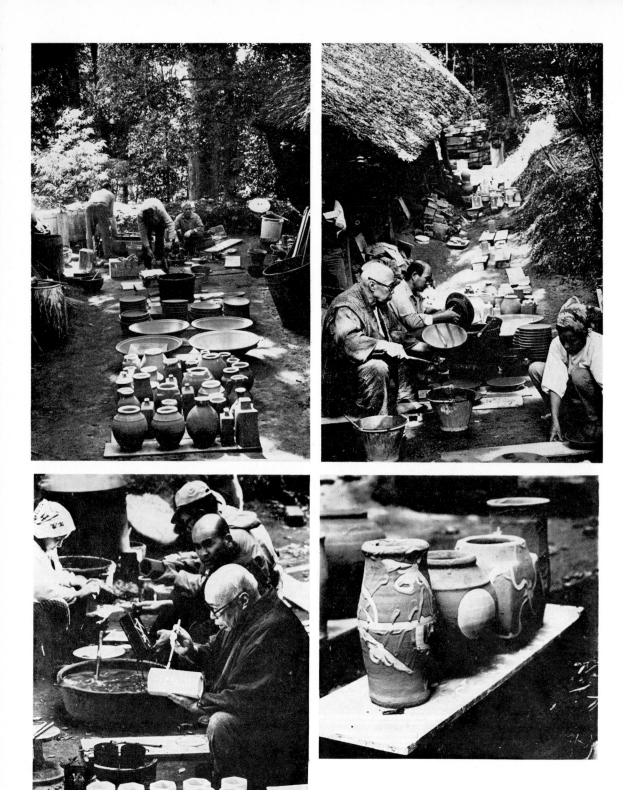

204–206. The teamwork of glazing;
207. Ash glaze must be heavily applied
for the effect Hamada desires.

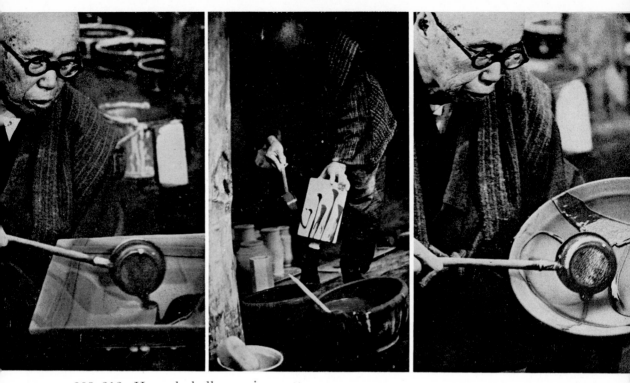

208–212. Hamada ladle pouring patterns.

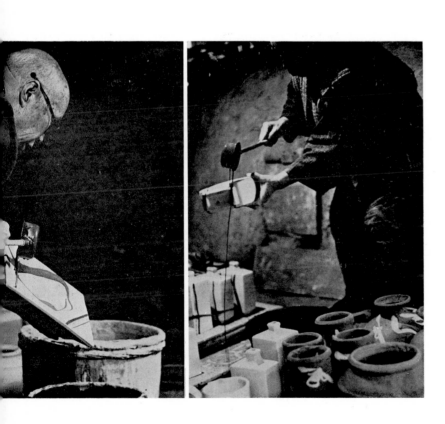

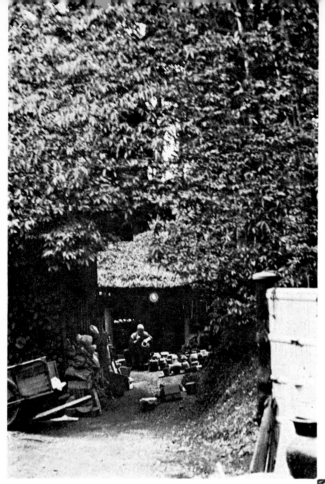

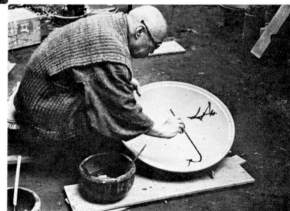

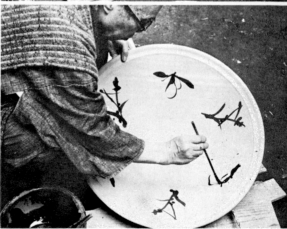

213–215. Hamada painting with his hand-made brush.

138

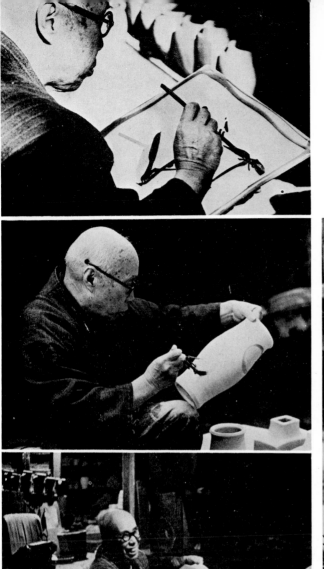

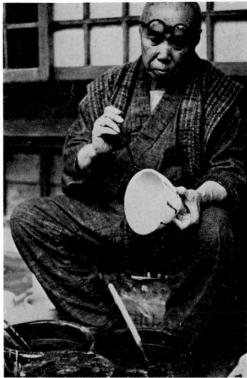

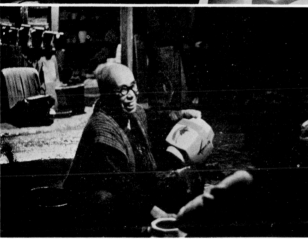

216–220. Hamada decorates: painting iron pigment over the glaze; wax resist; relaxing; painting iron pigment on the bisque; pouring ochre slip on a tea bowl.

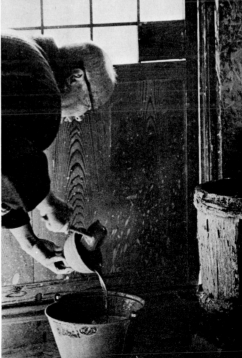

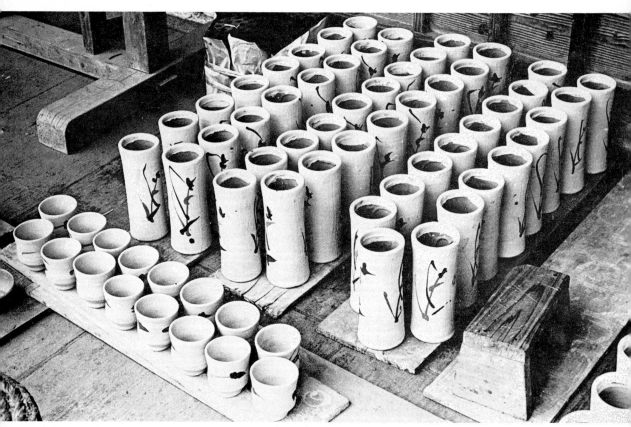

221. "It is my painting and I never grow tired of it even though I repeat it."

140

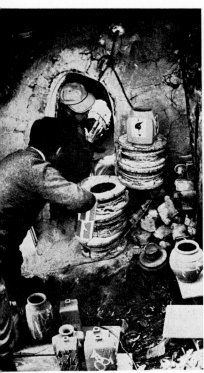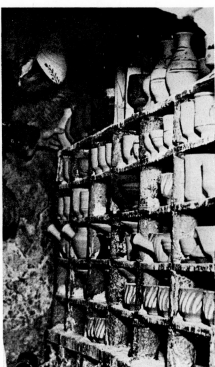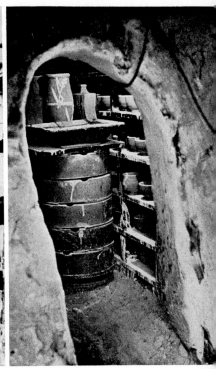

222–226. Loading the glaze kiln: ware being handed to the kiln loader; inside a chamber; plate saggers inside the kiln; bricking up a chamber opening and sealing it with wet sand.

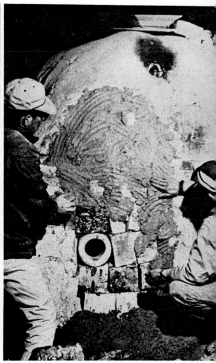

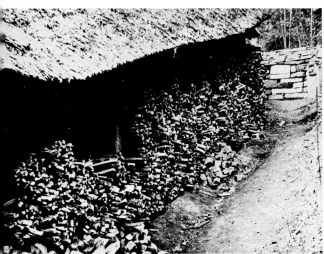 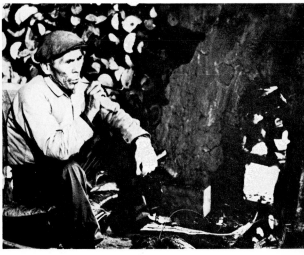

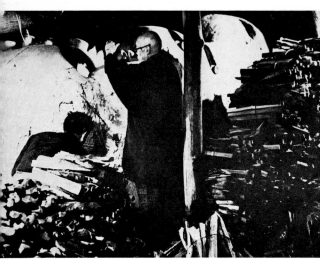 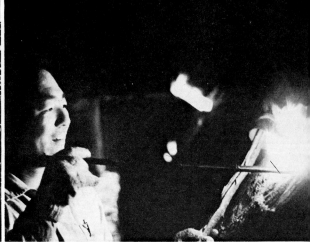

227–233. Glaze firing: wood stacked at the chambers;
beginning the warming fire; Hamada checks the glaze
melt; using a lighted bamboo to look into a chamber;
removing the plug to begin stoking; stoking a kiln
chamber simultaneously from opposite sides.

142

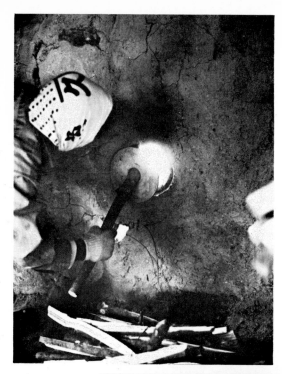

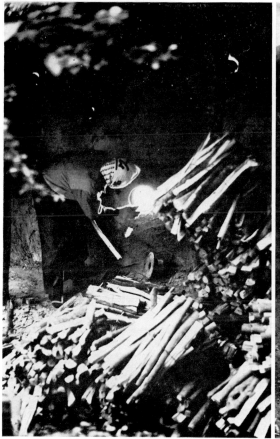

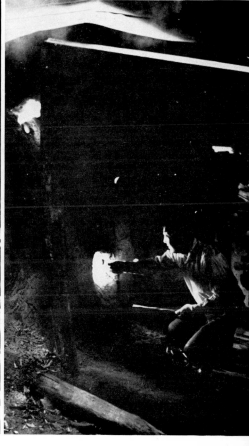

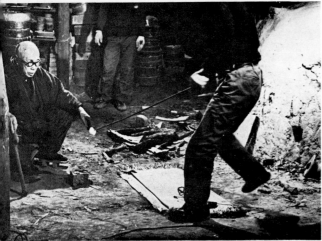

234–237. Glaze firing: fire belches
from the ports when the lower cham-
ber is stoked; test tiles are pulled at
various times from each chamber.

144

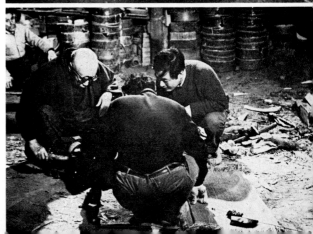

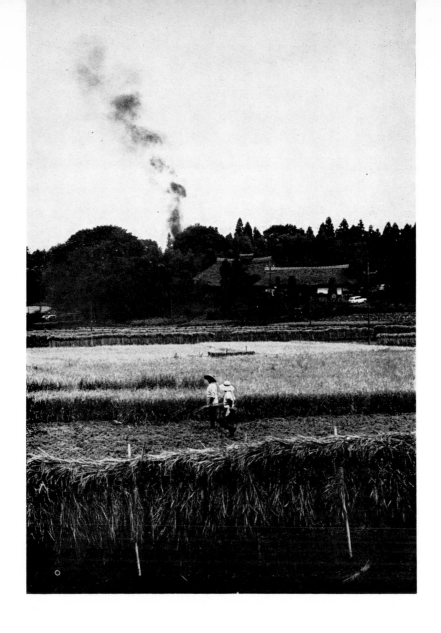

238. Hamada's compound at dawn with smoke
from the glaze firing; 239. The festive meal
after the firing.

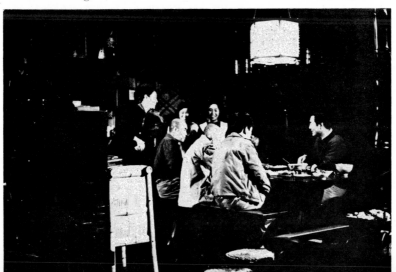

145

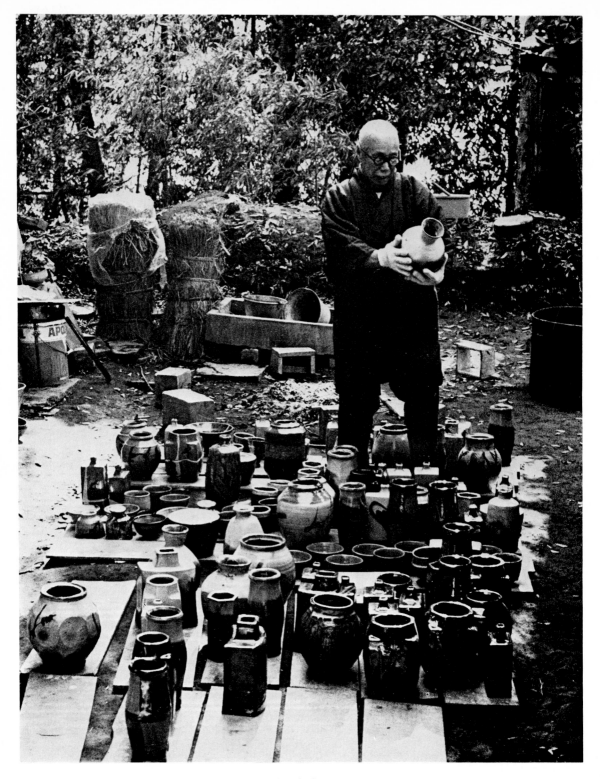

240. Hamada examining newly unloaded ware
from the glaze kiln.

146

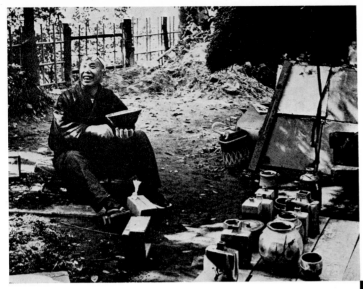

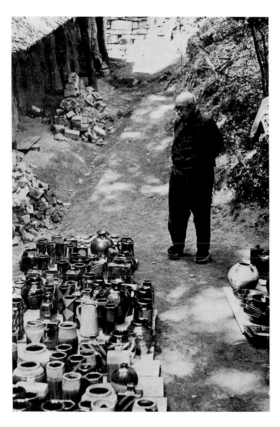

241–243. A shape and glaze delight Hamada; sketching the newly fired ware; surveying the kiln load.

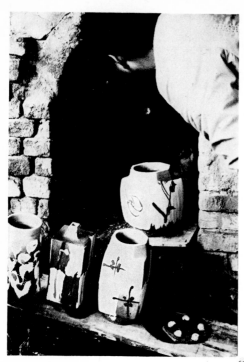

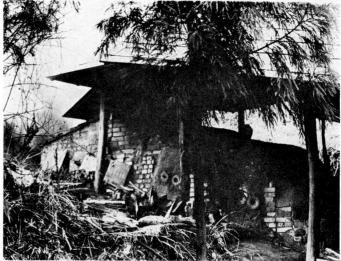

244-246. The salt firing: the slip-decorated, unfired pieces for salt glazing are stacked on shell stilts; chamber openings bricked and sealed; the warming fire is started with charcoal.

148

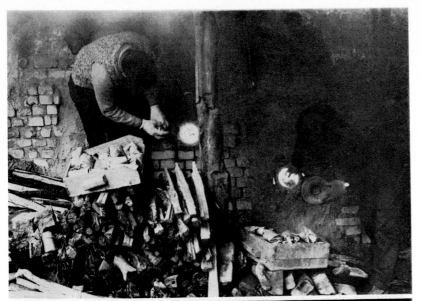

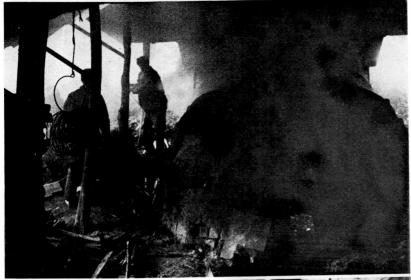

247–249. The salt firing: packages of rock salt wrapped in newspaper are thrown into the hot chambers; smoke billows from the kiln during salting; unloading the salt-glazed ware.

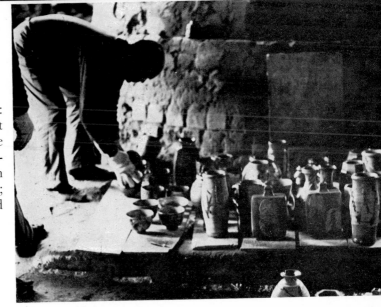

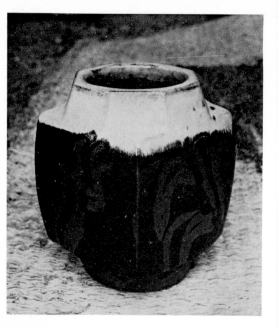

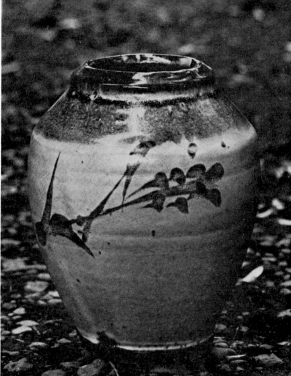

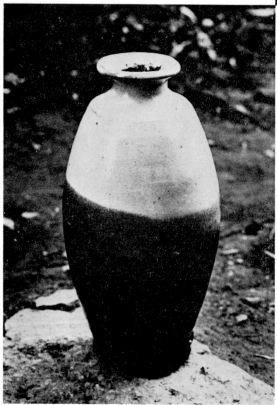

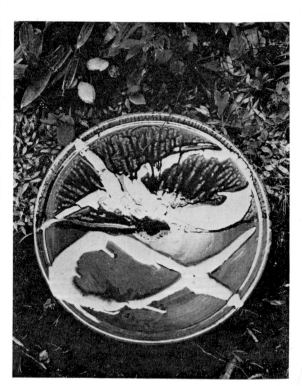

250–266. Ware from the autumn 1970 firing.

150

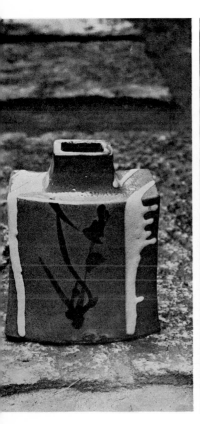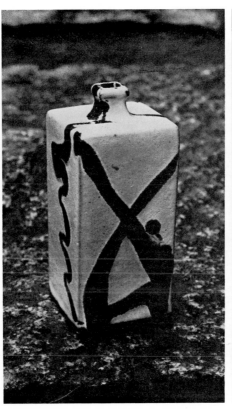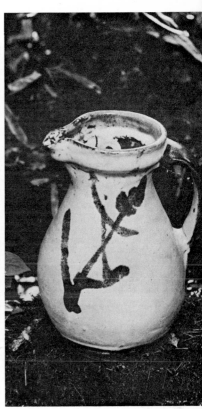

151

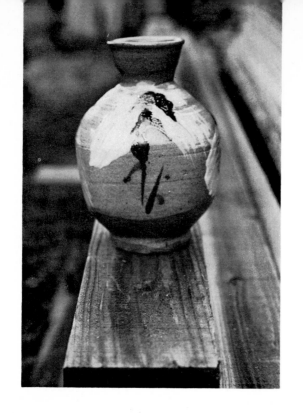

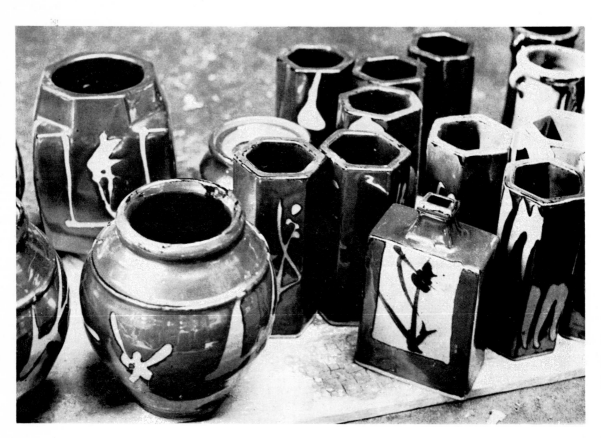

152

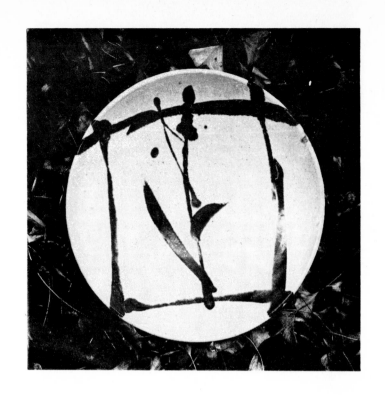

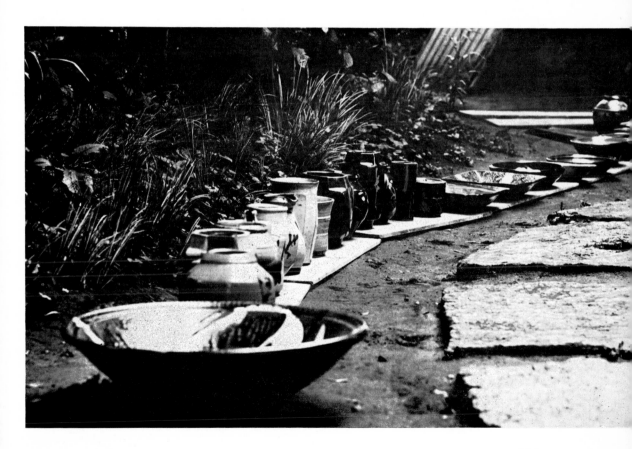

153

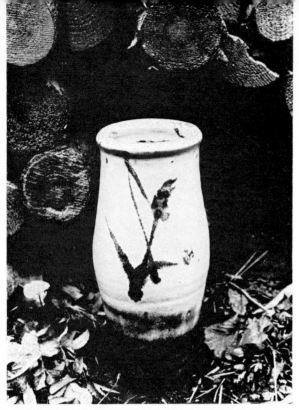

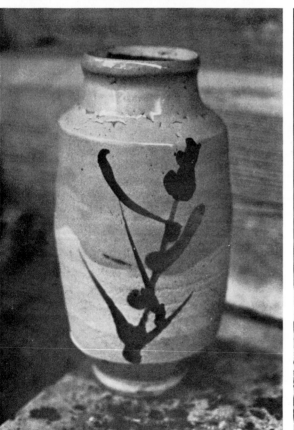

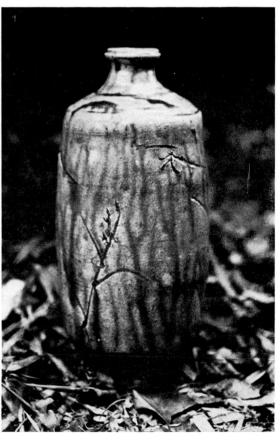

154

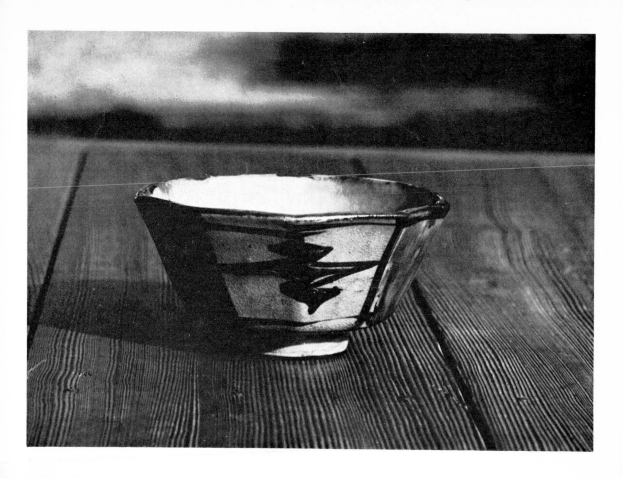

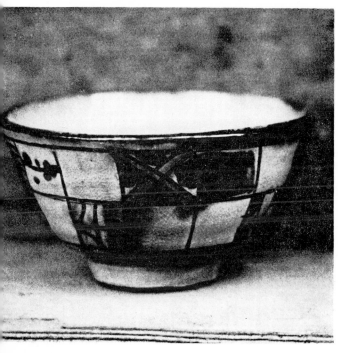

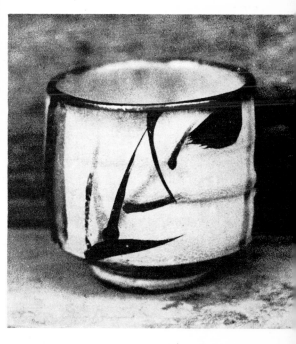

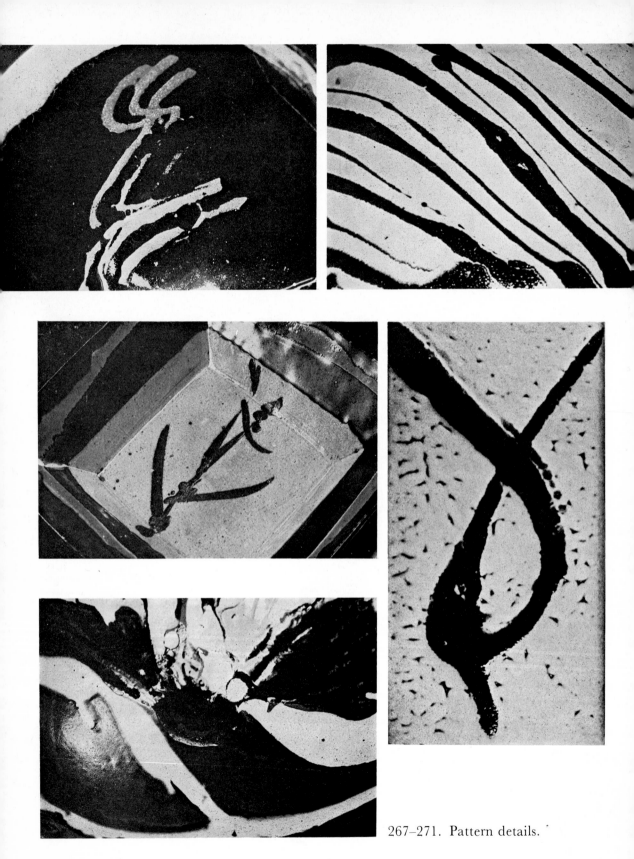

267–271. Pattern details.

What is in his mind's eye he expresses through his hand in the wet clay form and later with the brush or pour of slip or glaze. He does not see until the very end how it will be, not until after all has become molten in the high temperature and cooled to permanence. Any required change must be made on the next piece, which also never can be certain.

Perhaps this newness created from the very oldness of the work he is doing is what keeps the clay worker enclosed in his involvement and captive to this expression. Hamada says that to be a good potter you should be undefeatable at pottery but quite defeatable in every other aspect of your life, never let yourself be beaten at the pottery but be quite willing to give yourself up to every other situation.

Hundreds of pots to be painted are piled around him. He does not handle the base glazing of the big bowls himself but directs the worker's movements and then paints the decorations.

Ladle pouring is another technique of decorating. Hamada pulls the ladle toward himself fast, letting just the right amount of thick liquid out and turning his wrist to vary the width of glaze line. Many plates and bottles have pour patterns. After this ladling the piece is examined; if the glaze has dripped in an unwanted manner, the mistake is scraped down.

The air is cold. The wax brush must be kept in the wax to stay pliable. If left out, it hardens almost immediately and must be softened. Everyone is carefully watching these details, and if something splatters or a lip is not entirely glazed, someone touches up or removes an imperfection. Workers hover around the outside of the circle ready to remove or to bring whatever is neccessary, and someone is almost continously stirring the kaki glaze.

The constant attention to the materials is remarkable compared with most standards of studio pottery elsewhere. The quality control is almost like that of industry except no exact measurements are used, only the natural experience of time and testing in hundreds of repetitions.

With wax, which will resist and leave a pattern when the next glaze is poured over, Hamada makes rectangular stripes with the fat round bamboo brush. This requires holding the brush in a particular way,

not only for the stroke but because the wax cools almost immediately in this weather. While Hamada is waxing patterns, workers redip the pieces in kaki, or another glaze, revealing the waxed pattern as the liquid glaze falls away from the resist medium.

People who have not done this cannot realize the problem of standing in the cold, ladling cold glaze, even though steaming hot water is added, maintaining mental concentration and physical movement and creativity at once. Hamada's motions of selection are slow, stooping to pick up the bottles, standing by the pots of glaze. Eyeing the selected piece, he makes the pour, then, stooping again, bending from the waist, feet planted wide on the ground, his hands turn the pots, looking and planning what to do with each one.

Twenty-five pots have been kaki dipped. Another twenty Hamada iron brushes and waxes. Fifty ochre-slipped ones are waiting.

His arm moves swiftly with the ladle. The glaze falls long and stringy, just the right consistency. Somebody tests each glaze on another pot just before Hamada uses it; wax is also tested by using it, then adjusting it. Hamada paints, pours, drips, waxes some pieces, chooses more, moves them toward his seat, and decorates again.

The finished pieces are covered with plastic and placed on boards along each side of the kiln to keep them clean from blowing dirt. They stand precariously on the hillside. The ground where everyone has walked is very wet and muddy; one wrong step would mean a whole board of broken pots.

Hamada has been decorating continuously for about two hours. He works slowly, deliberately, occasionally getting up from his low seat to walk around through the hundreds of pots on boards on the ground. He looks at them, thinking out loud to himself, then moves a few pieces closer to his painting spot and begins work again.

Always, even when he seems to be working alone, someone is near. At noon the workers have left to eat and he is by himself, but as soon as possible, several return to do his bidding. Workers place yesterday's bisque from the small kiln in the shade under the trees, among the leaves. Every movement creates a picture. These sixty tea bowls, fifty tea cups, and two saké sets, which Hamada has made since the glazing for the new kiln began a few days ago, must now also be glazed.

LOADING THE KILN

The pace accelerates. Plate stacking, a real production, has been left to the last. Tiny, thin slabs have been wire-cut from rectangles of clay, then coated with dry kaolin. They will be separated and placed between individual saggers holding individual plates, allowing for air between the plates stacked in the kiln. It takes four or five workers to make the clay slabs, dip them in china clay, ready the saggers, clean the plate feet, and stack them up. Hamada is glazing plates, which have been glazed once, with pour patterns of a second glaze. He lets the stream of glaze fall from the ladle before allowing it to pour on the plate, to insure a broad movement. With a flick of his arm and a turn of the wrist the pattern is made. The Japanese word for pour-pattern is *nagashi-gaki*: *nagashi*, meaning to let flow, really describes more than the decoration on the pot—the word captures the fluid way in which Hamada decorates.

Even this last frantic day of finishing the glaze kiln was interrupted by visitors who were brought down to the kiln area by someone from the main house. Hamada, when he noticed them, got up from his painting and took them around, while the workers did what they could without him. His own sense of timing, of what he was doing, never seemed to falter, and he could always pick up his pattern wherever he had left it.

The men at the top of the hill are loading the last chamber. Big pots glazed this morning are stacked on the ground, saggers of plates are piled on the hillside on pallets made level with a brick to compensate for the slope, and several hundred unglazed pots stand on these rickety boards. Excitement builds as the sun goes down; everyone knows there is still much to do to pack this kiln before night.

Groups move together, with many of the workers barefoot in spite of the cold Japanese autumn. If Masao-san is dipping, near, or in line behind, or around him will be the glaze scraper, the sponger, and the person who paints alumina on the feet of the pots. Wherever Hamada is working, there are one or two pairs of eyes constantly alert to his needs, to bring or to take away, to mix or to prepare. The space is very confined for so much work, but this seems to enhance the intricacy of

159

movement as everyone steps through the pallets of ware lying close to each other on the ground. Men hustle, carrying the boards of unsteady pottery from one worker to the next, handing them up the hill to the kiln or down to the drying fire, or over to the storage shed, carefully not toppling the ware or stepping on the pots on the ground. A few men rest, warming their hands some seconds by the fire, squatting on a brick or a short stool, then jumping up and moving back into the line of work.

Everyone is called to the house for supper. We will eat together because there is more work still to be done tonight, before the kiln can be lit. Hisako is cooking small fish in a Chinese manner, and she hands everyone a glass of wine or saké as he comes into the room. The work-men are seated at the table, with Mrs. Hamada serving, Hisako barbequeing, and the rest of us sitting at the robata. Deborah says that the flat barbequed fish remind her of bacon. Hamada picks one up with his chopstick and refers to it as a bacon-fish the rest of the evening, enjoying that name. He remarks that his house has "interna-tional creative cooking," and that the Japanese have two words for food, cotton food and silk food. Country food is cotton food and restaurant food is silk food, he says, but the food of his house is inter-national creative food.

There is a real spirit of warmth shared at this meal, but only a little talk. When the workers finish, they bow formally in thanks, and return solemnly to the kiln. Although this ritual of firing takes place once every few months, it is still a new and expectant challenge for everyone. A whole kiln full of several thousand pieces produced during these many weeks has the hands of all these persons involved somewhere. Each time the cycle is repeated, the chain of patterns locks closer, and there is growth and continued reinforcement.

No matter how many times the actions are repeated, there is a vitality. Each pot is new, but part of an ancient and ongoing process. Probably nothing could be better than work of this nature; it contains meaning and satisfaction, newness, yet has its roots in the timeless beginning of man's crafts. Everyone goes immediately to the glazing again, and in no time Hamada has painted sixty-five more tea bowls.

The first chamber has taken the longest to load. Packing the hun-

dreds of different small shapes in this chamber takes a great deal of time and trouble. Most pieces are set on individual clay support pads dusted with kaolin, so that the feet will stay flat and not stick to the shelves. Candles stuck into balls of clay are placed in the back behind rows of pots, so the workers can see. When all the shelves are filled, then the individual saggers, each holding a single plate, are stacked ten high along the thirty-foot width of the chamber floor.

The atmosphere of the kiln will vary during the firing. The first chamber will be reducing, the second one neutral, the last three oxidizing, and the temperatures will vary perhaps forty to fifty degrees overall. All these give a different "flavor" to the same glaze, depending on where it is placed in the kiln. The clear ash glazes, and some translucent nuka-glazed pieces, are placed in the first chamber, kaki is best from the third up, and *seiji* turquoise, the copper glaze, is in number three. Nuka, which is the staple glaze and comprises about half the kiln load, goes into all chambers, and consequently several variations will result from the same glaze treatment.

Everything is last minute now. Hamada has carefully chosen some tea bowls to have no decoration at all because the form alone is enough. He wants them fired in the first chamber, where the atmosphere will cause the nuka glaze to have a special surface and color. Shinsaku supervises the last of the loading, deciding what to leave out, although most of it fits in. Clay patties with seashells are put under some of the tea bowls with a particularly runny ash glaze; Masao-san is inside loading these last pieces, which the young boy runs up to him. The door opening in the top chamber is bricked up already because it was packed with saggers of plates and the big bowls, and that loading went fast. Old-man carries the large handmade bricks used for closing up the door openings three at a time up the hill. Oka-san is sifting the sand for sealing the doors, shaking the fine grains into the wheelbarrow. Hamada has finished painting the last tea bowls and stands beside the fire, watching. A pile of sieved sand is dumped in front of each bricked up door. Hot water is poured into a hollow spot made in each mound of sand, and the door is mudded by hand with the mix, Oka-san and Uma-san leaving finger patterns as they slap it on.

Everyone has been cleaning up, stacking pallet boards, stowing the

161

big bowl of kaolin, mounding up the wet clay support pads that were not used, putting away the few glazed pieces that did not fit, and moving down the hundreds of bundles of logs and straw for the fire.

The wood is brought down in bundles by the workers in their chain procession, a great deal more of it needed this time and brought by truck, since the glaze kiln will fire much higher than the bisque. A huge fort of wood is built around the mouth of the kiln, which protects the men in the beginning as they sleep and work and keeps out the wind. Wood for stoking each chamber is piled higher than the kiln at each door.

Suddenly I understand that they actually organized the glazing according to chambers: the ware going in top chambers was glazed first, and ware going in number one was glazed last. The flow of the whole process was so casual, from making through bisquing and glazing, that it seemed to happen spontaneously. Actually the plan was so precise all through the operation that the ware needed first for stacking the top kiln chamber was made first and later glazed first, and so the same with the last tea bowls that went in the lowest chamber. This team of people, here most of their lives, is totally involved in the wholeness of this flow, and the scheme is so tightly interdependent that one wonders whether any change would break it all apart.

Now, when everything is ready, a bottle of saké and a plate of salt are brought for the Shinto offering. As Hamada lights the fire he throws salt over his shoulder for luck.

HAMADA TELLS STORIES

Everyone gathers in a jovial mood of accomplishment, to warm and chat by the huge fifty-gallon tank of steaming hot water on the fire. As they have done so many times before, the workers sit around on the small stools just barely off the ground, huddled together in camaraderie, laughing, smoking, talking quietly together. Hamada is squatting here too, his face lit with the others by the bright coals and licks of flame, his hands warming in the smoke and steam. He begins to tell stories.

When he was first in England as a young man with Bernard Leach,

he was surprised to hear that Japanese were considered very brilliant people. His English friends would ask him to tell a story about why this was, and he searched around through Buddhism to find something for them. Finally he hit upon a story that concerns three of Japan's most famous generals: Oda Nobunaga, Toyotomi Hideyoshi, and Tokugawa Ieyasu. Each was asked a question: supposing there is a bird and you want it to sing and it will not sing, what do you do? The story goes that Nobunaga answered if it would not sing he would kill it. Hideyoshi answered if it would not sing he would figure out how to coax it to sing. Ieyasu, however, answered if it did not sing he would wait until it did sing.

Nobunaga died young, by assasination, Hideyoshi lived long enough to conquer and to unify the country, and Tokugawa Ieyasu, who waited, founded the Tokogawa shogunate and his house ruled 250 years. Hamada says his English friends were very impressed by this story. Western people were just beginning to learn about the Japanese, and he thinks that because the two cultures were so different, Japan at that time had to be considered brilliant.

Another story Hamada used in England was about two men who founded two of the main Buddhist sects, Ippen and Shinran.

Ippen says that even if you are not good, even if you do not pray, God is always there giving a helping hand. Buddha and man are one. "I am Buddha and so are these," says Hamada, taking hold of his clothes. Ippen had no disciples, no one would listen. He died at an early age, wrote no sutras. Hamada says this belief is the true one. One does not have to study theory or philosophy to know this, you learn with your body and not your head. Mothers are very like priests in this way. No matter how much a child cries, the mother is still there putting out her hand to help. So these truths are in other things, basic things, one does not have to go to the church to find truths. They are demonstrated in ordinary life.

Shinran was called upon to pray in the palace for the emperor. "Think about it," Hamada admonishes all of us sitting at the fire. "God is probably trying harder to help those who aren't good, holding out his hand. It's right here, you don't have to go elsewhere.

"There are two kinds of people: those who make themselves the

center, who live as though their ancestors lived only to create them, and bear children only to carry themselves on; and those who make themselves as low as possible, consider themselves nothing in relation to the whole, live in order to protect and cherish what the ancestors lived for and bear children in order to pass that on. Most artists fall in the first classification and artisans in the second one."

Hamada does not like the word artist, and he feels that an artisan is a workman who does exactly what someone else is telling him. But of himself, Hamada says he has had a master, but a different kind of master—he has not been doing just for himself. Working as he does, his own nature comes to be expressed naturally. Most people nowadays are not patient enough to follow such a path, says Hamada. They do not understand that there is something of value in self surrender, no matter what. Most people want to express themselves too quickly.

The point is if you consider yourself the center of the universe, you cannot create anything universal because it is going to smell of your self. Hamada, speaking in third person, says that Hamada had a special problem in that he faced the difficulty of being aware of this, of being self-conscious about being self-conscious. He knew that if he had any faults they would come out of this feeling. So he decided to come to Mashiko. He had studied everything there was to know technically in school about glazes, but he surrendered himself to a few natural glazes and to an inferior clay. He put himself in this framework, lived as the people of the area live. Even though he had lived and worked in other parts of the world and he spoke foreign languages, still he came to this place.

Coming to Mashiko when he could have stayed in Kyoto or some urban area, deciding not to use any of the techniques he had learned, and having nothing in common really with Mashiko people—all was a surrender of self. Followers of tradition, then, or those who wish to strengthen it, cannot hope to find the pure strains in the river now. One would do better to ignore the surface movement, to stop where one is and dig down deep under the surface. Eventually one will find a spring of fresh water. Then he should let that flow through him.

Hamada wanted to have Yanagi's "experience," but he was already overeducated, so he sought it out in the best way he knew.

Now he tells stories from Yanagi's book, *Myokonin Inaba no Genza*.

There is a temple in Kyoto, Honganji, home of one of the Buddhist sects. There is a lady in Nagoya who is a devotee of that sect. When it rains and the wind blows in Nagoya she goes up on a mountain with a reed mat and holds it in the wind in the direction of Kyoto to protect the temple.

Hamada said that of course it is a ridiculous thing, but in her heart the feeling that she expresses by doing that is a wonderful thing. Each person must do his own small part as best he can and as he feels he must.

Listening to these stories, I realize that, more than most people ever are able to, this man Hamada pursues the goals he truly believes are right.

Another Yanagi story, Hamada says, relates to the visitors to this compound. There was a man named Genza who was a very humble man, an earnest follower of Buddha. One day he went to his field to gather the crop and someone had already picked it all, a neighbor or a thief or someone who was hungry . . . he did not know who. He went home to his wife with an empty basket and his wife said, "Why do you bring this empty basket?" Genza said, "It wasn't our turn, God had to have the crop. He had given us the field to plant, we had raised the crop, but we hadn't done it for ourselves, we'd done it for God. Though we had raised the crop, it wasn't our turn to receive it, someone else needed it and was given it before us."

Then Hamada said there is a second part of this story. There were some travelers in the area where Genza lived. They camped for the night and were having dinner. After they had cooked their beans they wanted to feed the horses, so they took their horses to the fields to graze. They happened to take their horses to Genza's field of grain, which was really for his family, not for horses. And Genza said of his own field, "Oh, you should go to the far corner of my field where the grain is growing much better."

Hamada says you can draw a parallel about his showing guests around. On the surface these may seem like ridiculous stories, he says, but they can teach.

The workers are all listening, enjoying the camaraderie, warming their hands and faces in the steam from the big drum of water over the

fire, and their toes in the coals, smoking, drinking tea, laughing with Hamada, but the main conversation is Hamada's.

At this point in his storytelling I remember that in Dublin last summer, while accepting with Bernard Leach the first awards ever given to craftsmen by UNESCO, Hamada said in his acceptance speech:

"My work is only half done, it is too soon to receive this recognition. My feeling is, in spite of all this, that I want to get back to my wheel, so that the seed such as I can sow shall be sown. There are many ways of approaching work, but action is mine. The best that one can do is from one's own true work."

Now, by the light of the kiln mouth, firing the three thousand pieces produced by this seventy-six-year-old man and the men who sit here with him, he says that the challenge that brought him as a young man to Mashiko is the same challenge that keeps them doing things in the old traditional way. It makes a bond between the past and present and gives meaning to the work.

If synthetic ash were used in the glazes, for instance, or if inorganic suspension agents were used to make the mixing less difficult, or if industrial type temperature measures were used in the firing, the same oneness with the materials and the actions of preparing and using the materials would not be there. It is a way of life, a wholeness of living.

"The one important thing," says Hamada with unusual emphasis, "is that I was able to have understood this at a young age, to have pursued it, and that I knew the importance of it for my life. At twenty-seven I knew what I wanted to do. I was not searching any more. I knew it was a long path ahead for me but I didn't worry. I might be successful or not, that didn't matter. I knew what I wanted to do."

Hamada talks about his good fortune to have been guided and aided through his friendships with such unusual men as Yanagi, Leach, Kawai, and Tomimoto, who left their impressions on him when he was young. He loves his friends, he loves fine simple human people, but in another sense he is his own man guided by his own destiny, by his own tenacity. He always speaks of this destiny with a humble pride.

166

Beginning the Glaze Kiln

The firing of the glaze kiln was begun at 11:00 last night, and we had all spent several hours talking by the fire, wearing off the energy and the excitement of starting the last stage. There were straw mats and blankets around the area of the fire mouth, inside the fort built of logs used for the burning. The teams of men working in shifts began in the night and will continue during the entire firing. One team sleeps while the other is awake. Food is brought at frequent intervals of day and night by the women of Hamada's household. It is always something different, especially prepared and arrayed on large square black-laquered trays, and there is always hot tea. This morning the old man sits on his automobile seat, busy at his usual job of stoking the firebox, shoveling and stirring the great glowing pile of hot coals there.

Steam pours from the top flues of the kiln, up the hill, up into the sky. This early, slow, water-smoking fire is vaporizing the moisture in all of those porous pots, wet from the application of the liquid glaze.

Old-man seems to be a symbol of this kiln, surrounded by his log pile, enthroned on his automobile seat, his head tied in a blue and white kerchief, and continuously smoking a long thin brass pipe held in his cold hands. Half bent over each time he rises from the low seat, he keeps the fire mouth packed full of wood. Every log possible is stuffed into the opening. As each log burns, he pushes it further into the mouth and shoves a new one in its place.

The first chamber glows red by four o'clock in the afternoon, but the flue at the far end of the kiln is still belching wet smoke full of sulphur from the wood and fuming with moisture. The second chamber is not a bit hot. The heat must progress very slowly so the huge kiln will warm evenly. If the front heats too fast, if the far end does not get hot, then steam from the first chambers would form water again in the next chambers, which would be disastrous for the ware.

Wood for the fire is red pine cut from forty-year-old trees and then aged two years. Hamada owns forests and keeps people cutting all the time, and he stores wood bundles by the thousands piled up all around the compound. Two years for curing is just the right age for these logs. If aged longer than that, the natural oils dry up.

167

The best time to cut the wood is from December to January, when not too much liquid is circulating in the tree, as it is after after January when new buds are forming. How the firing will progress depends on the kind and condition of the wood, the condition of the ground around the kiln, and the weather. Autumn is the best season for firing. These months are somewhat warm and often moist, but not too moist.

Wood is hard to get and expensive. No other potter in Japan uses it as fuel for the whole firing now. With the cost of materials, salaries, the time it takes to do the work, and the firing of the huge kilns, it is easy to see that this is an expensive establishment to maintain, "Which is another reason to work all the time," laughs Hamada.

During the long first day of stoking the fire mouth, the workers, the sons, and Hamada have stood around the kiln together. They talk about the weather, the fire, the smoke, and the way everything looks. Periodically each one walks around the kiln, pulling plugs from various holes and feeling whether there is heat or moisture coming out. Where the chamber is red enough inside to see something, the men are continually peering in to check the fire turbulence, the heat color, and the look of the ware. Always there is the sound of the big logs being clunked into the fire box, being pounded in tight. The snap of the sparks, the roar of the fire, and the spewing of steam make the whole thing seem eerie and improbable.

Hamada says the weather is quite dry and there is no wind. The wood is dry as well. Therefore he guesses that the important stoking will be at 5:00 or 6:00 A.M. tomorrow, the second morning of firing. The crucial thing is to know when to begin stoking the first chamber. After heat from the fire mouth has brought the first chamber to about 2000° F. (1100° C.) it must be fired quickly to the 2300° F. (1260° C.) completion temperature. The complexity of this kiln with its five very large chambers seems, to a Western potter, an impossibly difficult problem of firing control. Hamada and his workers undertake the challenge many times a year, in all weather conditions, just as Oriental potters have done for hundreds of years. Oka-san says that the firing is slow today and that it will take a long time to get the kiln to the crucial point.

168

The conversations continue as all concerned get the feel of the fire. Hamada is the leader, but when he goes to see guests or to sit with his family or to play with the grandsons, then Oka-san, the deshi, is in charge and leads and makes the critical decisions. The people who help Hamada have been perfectly taught; his supervision conveys his thoughts and his feelings as well. In this, too, there is an exhilaration.

About midnight, the two small holes on either side of the big fire mouth, the eyes of the dragon, are stoked with split logs. Oka-san decides to add the logs after looking at the heat color in the firebox and at the melt of the glaze on pots in the first chamber. He wants the temperature to be about 2000° F. (1100° C.) in the firebox. He says after that it will take four hours to get the next hundred degrees. It is always more difficult to get heat past 2000° F., and 2300° is the goal for these glazes.

The pace speeds up at the fire mouth with two men stoking quickly. When wood is put in the mouth, black smoke billows from the flue at the top and out of the side holes. The first chamber and second chambers are burning red, about 1500° F. (816° C.). Th brick walls inside are shiny and molten, glazed from so many years of wood ash. The third chamber is glowing, four and five show a dull red. A strange aroma still wafts from the flue.

Every ten minutes logs are put in the ports—the eyes—on either side of the mouth, which spew ten-inch yellow flames and much black smoke. The first chamber is under an atmosphere of reduced oxygen, which will cause the glazes to be especially mellow and slightly blueish or celadon color.

It is 3:00 A.M. Looking into the first chamber, one can see that the glaze on the tea cups is liquid shiny now. The stoking at the fire mouth and of the two eye ports continues. The men of the team doze on straw mats between firings. No one says to the other to do something, they just do what is necessary. When a bundle of wood is needed, someone takes it from the big stack and drops it on the ground to loosen the wire holding the logs. The number of bundles used is calculated by hanging each wire loop on a hook at the front of the kiln. When the men are playful, they throw the wire from a long distance to try to catch the hook. The fire roars now as whole bundles of logs are stoked.

169

With a poker Uma-san churns the red coals away at the big fire mouth to make room for more logs. As the poker bends with the heat and the weight of the logs, he bangs it on the dirt to straighten it again. As the logs burn, the coals are stirred, making a mosaic pattern of firey red shapes.

Food in variety—Japanese tangerines, *sushi*, cream puffs, and candy— and more hot water for tea were brought out at midnight and are now almost gone. At 4:45 A.M. a conference on whether to begin stoking the first chamber is held. Oka-san and Uma-san look into the first chamber together, one on each side of the kiln. Then they come around to meet and discuss how they feel about what they have seen of the ware inside. No, it is not time yet, the glaze is not glossy or molten enough.

Inside this chamber the atmosphere is quite clear, not yellow and not smoky. "The temperature has been 1160° C. for a long time and now maybe it is approaching 1200° C.," says Oka-san, using the centigrade scale and reading the color of the fire by looking at it instead of using any standard pyrometric devices, To be able to guage the temperature of a fire by eye in increments of ten or twenty degrees is an unbelievable skill that can come only from very long experience in burning kilns in this traditional way.

Now at 5:00 A.M. the morning of the second day of firing, the time that Hamada had predicted, the big decision is made to begin stoking the first chamber. This means that the glazes are ready to be brought to maturity and the firing must be culminated quickly. The three men break into action.

Ten minutes later another test tile is pulled and looked at. The clear glaze is good, but the nuka glaze is not melted enough. "One more time," says Oka-san, who is responsible for the firing.

At 6:00 A.M. Hamada comes out to look at the glaze test trial. No one called him, he just came. After one more firebox stoking, which they do with another forty logs, the next test is pulled out. Hurriedly agreeing that this time it is finished, everyone works quickly to close up the first chamber. "It's a little hotter than this chamber was in the last kiln," says Hamada, from his remarkable memory. And he says that my guess of a good 2350° F. (1288° C.) is right. But then he would probably say I was right even if I was not.

170

Stoking holes are plugged and mudded up; all ports of this chamber are closed so that cooling will take place slowly. If the ware cools too rapidly from this extremely high temperature it will crack from the shock. Everyone races to close it off. At 6:10 A.M. Uma-san plugs chamber number one and begins the immediate stoking of chamber two.

It is dawn, and the great black cloud of smoke rising above the kiln is more visible. The smoke cloud goes up into the sky, billowing slowly from a moving circular stream of black fluff into an expanding wider mass as the smoke is blown off on the breeze. These clouds are characteristic of Mashiko town and can be seen every day coming from the kilns in parts of this village.

A new shift of workers comes to continue the stoking, although Old-man and Uma-san stay. Masao-san looks into the first chamber, which has just been finished, to see the look of the ware and to know how the next chamber should be. All the glazes inside glisten like melting ice and are a glowing red.

Thirty logs at a time now, and the men are stoking chamber two every ten minutes. The whole kiln is belching hot, at the peak of the firing. Hamada sits down with us at the steaming big drum of water on the warming fire this early morning, and tells an old story about Bernard Leach. It has nothing much to do with the firing, it is just a story he wants to tell.

Leach had heard Yanagi talk about a man who was over ninety and was worried about how to die. The man wanted to die peacefully and asked the Zen master how to do it. "Just die," he was told. Soon he did, and several weeks later the master also died. Leach had heard Yanagi tell this story over and over. Once when Leach was having a problem of his own with trimming bowls and wondering how the Koreans achieved such good feet on their tea bowls, suddenly he remembered the lesson of the Yanagi story. He exclaimed in wonderment to himself, "That's it. That's how they did the tea bowl feet. They just trimmed them. And that is how to do it . . . just do it."

With that story in the air, Hamada left the fire and went back to bed.

FINISHING THE FIRE

The second chamber finished at 8:00 A.M., fired to about 2370° F. (1300° C.), slightly hotter than number one, and the third chamber was begun. The fire mouth no longer glows with coals, since cooling has already taken place at the front of the kiln. There is still half the kiln to fire. Draw trials are pulled from chamber three, and Oka-san says that it is probably a little hotter than the second chamber, 2380° F. (1304° C.). It has taken thirty-five bundles of logs to fire this chamber to this temperature. At 11:00 A.M. of the second day, after two nights of firing, the third chamber is begun. The men are tired, but the pace is steady; teams change, work continues.

Blankets placed on bundles of wood resembling lounge chair shapes are used for the minutes of sleep in between, but someone is always awake. Masao-san waters down the dirt on the hill toward the top chambers because moisture helps the fire. A steady pressure of flame and smoke comes from chambers four and five, although not as violently as earlier, because part of the kiln is already shut down. When the logs are thrown in, there is an immense roar at the two upper ports of the chamber.

Activity during the remaining time is that of concentration, discussion, and the physical heaving of thousands of logs. The men watch, pull tests, and inspect as the fire grows increasingly hot and mountains of black smoke rise. The flue at the top of the hill spews a yard-high wall of flame along its thirty foot width. The first two chambers are cooling. They glow dull red with the glazes almost set and blackness outlining the semishiny forms. In between stokings those men who are not sleeping clean the area. When night fell, the darkness, fire, and cold air, with the water steaming in the big iron drum and the food and the tea contributed to a greater atmosphere of conviviality than during the day.

Chamber four begins, Oka-san and Uma-san work tirelessly. Now it takes fifty-four small logs stoked from each side to fill the chamber from one side to the other, throwing the wood first to the center. These last chambers, when the men are the most tired, require the most skill and physical effort. As the wall of flame at the other end burns higher,

172

more smoke rises and becomes visible everywhere in the village. Mashiko potters always know who is firing because they know the location of each kiln. The fourth chamber stoking is finished at 1:30 on the afternoon of the day. The fifth chamber, with the large expensive bowls stacked inside, is tended and watched very carefully.

Uma-san and Oka-san insert long green bamboo stalks in the ports of the first and second chambers. The stalks catch fire and provide light for checking the color and cooling of the glaze. Cooling is as important as firing; some chambers are cooling while others are still heating. Cooling is regulated by the way the rest of the kiln is fired as well as by controlling the draft. If it is wrong, the pots may crack or the glaze might be immature.

Three hours later the firing of chamber five is finished. A few bundles of wood are left from the hundreds and hundreds that were here. The men are looking into the chambers again, holding the bamboo to ignite and light up the interior. Chamber number one is black cold, chamber number two has a faint glow, three is dull red, four is orange red, and five is white-hot.

This is an exacting, demanding total effort. It is an effort of experience and sharing for men to work without temperature gauges or any type of indicating apparatus. They work without seeming to control anything and yet, in fact, they perceptively control everything. It indicates mastery in the extreme. The numbers of variables seem impossible to manage: the size, kind, and condition of wood; the way it is fed into the kiln; how the kiln was packed; weather conditions; the fire color at all times in every place; the amount of pressure building up inside the chambers with always the danger of explosion; the continuous watching as the glaze begins to develop its molten surface; the control of the fire and temperature to bring the glaze to just the right nuance. These variables are continuously manipulated over a period of forty-two hours.

The firing is finished. There is general exuberance and a reluctance to leave. We have been here nearly sixty continous hours including the last day of glazing and packing. The excitement and seriousness is felt by everyone and it is hard to let go. So there is a bustle and a lot of busy work putting away the wood, sweeping with a twig broom to

clean and refresh the dirt around the kiln, and stowing away the blankets. When all is neat and in place again we look once more at the big kiln that has consumed so much of everyone's concern and energy. Hesitantly turning our backs on the job just completed, we all walk toward the house, talking softly or not speaking at all.

Inside it is gayer. The table is set closely so that eight or ten can squeeze together at once. It is like a meal after harvest, and I realize, interestingly, today is the American Thanksgiving Day.

The table is filled with food. There is soup made from the stem of mountain potato, bowls of sweet-and-sour pork and vegetables, deep fried pork on shredded cabbage, raw fish, grated radish with finely chopped fried bean curd, and green onion. Large chunks of cabbage are passed around, and cups of yogurt with homemade blueberry jam and heather honey, saké, and rice, in this order. There is not much conversation because everyone is very tired and hungry, although there is a general feeling of fraternity. The young maids and Hisako and Teruko are replacing bowls or tending individual wants intuitively without being asked.

More Scotch and saké are brought out. The service is completed, and the tightly knit group disbands for the several days it will take for the kiln to cool.

HAMADA AND SHIMAOKA

On the following day Hamada goes to visit Tatsuzo Shimaoka, his nextdoor neighbor who was one of his deshis during the war. Shimaoka is about to have a Tokyo exhibition and asked Hamada to see the pieces of his last firing and the choices for the show.

On the ground by Shimaoka's kiln all his wares are laid out and wood boxes and wrappings for each pot are spread around. Hamada takes notice first of the boxes that Shimaoka has already signed. He picks up a lid to inspect the signature, "Not bad. You pass."

This *hako-gaki*, or "box writing," is traditional and customarily practiced by all potters who sell their work expensively, whether or not the potter signs his pieces. It is very necessary to provide fine wood for the boxes—usually *kiri* (paulownia) is used. These boxes are made

174

by a professional box maker and inscribed on the top by the artist with the identification of the object, such as saké cup, bottle, vase, and so forth, the source of the ware, such as Mashiko, and the potter's name and stamp. This stamp is in Chinese characters and is usually in red ink on the lower left-hand corner of the box lid along with his calligraphic signature. One's brush writing is important and may be as much a work of art as the object inside the box; Hamada has looked at this before he looks at the pots.

Shimaoka takes us into a newly built house, where he has choice pots, and Hamada makes a joke about only rich patrons being able to come here now into this small new guesthouse, and that we are the first, therefore the richest. Hamada compliments Shimaoka generally on the ware, then says that the quiet Bizen type pieces, which have very little glaze, are "too tasty, too self-conscious." Shimaoka takes this criticism from his master with a bow.

Moving to Shimaoka's main house for tea and conversation, Hamada seats himself in the most humble spot, near the door. The position closest to the *tokonoma* alcove in a room is the honored place. Hamada did not sit there, so neither could anyone else. Shimaoka sat on a stool a little behind Hamada.

Shimaoka brought out an old Tamba pot and a faceted Yi dynasty Korean porcelain with small paintings. Hamada said both were quite fine and rare to find these days. Shimaoka also brought out a Pre-Columbian clay figure, and Hamada said it was probably made at a time similar to the *haniwa*, produced during Japan's Tumulus period. Hamada admired a brown slip-glazed pitcher, undecorated, and Shimaoka brought it to the table. Hamada said it had too small a mouth and too small a handle but " . . . the overall effect is quite nice. One must always look at the whole piece."

As we walked home we passed by the small fishing ponds belonging to Hamada's immediate neighbor between his compound and Shimaoka's. The ponds below the road on the edge of the rice field are stocked with fish and used on a good day by many men and a few children who stand around the cement embankment, fishing. Hamada watches for some minutes, and his grandchild eats a little with him at the fire of the fishermen. Then the potter and the young boy return to

175

the quieter retreat of the separate intimate family room at home. Mrs. Hamada does not come at this time, but waits for her husband in the next room. He has worked an incredible pace these last few days and, although he seems not to show it, he is very tired.

UNLOADING THE KILN

Two days after the firing, at ten in the morning, everyone gathers for the opening of the kiln. The gate is closed and there are no visitors. Three chamber doors have been unmudded, but no bricks taken down, waiting for Hamada's approval to unload. There is a jubilant, expectant feeling all round. Hot air is still coming out of the top flue holes of the kiln.

As Hamada walks up, the workers pull a few bricks out of the first chamber door so that he can peer inside. Shading his forehead from the heat that pours out, he nods that it seems cool enough, and people leap to unbrick the doors and to unload pots. Workers inside the kiln hand out the pots, and a chain of workers outside hand them down the hill to be stacked at the bottom on pallet boards.

It is customary for Japanese potters to go around visiting each other when their big kilns are opened, to honor their friends on the occasion of finishing so much work. But no one is here for this opening except those who have worked on the load. I ask if any visitors will come, and Hamada laughs that most potters are so busy making money for themselves they would not come. This is his way of ignoring my question. Hamada's kiln is really always closed, except for occasional invited guests, or there would be so many people underfoot that nothing could be done.

The excitement of seeing the ware is very great. "Would Shimaoka or Sakuma come to Hamada's opening?" I ask. Hamada said, "Oh, my old friend Sakuma might come, he is so honest that sometimes he looks like he understands everything, but he doesn't. Sometimes he looks like he doesn't understand anything, but he does." Hamada's evasion makes me understand that it is indeed a rare privilege to be invited to view the opening of his kiln.

As the wares pile up on the boards, I look at the varying colors

produced by the kaki glaze. This glaze of volcanic stone that is Hamada's specialty has a seemingly unlimited number of effects, depending upon where the pot was in the kiln and the thickness of the application of the glaze. The color can be caramel brown breaking to rich black, or a smooth satin red brown, or a variegated surface of spots of black against a lighter iron-rust. If wax is used between clear and kaki, there will be a sharp black line outlining the decorations where wax resisted the glaze. Where the kaki was overlaid or dripped, sometimes there are changes in the surface that can be felt but barely seen.

All this variety is the result of tremendous skill and knowing how to apply the glaze, yet it is also absolute abandon—this is skill that is not skill. Hamada calls this "subconscious consciousness." It is choosing and sensing the necessary pot form and clay texture in order to produce a desired glaze flow, then chosing the proper chamber for firing, and even chosing the proper place in the chamber. All of this is directed by Hamada during the time of glazing. Now as he looks at the pots being unloaded, he observes, "If you learn too much you can't be a potter, you're a merchant."

The Ware of the Kiln

As quickly as the pots come out, they are mysteriously organized. In an effort to see how this happens, I watch Hamada, standing on his geta, hands behind his back, glasses on his forehead, rocking a bit and beaming, to see if he is directing the placing of the pots with his hands or his voice. He is not. The workers are segregating the pots according to what they know he wants, and if they make a mistake then he will correct.

The piles accumulate with order. What amazes me most is that some pieces I know I saw being handed down the hill I do not see again, wares of particular beauty that somehow are spirited away, perhaps with an obscure direction from Hamada. In that second those pots become either part of his own collection of his very best work or they will be saved to go into museums.

The visible segregation of pots into areas along the dirt paths, or

the stone walks, or the boards at the base of the hill, or all the way down the walk to the front gate house comprises the sorting. Wares are grouped for various exhibitions, for showcases in department stores, for sale in shops, for sale at Hamada's, for special sales, and for gifts. He says there are two categories of the few pieces that are not very good out of these three thousand pots: some will be sold, some will be broken.

Hamada is delighted with a bowl that is delivered to him, which has a fine new test glaze made of the ash from his robata, but it is cracked from too fast cooling. He sits down on a small stool and fondles this pot. It is a flared-shaped bowl I remember watching him make. He holds it and looks at it, with its shell foot pad still attached to the bottom, and plunks it with his finger at the edge, It emits a dull thud, as any cracked bowl will. He says, "Such a good bowl, so nice a glaze."

The slight note of wishing the pot were whole lasts only a few seconds, then he is on to the next piece. "The first chamber cools too quickly sometimes," he conjectures, "probably in the beginning of the cooling when the kiln is blocked off, or perhaps maybe as the last chambers are firing."

Then there are some really good pots coming out and he is exclaiming, "Oh, fine, fine," or remarking that "there's a good one for this coming exhibition." Out of maybe twenty similar tea bowls he chooses four and sets them on the special exhibition board. He picks up a beautiful cylindrical bottle that he had decorated with tool marks slashed in the clay. He says it is excellent and strong and one of the best pots in the kiln. And so it goes as everyone sorts the wares and discusses the firing.

The top chamber fired about the same temperature as the first, about 2360° F. (1293° C.), but the first chamber cools fastest, and this makes a big difference to the glaze. The last chamber has been subjected to heat the longest, so the look of the pots is different there also.

After a few hours Hamada motions for us to walk in the woods, constructing another pause in the continual pace, indicating a need for relief from the visual impact of three thousand pots glowing in the sun.

We walk through the woods, talking of the mushrooms they gather there, of the old tomb excavations made on the side of this mountain, of

the ancient *haniwa* shards he has found here, of the small house alone in the woods that he built for a friend of his from Tokyo during the war, whose son had consumption. Japanese people are very afraid of tuberculosis, so these people could not find a place to live. Hamada built this house in ten days, when he knew his friends had no other place, and they lived there until the son died. Such a nice spot, says Hamada, with only the woods to look at. We walk through the thatch grass, as we have done on other occasions, and he talks about the beauty of the big Japanese oak trees he has espaliered all around the farm for fire breaks, and of his fear of fire. That is why he chose the crest on the top of each house to be the sign for water.

The chestnut logs lying on the ground are part of the last old house that he bought but never assembled, which will be part of the museum he plans to build next year for his collection.

Everyone is called to the house for lunch. Shinsaku's wife, using one of Hamada's two-thousand-dollar bowls with a chip in it, dumps a huge wooden container of hot rice with beans, raisins, nuts, and spices into this bowl. This is the family's own festival rice, served on special occasions, because, of course, opening the kiln is special. Oka-san takes the first small bowl and puts it up on the mantle of the English fireplace where the small shrine is, placing the bowl as an offering between the two bottles with pine needles in them.

After everyone has eaten the rice, Hamada leaves to cull the load again, saying that he arranges the pieces in his mind when he sees them come from the kiln. He has an area for exhibition things by the front gate; he says we should go there to continue the discussion, and we move from the kiln area to the show area. It appears that there were invited guests, Sakuma and Shimaoka, because they have arrived. Sakuma was Hamada's companion from his first Mashiko days. The two made pottery together in Sakuma's father's traditional workshop, where the young Sakuma gained a new kind of awareness from his well-traveled friend. The three men go to view this latest work of the master.

They speak of the ware. This one is too weak, the color a bit wrong; that one is strong and good. The black glaze sometimes has a warm green tinge, maybe from too much smoke in the fire and perhaps from

179

being not quite hot enough long enough. Hamada is fond of that result. In the finished tea bowls that were ochre-slip dipped, I see that the slip has very little iron in it and reduces to a greenish celadon color, making the color contrast more subtle now than it looked in the raw. One tea bowl has his new American Indian basket design painted on, the ash glaze crawls over the trimming marks at the foot, and the color of the body is gray pink. He likes this better when the fired color is greener, more quiet.

Hamada picks up another tea bowl and says it has a good brush on the side but that he forgot the brown lip he meant it to have, which means that he had forgotten to ask the boy to dip it in iron after it was painted. But handling two tea bowls at once as he often did during the glazing of sixty-five bowls at a time, in the last minutes before finishing the stacking it is easy to make a small oversight of that sort. Giving orders to the workers was not possible most of the time as they worked in unison, but his sharp eyes could signal corrections when something was not handled properly or placed in the kiln in the right position.

The ware of this kiln stays outside on display several more days. Department store people and other buyers come to purchase it. Atsuya handles the sales, the cataloging, and the pricing. In addition to counting the wares, pinging them with his finger to listen for cracks, and writing them up, Atsuya squats on a low stool rubbing the feet of a group of pots with carborundum to smooth them. A high, belllike ring when he chunks each piece with his knuckle or fingertips shows that the piece is not cracked. Having seen him ping the pots, two dealers delight in picking up shapes to try it, only to be surprised with a thud because they hold the side of the pot, which damps the ring. Another worker joins Atsuya, and the two continue going over about fifty pots chosen for this particular department store in Kobe.

As the ware remains out in the sun along the paths, Hamada sketches in his book and makes notes. This is his usual manner for imprinting something on his mind, and he does not need to look again at the sketch or notation. People come and go, and gradually the three thousand pots dwindle. The exhibition choices remain along the stone walk, several hundred pieces being looked at and discussed and moved and replaced. In this manner he sets the show that will go to Tokyo.

As I look at these wares, the ordinary works of this kiln, the ones remaining when the exhibition materials have been segregated, when the next best pieces for the shops have been removed, I can remember Hamada standing or bending over the same long lines of bisqued pots or pots covered with a first base coating of glaze. He would sort and move some pots over to a barrel of glaze, several people moving with him to form a team. He would choose systematically what was to be done with each group. When those pots were finished and carried away, he stood above another group, choosing again the way of decorating for each one. Over and over, hundreds of pots were considered at a time.

As one looks at the pots now, no two are alike. Each one has a life and being of its own, from its special place in the kiln, from the overlap of two glazes, from the pour or dip of color, or from the different strokes of the brush. The rhythm and the system come from doing a large group of similar pots, from having a great many to work on at once. Never could the same spontaneity and sureness result from a single concentration, from too much thought or care of one piece. Only from a large number can this be achieved.

It seems to me that Hamada's way and work involve three inter-related aspects: the main body of work—the nucleus—and two extensions—the enamel and the salt glaze. The main activity is the daily flow of traditional pottery making done by Hamada with his skilled workers, guided and controlled until they seem an extension of his own hand.

The daily work cycle requires great organization, control, and attention to all detail done in the difficult manner of traditional hand pottery, whose purpose is utility. The enamel work demands expert control of materials, a control made intuitive over years of experience, and, more than that, a rare artistic perfection and an extremely sensitive previsualization of how each finished piece will look out of the fire. In contrast, the salt firing is dramatic and exhilarating—the result is achieved by chance, by the explosion of rock salt and the alchemy of the kiln.

The intermingling and repetitive character of the main cycle is regenerative for the group, of which Hamada is an integral part.

Essential for his own regeneration in a different direction, though also part of repeated processes, are both the spontaneity involved in the salt firing and the sophisticated control of enamel. Each complements the other; the interplay of these opposites constitutes renewal—salt and enamel are Hamada's own activities and necessary. Maintaining the total flow of daily work provides a balance.

At 6:00 P.M. it has been dark over an hour, a half moon is out, the sky is clear, the air cold, but Hamada is still standing here with Shinsaku making notes of his pieces, and two of his workers change, carry, or move the ware away when it has been cataloged.

A New Cycle

"Making pottery should not be like climbing a mountain, it should be more like walking down a hill in a pleasant breeze," Hamada once told Yanagi.

The following morning in the workshop a new cycle is beginning. After the quickened pace of glazing and firing and the excitement of opening the kiln, the movements are slow as the workers return to the routine of the studio.

Not so Hamada, who is delghted and eager to begin the last effort required for the Tokyo exhibition, his salt firing. He will make two or three hundred different pieces virtually by himself. The salt-glazed pots comprise a smaller but essential part of his work and achieve the desired diversity for his exhibition.

In the next few weeks he will make two more trips to Tokyo, do more enamel painting and firing, and continue his visits to the Imperial Palace, where he is invited periodically to instruct the emperor in folk art.

Clay is prepared for work again. The huge mound at the back of the studio is chopped down. Oka-san wheelbarrows it to the opposite end of the workshop and dumps it on top of the new mound of moist plastic clay that grows taller as each load is added. Uma-san stands barefoot on top of this cylinder of wet clay seemingly doing a folk dance on the mound, wedging it with his feet. As the clay gets higher, Uma-san's head is in the rafters and he hangs onto a bamboo strut. All the workers are clapping and laughing and being gay in this process, which is really a quite serious part of the clay mixing.

Dry trimming scraps from weeks of work have been piled up against the wall at the end of the studio. In this area there is a cement slab on the dirt floor. The pile of clay scraps was sprinkled with water some

days ago. After the moisture penetrates, the wet clay is troweled and raked into homogeniety and wedged again. This reworked scrap will be added to the plastic clay from Kitagoya, which has aged all year in the studio. This makes a clay body of perfect consistency.

There is one more step in the mixing process. In another place at this end of the studio, four hundred pounds of dry *kibushi* clay from Seto have been dumped out on the cement. Water is poured into a hollow that the men have made in the clay powder with their hands. It is built like a huge dam, as a child would do at the beach in the sand. Covering an area about four by five feet, the kibushi clay is left to stand with water in the center of the mound for three days until the moisture is all absorbed. Because Mashiko clay is too brittle alone at high fire, a small proportion of fine-grained kibushi clay is added to the local clay and scrap that Uma-san and Oka-san have mixed. All of it together will be blended again in a homemade pugging machine. Then every bit of the clay will be hand wedged two hours before using.

Hamada's Museum

Preparing the clay for making the pots for the salt fire takes several days. Hamada says now we have enough time to see his museum. I have watched him take hundreds of visitors into this house. I have wandered in occasionally by myself. But having Hamada bring me this time I realize is part of his effort at continuing what he has called my time here, "a living study."

A group of fifty Windsor chairs from his collection of three hundred is being aired today in front of the museum house, the largest and most beautiful of all the old buildings on the compound. This is Hamada's own house, brought here, reassembled, and used as his own for many years until the need for storage for the collection became so acute. Ten years ago, when he was using it as his own sanctuary, it was a big clear space, the objects stored in the great cabinets along the walls brought out to show one at a time, the rest of the space open and serene. Not any more. Now most of the house, with its heavy thatched roof and magnificent windows paned with shells, is piled with boxes and crates, many of which never have been opened.

The chairs, airing outside, are some of his favorite things. He pats them as we walk around them, rubs his hand over the wood, and invites me to try a seat. Here is the landlord's chair, he fantasizes, pointing to a sturdy old flat-backed angular softwood chair. He touches a rare Shaker chair with a rush seat, and a colonial American Windsor, moves to an old English chair and remarks that they always seem to be heavier and more squat then the early American ones. He points to the seat of this one, shows how nicely worn it is, sometimes as much as an inch, and where it was chipped; even the chip scar in nicely worn.

"This is my first chair," he says, picking it up, turning it over, enjoying it. "In the beginning in England I didn't have enough money to buy chairs. I bought watches. But later I asked a friend who was going to Europe from Japan to bring back this one I had seen and admired. I described it to him, drew a map, and he went to that shop when he was in England and got me this chair. When it came, I left it with Kawai in Kyoto. He put it in his garden, as he did not care so much for such things. It got broken, lost a few nails, and Kawai repaired it with glaze. Now it is nicer than ever," and he points to three spots on the two arms where there are small raised mounds of blue green glass, melted glaze globules, placed in some holes in the weathered gray of the wood.

At the entrance to this house stands a Charles Eames chair and ottoman, which Hamada purchased in California. I remember the long dialogue Hamada had with himself in the Los Angeles store as we returned several times for him to sit cross-legged in this chair. He was not certain he should allow himself to have it because he liked it so much. He considered the chair a truly fine work, and the Eameses are his treasured friends, but he knew that if he had the chair he would have to vow not to sit in it too much.

A Hong Kong basket chair hangs on the porch facing the woods, there are Okinawan funerary jars, a Peruvian clay bull, a huge Karatsu bowl, an American salt-glazed cheese jar, and a rust red seventeenth century Spanish chest with fine peasant paintings he admires as he tells me his adventure of finding it. Then he uncovers some ancient Coptic fabrics from Egypt, which are framed under glass, shows me a very fine collar with rope decoration and woven reed backing for

the carrying of loads on a person's back, and more fabric: *kogin*, fine stitching from northern Japan; San Blas Indian molas; a Japanese apron; and two handsome old Japanese warp-dyed cotton pieces mounted now on paper, hand-woven in traditional indigo and white, each with a castle design, which were made and used as futon covers in an earlier day. He rolls them out flat on the porch, saying that they need an hour of sunshine. Part of the collection is always being aired each day when the weather is good.

Everywhere the big old house is stacked with treasures, not necessarily expensive or elaborate treasures, but somehow all are works of heart and hand. Scores of old European and American clocks, which he collects avidly, and of which he is so found, hang on the walls. The curator who catalogs and cares for these things has been doing so for forty years, but his work is always only about one-half completed due to Hamada's continued additions to the collection. Wooden boxes containing the most important pots are marked with a photograph outside, but even this cataloging cannot keep up with the buying pace.

It would be impossible to see everything even if one spent many days. Even Hamada is not sure he has seen everything. I notice some Spanish santos, and he says he has better ones but he does not know where—"somewhere in this house." I see some Hamada pots, and he says, "Yes, I have kept about fifty pieces. I will have two Hamada cases in my new museum building."

He points out a four-hundred-year-old painted Japanese wooden top used by wandering performers. Worm eaten, it is not a very good shape, too low, too thick, and too rough. "Usually they are thinner and wider and better proportioned, but I like this one, strong, steady, and sturdy." His eyes twinkle because he knows how many times we have talked about those qualities. He says he would like to have a glass case for it to keep it from rotting more, but glass is so expensive in Japan, which is to say that he really does not want it preserved in a glass case.

Most of the rooms of the house have thick tatami mats covering the floor. Other floors are of the beautiful polished black keyaki wood, and the ceilings are lined with thin half-round brown bamboo and heavy black timbers. Everywhere there are tansu chests, some very big,

others small, collector's items themselves; but the insides are also filled with many small treasures and fabrics. There is a display case of Japanese stemmed glass goblets, which Hamada says are about fifty years old, made in Japan for serving European ices.

Old Persian pots and Chinese pots abound on the floor or are piled on shelves, a huge jar at the entrance looks like old Tokoname but Hamada says it is probably from the Kanazawa area—a variation only a connoisseur could distinguish, and there are drums of every size and shape from many places. He goes off and returns quickly with a stick of heavy hardwood, long and highly polished, and asks if I know what it is. It looks like a big carved piece that might be used for hanging a kettle over the Japanese open hearth, but my guess is not good. It is a tool for hammering down the thatch when making a roof. The face of it is flat, much carved, with the grain highly raised. Hamada says that for a time he tried to use this long sturdy tool, which he liked so much, to decorate the wet clay surface of his big pots, pounding it into the clay similar to the way in which he uses his carved wooden paddles. He says the result looked too much like the face of a demon, so he stopped.

He purchases things abroad as well as locally, which is what he has done since his first trip to Europe, Crete, and Egypt fifty years ago. Among his particular enthusiasms are the folk cultures of the United States, Appalachian, Pennsylvania Dutch, and all types and vintages of American Indian. He is particularly fond of Mimbres Indian wares, quite rare ninth century pieces from the American Southwest made of light clay with simple, small black line drawings, for which he has paid as much as several thousand American dollars each. I ask where the ones are that he bought the last time we were together in California, but he does not know, there are so many things here. We look at some American Indian baskets and chief's blankets, Mexican rugs, contemporary Persian and Greek weavings, Taiwanese beads, costume shoulder pieces of glass beads, and some small bronze Egyptian artifacts. He says he has purchased some things in various places in Japan that have yet to be picked up, for instance some old chests and framed San Blas molas he bought from a recent exhibition in Tokyo. And the museum he will finally build here, to house all these objects, will be one more

concrete step in the path of sowing seeds, which he has so consciously developed and furthers every day.

Japanese exhibitions are often open to special customers for purchasing prior to being opened to the public, and much of Hamada's collection is acquired in this way. Art and antique dealers know what he wants, what he likes, and what he might be looking for, so he is aprised of many things in this way. For him, however, the fun is searching himself and finding some fine thing or an object he does not have, or rarely, possibly finding something he did not know existed.

His mind is so keen and he has studied so long in the books and museums of the world that he is also art historian and archaeologist. He knows almost for certain who made an object or when, but then he puts this knowledge aside and enjoys the object for itself alone.

Returning to the chairs, he singles out one with carved rounds at the back, pointing to the beautiful way in which those wooden spheres are flattened on the forward side from long wear, and where the wood of the seat is rounded from the pressure of those who sat. The natural turn of things is what he most prizes, the shape of use and love.

THOUGHTS

We have spent hours looking at Hamada's collections in the museum house, a simple, luxurious, relaxing time for both of us in contrast to the bustle of routine and work the last few months. Deborah is leaving today, to rejoin us in a few weeks at the exhibition in Tokyo. Hamada asks her to sit with us on this last evening in case he needs translation help with something he wishes to tell me. He has written it all down in rows of Japanese characters, planned it out on many sheets of thin paper, but he does not look at the notes and speaks to me in English.

As we sit by the fire, Hamada leans on the railing of the robata, eyes bright in the light, hands moving together in the same characteristic motions he often uses before beginning to work the clay at his wheel. He holds the papers too, but he speaks without reading.

" 'Create,' that word—so often we use it. People use the words 'to create' very readily, but I don't like to use them very often. The things that I do, my wares, are not made but born.

188

"If you can't give birth to the thing then you can't call it creativity. But that is so difficult. Really if you don't have some kind of help from God you can't give birth to things.

"Ordinary people think that 'good' means something rare or unusual, but really something good is too difficult a concept, so people are content thinking that if it is different is it good. They are fooled by that and like to make things that are shocking or will surprise people, and they fool the public. Within what is fashionable at the time they try to make something that is different, and within the fashion at the time they look for a hole and try to pull something through it, something for their vanity, or to show themselves off. That's the usual reason for making. The ordinary person who thinks he is creating something is doing this instead.

"Shiko Munakata says, 'I am not responsible for my work.' That is very interesting. He sells his woodblocks at high price and has always had a famous reputation, but still he says that. We don't bear a responsibility for that. This attitude of not bearing responsibility is the true attitude of bearing responsibility.

"People who are making things must put out an antenna above everyone else's head and a probe in the earth deeper than anyone. Having what you can call an individual character isn't very useful; just words, no good.

"In Mashiko and in Okinawa there are deep unconscious roots of tradition in the earth. For instance, compare dwarf trees in the garden and trees on the hill. If it's a dwarf tree, when the weather gets a little bit bad you bring it in the house, if it gets dry you give it water. You trim the branch for the tree or you make it grow in the way you want, or lengthen the branches or not, as you want. A traditional potter is like a dwarf tree. In the case of the tree you have to be careful about the weather, the condition damp or dry; the garden tree is only half a tree, the other half depends on the care you give it.

"A tree in the mountains grows by itself. I should like to become such a tree.

"The traditional potter is aware of himself today . . . that is not good. Why is the mountain tree good? The roots are most hardy, the trunk is the finest, the leaves and the branches will grow well even if

189

you leave them alone—you don't have to bend them or trim them, they're OK.

"If Mashiko and Okinawa didn't have such fine roots I wouldn't have worked here, or over there. Masu Minagawa made more than six million teapots in her life. When you do that many pots it becomes so that the work itself does the work.

"My friend Sakuma-sensei is a real devotee of pottery, like a religious person, but Sakuma is a devotee of pots not religion. If you can express your personality in the work, that's usually all right. Sakuma and the area of Mashiko itself have a personality, but usually people born in this area here are not satisfied. Sakuma's work is free, full of ideas. Usually a person thinks very hard where to get a new idea. Sakuma doesn't work for that, he just has a new idea. In the past he gave his work away; he has the real wellspring under his feet.

"Water is underground, running anywhere, anytime, and people must get this pure water. Usually people receive the water from the branch of a river, but there is this underground spring that anyone can probe if he would. The water that is easily available to you is the stream, but the underground water is the spring.

"Even when Sakuma has a new idea, it has the smell of the land in it, or is like a tree on the mountain. When you get that far you can advance even farther.

"Go one step more, say that spring water becomes your blood. If one comes to that point I think you feel you can do anything.

"Now here is something else: in Japan when you look, look with sharp eyes. If a great tea master says this is good, then everyone follows. It is very difficult to refute the tea master, so if a really good tea master says something is good, people follow that. In Japanese we say that the object gets a bloodshot eye, that there is something in the eye that needs to be cleared away and looked at with your own eyes. But if the tea master's rule is more powerful than you, it is hard to clear your own sight. With one's own teacher, take care not to go only by the rules of knowledge.

"Some Zen priests asked their pupils, 'Which is right?' No answer. 'Which is left?' No answer. That is an answer.

"Another monk said that the answer right is correct and that left is

correct, it is the same thing. For instance, laughing and weeping are both the same thing, both are all right. Every day we repeat some things.

"When I, Hamada, ordered my suit from the tailor, he noticed my right arm was three-quarters of an inch longer than my left. I hadn't noticed that. It means I had already been turning the wheel for forty years, and I was so thankful for the tailor telling me. But I noticed my work was not so much different, although my arm lengths had come to differ by three-quarters of an inch. Maybe I didn't tell a lie even in my first piece.

"When I feel something is good, it has to be from myself. When I was young I wanted to copy. That was a lie.

"Children cry and laugh every day, but it's the same thing. Everything children do is important. It's all the same, everything has importance. That's how our children have been raised in this house."

With the glasses on top of his forehead, face serious, and the lovely twinkle in his eyes, he continues:

"Every day one must clean or straighten up the house; we can't leave today's mess for tomorrow. In Japan you clean the house and after that the dust piles up again. The more dust there is the better, because it means the house is alive.

"About one-third of this exhibition in Tokyo will be good. Only about one-tenth of all my work is worthy of exhibition. I would like this proportion to be one-third, but I still feel only one-tenth is worthy. I would like the work to be one hundred percent worthy before I die, and then I could sleep naked in front of everyone.

"At one time this could be achieved, people could do this. Now it is very difficult. Anyone can select only good things and throw everything else away, but to exhibit not quite good but not bad pieces is all right if it is one's ordinary work.

"Anyone can choose one-tenth of his work and put on a good show. That's easy. But if you can exhibit your own work, almost all of it, and still have a good show, that's better.

"It is like a swimming race where the winner wins by the length of one hand. But your body must be ahead, so anyone is able to see from looking at your back that you are the winner.

191

"Yi dynasty craftsmen in Korea were very good, they were like this. Usually when people put on a show they put their heads on exhibit and hide their tails."

I remind him that once in Los Angeles, quite spontaneously and out of context with what we were doing at the time, he had said: "I used to think great art or great things came from the root of a tree, but as I got older I thought no, from the branches, then later I thought from the twigs and the leaves, the tips of the tree, but now I know it's from the heart." He remembers saying this and adds that he does not think he changed his work, but that the work changed itself with age.

Hamada finished these thoughts by saying that he had always distrusted speakers fluent in words who do not "do." One of the reasons he has never written or talked much is that he feels that his work speaks for him. "You must have done a very great deal before you are worthy to speak about it."

His monologue this evening has focused this purpose. I have watched Hamada practice what he has verbalized tonight and am documenting the pattern that began in his youth, with Leach and Yanagi, with England and Japan, West and East, with the workers and the work and the way of living, led by this man who is the tree on the mountain.

Making Pots for Salt Glazing.

The ware for the salt fire is quickly made. No glaze will be added. The raw pots will be stacked in the special two-chamber kiln used only for salt glazing, which Hamada built in 1956 when he was in need of another challenge.

Rock salt is thrown into the kiln at peak temperature, and a glaze forms from the union of soda from the salt and silica in the clay. It gives an orange-peel glassy texture the color of the clay or of colored clay slips applied in decoration. The salt glazing method, developed in Germany as early as the twelfth century, was also known in England and later in early America. It was used for utilitarian wares of the commonest sort, such as butter crocks, jugs, mugs, pitchers, storage jars, and water pipes. For Hamada it is just the right blend of control and chance in the process that interests him.

His approach to the making of these pots is spontaneous, almost joyous. He throws jars and facets the sides, makes pitchers and pulls handles, throws tea bowls, bottles, and has Masao-san press some square bottles in the plaster molds. As Hamada throws his large jars on the wheel, his young boy helper crouches opposite him and helps him turn. Hamada is working continuously, making all the ware for this kiln.

Now and then he stops and draws a profile in the wet clay on his wheel head or moves his fingers in the air, drawing in space to tell himself what he wants. It might be normal for a potter to try new or different shapes for an exhibition. Hamada, working now on three hundred pieces to fill a kiln by himself, throws shapes one after the other as if he were composing a symphony. There is variety, there is difference, but it is all of a kind. All these shapes emerging at once, in the space of a few days, are not different from his regular work that is spaced out and woven in with that of his workers. I have watched enough now to know that this variety is the norm, that the process of his life is here in these shapes and decorations, as in all the others.

The clay is very soft for the thrown coil additions to the jars, but the wheel moves slowly, the pressure is sure and light. The shapes are sketched in now for later paddling, cutting, or painting. One marvels at the time and patience involved in each piece and the care to leave the freshness even in the later refinement. A jar is bellowing into a wider form when there is a phone call. The interruption is enough to make him stop and say it is his birthday, December 9, and please will I stay for dinner. The girls have made his favorite slightly sweet egg roll but he apologizes that it will be simple fare, and says usually he likes to spend his birthday in a restaurant with all his grandchildren. He says he is "always every year one year younger."

At dinner Hamada talks about the schedule for the next few days. He has been discussing it all week, in the manner one does when minutes are few and there is too much to do, impressing on himself how it will go. He says that perhaps tomorrow they will begin the salt kiln packing and preheating, using a special charcoal for the slow fire necessary in the beginning for the freshly moist clay ware.

Charcoal is made here, by the workers, in another long process.

When a certain tree has achieved the right thickness, a charcoal fire is built of it, burning approximately two days. Careful watching is required and just the right amount of air, or, he laughs, all will be ash instead of coals.

If they start warming the salt kiln tomorrow evening, it will take a full twenty-four hours of wood burning before the temperature is hot enough to salt. At that time they will stoke the fire with more wood very fast and throw in two hundred pounds of rock salt, pulling test tiles to watch the salt glaze build up, salting until the tests look the way they want the glaze to be.

Hamada speaks of the forthcoming exhibit in Tokyo and of how his life is now. He says he has never been so busy as the last two years. For an exhibit he is always working to the last minute, unpacking the kiln about 2:30 A.M. on the morning of the exhibition, choosing the pots, packing them up, and going to Tokyo in the car in the middle of the night, a four-hour drive in the dark, arriving at Mitsukoshi department store about 8:30 to set the pieces before the opening at 10:00 A.M. This time he will have been to Tokyo on the day before to set the basic installation plan with some of the wares that have already gone by truck, and he will return to Mashiko in the same day to finish cataloging this last kiln. For years he has done this at exhibition times, but now he says it is like this all the time, all the days are like this, not just at exhibitions.

At Mitsukoshi he is responsible only for the work; he says the store knows about pricing. He does not do that well. Yanagi used to do the pricing for him. Each piece sold at the exhibition—and usually nearly all pieces are sold—has a box that will be made for it as soon as it is sold, made by the man who has been doing this work for him for forty years. Each pot has already been measured and everything is ready for the box-making.

I remember sitting with him in the Los Angeles airport several years ago prior to a big New York exhibition; he had not yet priced the pieces, which had already been sent from Mashiko. I was to call the gallery director with the prices while Hamada flew to New York City just in time for the opening. So I remember that, yes, he hates to price pots.

194

The great recognition of Hamada's work in the United States has grown over the years to a sell-out crescendo on the rare occasions when he has held exhibitions there. Collectors vie to collect him, museums request his demonstrations, he has been invited to the White House; Mrs. John D. Rockefeller III welcomes him with a fire of glowing coals, symbolic of how long she has been waiting for him. But he is perhaps happiest in the San Ildefonso pueblo of Maria Martinez or standing on the valley floor of Yosemite. The chore of pricing pots is understandable; in Japan, the United States, or anywhere it is difficult to set value where none is intended.

The pieces for the Tokyo exhibition, changed and culled for days now at the gate house, are finally being cataloged by Shinsaku and the workers. Japanese figures are brush-written on small five-sided handlaid paper stickers and attached to each work. Important pieces are sketched by Hamada in a book. In this way his memory of the object is strengthened, and for the same reason he sketches his collection or things he sees in museums.

The special Okinawan pots lined up together this morning along the walk are a rare sight. Some of these have been in each day's enamel kiln firing and now they are being cataloged for the Tokyo exhibition.

On short trips to Okinawa Hamada has made and fired the pots from the island's rich red clay. He has covered them with the indigenous white slip and the glaze made of coral and flown them to Mashiko for reglazing here with enamel painting. There are small ink pots and covered jars, ten lidded boxes, and perhaps thirty tea ceremony bowls. All are remarkably beautiful, but some seem especially fine, for instance, a purple-red clay bowl covered with cream slip, warm to the eye, with gray blue washes of the impure cobalt of those islands underlying the brushstrokes of amber and red and green enamel on the faceted sides. An iron brown line edges many of the bowls supporting the brightness of the opaque rust red and transparent grass green enamels.

These wares are almost overpowering in brilliance, at the same time sensitively quiet. They are like clothes we have worn and grown used to, or, as Hamada himself says, like old wine that has mellowed with the seasons, bright but worn bright, flavorful but mellow. Backgrounded here by the rich brown earth, which is iced over this morning, display-

ed on the rectangular stone steps, or on the weather-grained boards, the Okinawan enamels, rare because few are made, are perhaps the finest treat to see.

There are still fifty tea bowls to make for the salt kiln, and more than one hundred pots to decorate with *hakeme*—textured brushstrokes in thick white slip. I have come to realize that what he says to me or to his family about how much more there is to do at any given time is always more than it is really possible to do. The words become his means of setting his own goals high enough for possible, though not probable, achievement. There is always one more thing to do.

The warming fire has begun in the salt kiln with the special charcoal, which has been carefully unwrapped from straw bundles. The two chamber door openings are covered first with cardboard, then with iron, for preheating. The first glow of embers is slightly visible, framing the slab that partially blocks the mouth of the firebox. Packing the chambers should take place tomorrow afternoon, then the twenty-four hour wood stoking before salting.

The rush for the exhibit requires that this kiln be fast cooled in about six hours immediately after the firing. Utmost care in this cooling process, to prevent cracking the pots in the freezing weather, is another link in this chain of skillful effort.

There have been several large groups of visitors today. As always, Hamada takes time with them, showing the museum, showing the workshop, and offering tea. Those responsible for keeping him on schedule are impatiently upset with the interruptions, especially when visitors arrive who have previously been told on the telephone to please not come today. The family is concerned for Hamada's well being when he takes these daytime hours for guests away from his work. It means long, cold hours in the workshop for him at night. A doctor comes to the house regularly every few days to check his blood pressure. When it is too high, he is admonished to rest and slow down, and one notices his real attempt to follow this medical advice, depending on the demands of his activities, however.

The huge wooden doors of the gate house are closed every day now, protecting the several hundred pots lined up along the stone walk from there to the main house. These are being changed and evaluated for

196

the exhibit. The red sign saying "closed" is hanging outside, but still the guests arrive.

Boxes of fruit, *mikan* and *nashi*, come every day and are piling up around the robata. It is the season. Several days ago there were even more baskets, plus *yuzu*, the delicious yellow citron, several kinds of persimmon from various perfectures, and great bundles of long-stemmed onions. Quantities of these were packed off to the two families in Tokyo, Hamada's oldest son and first daughter. According to Mrs. Hamada, vegetables and fruit last a long time in cold storage.

The quantity of food needed for entertaining the huge number of visitors is staggering. I have watched the baskets and baskets of raw materials bought and collected over the months, and the steady preparation of more. I have seen the continuous planting and growing of the garden in addition to the quantities of food arriving, purchases, and gifts from elsewhere in these islands. The flow is astonishing, and one assumes that only the continuous unbroken attention to the routine of all tasks keeps the whole line in motion.

The salt kiln is being loaded. When I left last evening, Hamada thought no, they would wait another day and he would paint more pots tonight. Some tea bowls were still not decorated. The packing of the kiln means that he has stopped himself. Later I notice that there were even a few pots too many to fit in this load, and some are left in the studio. But his eye was just about right, judging the several hundred pots of varying sizes and shapes as he made them and visualizing how they would pack in the kiln.

Uma-san crouches inside one chamber of the kiln, Masao-san in the other. Oka-san brings pallets of ware and feeds pots in to the men. Each piece is set with a clay pad and clamshell stilts, made individually by pressing the foot of the pot in a pad of clay first, then arranging shells along that line for proper support of the piece during fire. During the loading, pots are changed, restacked, in the laborious task of making everything fit, and Oka-san brings single pots and pads for filling empty spaces. The sturdy supports and thick shelves are dusted with powdered kaolin, the pads and shell stilts are calculated to be strong enough to withstand the throw of logs and bundles of salt. The pots are raw, not bisqued and not glazed; this fire and the salt will do both.

Seger cones 9 and 10 are placed in the kiln. When these cones bend, the salting will start. The chamber doors are bricked and sealed with wet sand, leaves are raked away, dry grass growing at the flue end of the hill is cut, and Old-man, who still is learning to fire, puts cedar twigs in the mouth for a soft, slow burning.

In mid December the compound seems vacant, so many trees have shed leaves that limbs everywhere now look like line drawings. The sprouts on the roof thatch grow greener in the moist weather. Long paths of water-smoothed pebbles are bordered on both sides with piles of dry, orange-tan and rutile-colored leaves. The short trimmed hedges that line some walks and frame some buildings are masses of twigs, where some weeks ago their small leaves flamed with color. Even the bamboo stalks become tan among their green leaves. Moss grows on the trunks of some barren trees and on the damp black earth, but the tall oaks, espaliered, are still very green, standing stately in geometric lines all over the compound. The areas of the compound rise from the gate house, from the road along the rice fields to different levels, ascending by leaf strewn, log-bound paths or muddy walks covered with the thick straw matting saved from the charcoal storage.

The salt kiln is at the top of these rises, above and behind the workshop. The kiln will fire a day and a night and be salted during the following day.

The Salt Firing

It takes nearly half a day for the team to bring the wood, carried on each person's back, from the storage area down the hill, up the log steps to the salt kiln, piling it in a U-shaped fort around the firebox. The bundles contain different sized logs, big for the firebox, longer and slimmer for the chambers. The pile of wood makes a shield from the cold for Old-man, who sits inside at the mouth of the kiln. Shinsaku strings a light bulb from the wood. The kiln is already smoking gray from the wood fire, and the steaming moisture is evaporating from the pots.

It is impossible not to be caught up in the warmth of the group of men as they prepare for another all-night job, working without words,

each doing a task that is needed. The kiln is old and it has already been salted many times. The salt-glazed brick on the inside gives off residue chlorine, which comes out as white smoke from the ports. The crackling of the wood fire adds more mystique, and the atmosphere is almost carnival. Clean, noiseless fuels cannot possibly yield as much romance to the doing of this work as handling the wood, watching the fire, and hearing it burn.

It is like a tribal ceremony with everyone around the fire. Those whose job it is to work, do. Others, caught in the beginning energy, are kibitzing rather than sleeping or leaving. Food and tea are brought. The job of preparing the salt is still to be done.

Rock salt, dampened, is wrapped in individual newspaper bundles, about a cup to a paper. Not so much salt is needed per fire this time because of the accumulation of so many firings already. They will use two hundred pounds. The fat bundles of newspaper-wrapped salt are stacked with the logs at each chamber.

The salting is begun on the afternoon of the second day, when the temperature is very hot. In a spirit of excitement and fun the newspaper bundles of salt are pitched into the chambers very fast, in the same manner but faster than stoking wood. The fire pops, spits, and throws sparks as the salt explodes. Billows of white clorine smoke choke from the kiln, more as each paper is heaved in. Salting keeps up with this speed until thirty bundles have gone in the kiln on each side. The snapping and popping is beautiful.

One is quite likely to be burned, but the possibility adds to the excitement. This is the only area of ceramics where the glaze takes place as an act of spontaneous chemistry and is formed by the fire and the elements, directly on the pot. Hamada has said that glazes are like clothes on the ware; in salt glaze the whole is one. It is his favorite fire.

Next morning the salt kiln is cool and the doors are unbricked. Unpacking is quick, with Masao-san and Uma-san inside, Oka-san, the young boy, and the old man carrying pieces one at a time down the short hill to the pallet boards. The wood bundles that had made the enclosed fortress for the men at the fire mouth are used up, and this area is open for laying out and looking at the ware. Uma-san and Oka-san make the decisions when there are obvious faults in some pieces

199

and leave those wares in the kiln or separated on the ground. Hamada has made almost all of these two hundred pots himself. Except for a few pressed bottles, they are all of his throwing, made in the past week, thrown, trimmed, slipped, painted, and now salt glazed.

The good pots are carried to the gate house to be placed along the stone walk for viewing and deciding. Finally Hamada has a chance to come to the kiln to see if the men have left anything he would choose. He finds two pieces he likes. He looks in the kiln at all the pieces that are stuck fast to the slabs and says with a laugh, "We must rebuild this old kiln, it makes so many mistakes now."

The strength and vitality of these pieces viewed together is awesome, not just due to the excitement of the process but probably in some measure because of it. The things chosen from this kiln, the thirty or forty pieces for this exhibition, are strong, beautiful examples of the best in salt glaze texture and quality.

Perhaps it was the spontaneity of the need to come to the end of the cycle, the last push for the exhibition, but really I think that it is because Hamada takes great joy in the salt fire. These pieces are free, almost gay with the sweep of line and direction of stroke. The application of blue clay against brown over thick white or warm gray, the strength of the stark white slip put on with a broom brush wraps many of the forms, bristle marks swirl around, or fat brush dobs, or ladle pours, making a ground, a base, for the rest. When the pieces are brought down to the gate house and lined on the pallet boards together, it is amazing to see the variety and excitement that characterize this mode of fire.

Some of the tea bowls have salt crystals still lying inside, melted, but possible to chisel out, and this is done. Shell stilts are knocked off the feet, leaving the tiny line imprints on each piece. Everyone is working fast, carrying the pots for final decision, because it is nearly time for Hamada and Atsuya to go to Tokyo in the car.

I pick up a five-sided tea bowl that has been discarded and ask why it was not all right. I like it. Hamada says no, he had forgotten something in the design, forgotten some dots. Here is another example of the overwhelming plan he has for his work. In the system of decoration, when something does not mesh properly, it is not used. Pieces with

too little salt or too much variation from one side to the other are not used either.

An already prepared soft Japanese paper sticker with black brush figures giving the price is glued onto each piece chosen for the exhibition. In these last minutes more selections are made, wares are wrapped in straw or newspapers and piled in two of the big black cars that belong to the family. Hamada has gone inside. Inviting me to have a last supper before his drive to Tokyo, he apologizes for the simplicity of the meal, which could not have been more delicious. It will take five hours to get to Mitsukoshi, the Tokyo department store, and more hours to complete the installation. Already it is night and the exhibit opens at ten tomorrow morning, still I am being feted on our last Mashiko evening. Everyone is exhausted, but an attempt is made to seem otherwise, and we reminisce hastily over the past months of being together.

Then Hamada ends the session. He rises quickly and jumps down from the floor to the slate entryway, steps into his geta, picks up some packages, and walks to the gate house with all of us following behind.

He climbs into one car with Atsuya; Oka-san drives the other car. Both are packed with pots. Everyone, including the three white-aproned maids, waves from the gatehouse in the night with flashlights, and Hamada is gone. Shinsaku and I will go to Tokyo tomorrow, since he has work yet to do here. We will leave Mashiko in the morning to arrive at Mitsukoshi in the afternoon.

Exhibition

Now in the early morning we are leaving this village. Mashiko in its special way has influenced Hamada's life and work, as he has influenced it, and both in their own way have seemed to remain independent of Japan's phenomenal movement from a traditional to a modern urban society.

Mashiko, the town with one two-mile-long street winding up from the railroad station past Hamada's house, where women chat and work with babies strapped to their backs, where the small stores with wooden shoji fronts follow one upon the other, block after block, close together, with occasionally an alley between. Bright yellow and pink plastic utensils cover the fronts of the grocery shops, the notion shops, the flower shops. Here is the bonsai man, with racks of small potted trees, and the shop of the flower lady who once a week was hired by the inn to change the arrangement in my room, and the peanut man drying his crop, and the hard-working couple in the rice polishing and sales shop. An endless number of pottery parlors with wares for sale from the 105 kilns are all along this street and its tributaries, full of an amazing variety of shapes.

The stores, absolutely next to each other, seem to number hundreds along the narrow street. All the fronts are open during the day and closed at night with sliding doors of wood and small panes of glass, when the family moves inside. There are so many vegetable and fruit stands that it is impossible to believe people can eat or buy so much. Boys and girls walk to school in blue uniforms and carry airline flight bags full of books, men and women ride bicycles piled with merchandise, or carry loads of wood or other bundles on their backs or heads. The costume of the women is *mompei*, traditional baggy country trousers, or kimono, and one almost never sees a Westerner on the street.

Mashiko is a town now with a population of twenty thousand. Traffic on the narrow two-lane main street is conjested with cars, busses, trucks, bicycles, carts, pedestrians, all wanting a place. Noise is a terrible factor, the horns of all vehicles being the most used noisemaker when passing, or when thinking of passing, or in warning or in greeting.

Rice husking machines sputter in the fields, and there are the hammers of new construction, the thrum of heavy tires against pavement, and the clack of all sorts of things carried by hand or on poles over the shoulder. Still it is possible to be unaware of these constant sounds as soon as one climbs a path toward the hillside away from the main street or goes beyond the confined area of town in any direction.

Shrines are to be found in the hills in cedar groves, surrounded by red maples against the dark green, so near to the town that they are really only a few steps away, but giving the immediate impression of being in dense forests far removed from people. Many times from these same hills I have looked down into the valley across the blackened rice fields piled with the harvest, to the roofs of blue and black tile standing out among the thatch of the old-style farm dwellings. The people from the potteries often visit the shrines after the hard work of firing a kiln.

Always black smoke from the kilns rises straight up in the sky, dense and thin at the narrow base of the inverted cone as it comes from the flue, broadening and dissipating as it rises slowly high into the air, gradually becoming nothing. On a clear day when there is no wind, when the sky is blue and there are no clouds, then the cone of smoke stays in the air a long time, eventually spreading out horizontally, with gray wisps suspended over the spot where it was born. Smoke from the kilns is the trademark of this village.

The road leaving Mashiko is lined with fields of rice, and harvested straw is bundled in a variety of shapes, making rows of yellow ochre forms coming together in perspective points. Shinsaku and I drive through small towns, smaller than Mashiko, past places to fish in ponds near shrines, plastic-covered hothouses of strawberries and tomatoes, past fields of rich black earth newly plowed in small plots, the yellow green of cabbage, lettuce, barley, onions, radishes, the vista of softly rolling hills in the distance covered with red maples and yellow

203

chestnut and evergreen cedars. Schools are two-story frame buildings with sizeable playgrounds overrun with the blue uniformed boys and girls. Our narrow road is a mass of cars and small trucks with big loads, women walking with babies in halters on their backs, men pushing carts or pulling wagons or on bicycles. We cross a large riverbed spanned by a long bridge, containing only a few channels of water but full of short, stubby vegetation and the undulations of endless piles of water-smoothed pebbles. Washed clothes hang from the house fronts like scarecrows, on bamboo rods through both arms or one leg, the whole laundry hung facing the street. Futons and pillows are always piled high outside every house, airing every day. Japanese villagers are alive to their neighbors, and though they live close to each other, still there is the effect of privacy, especially at night when the shutters are closed and the streets are silent.

Finally the countryside is gone. The city appears, stark, gray, smoggy, Tokyo Tower in view, skyscrapers, neon signs. This is the largest city in the world and one of the most foreign. I feel substantial regret, the loss of my village and the months that are past, knowing this closes a chapter of time for me.

Shinsaku and I arrive at the exhibition, in a large open room on one of the top floors of the big department store. A bustle of visitors walks in single file, patiently moving along the pots, which are open, free to the touch, displayed on a wide ledge around the room. The light in the room is bright and strong. There is no dramatizing the pottery with contrived installations. The pots are just set out one after the other, each having its own presence.

The very big bowls are at the far end of the rectangular room. Bottles, vases, and individual plates, some on teak stands, line the side walls. Tea bowls are by themselves in the center under glass, and some are on top of the cases. These tea ceremony objects are picked up and handled carefully by the passing visitors, held sometimes for a very long time. I am surprised that there is no attempt at elegance or display with improvised staging, in the manner of Western galleries.

Everything is labeled. Tea bowls made in Okinawa and enamel painted in Mashiko are priced in yen equivalents of four hundred to five hundred dollars, the square plates are nine hundred to twelve

204

hundred dollars, the highest price being for the brown wood ash glazed one with the four fantastic nuka pours, the plate with a paddle textured edge. The greenish ash glaze makes a dark line where it is heavier, near the rice husk ash white on this piece, causing a special enlivening of the texture. Another square plate has kaki and clear-glazed rectangles divided by iron brown lines, with enameled red and green dots on the dark background, and green enamel by itself on the transparent glaze, an unusual play of color. Another plate that Hamada likes because the kiln atmosphere has created variation in the color has the white rice husk glaze over ochre slip with long loops of shiny black, in contrast to the paddled edge, which takes the textural break of the dark slip showing through the light. Still another plate has matt turquoise over the rice husk base in swirls the shape of Hamada's ladle pour movement. The movement seems to continue even in the cooled color.

There are more ladle patterns on view, especially black on white. And there are all the other effects of his kilns, including the vitality of the salt glaze and the brilliance of the overglaze enamels. The room is ablaze with familiar color combinations: seiji turquoise on kaki brown, the light ochre color of iron wash over white nuka, or the ochre slip under the overlay of fused greenish color when the white and black are poured or dipped together, the splash of brown robata ash glaze—amber transparent against matt turquoise—or the copper green bisected by very thick white nuka stripes, the fine strings of shiny black pour patterns against gray or white, the washes of Okinawan cobalt blue under the enamel paintings, and the gray blue of that color contrasted with the slightly more brilliant blue of the cobalt in salt glaze.

The forms are familiar too, and compatible: the medieval look of the salt-glazed pitchers, the bulbous jar forms bellying fat at the shoulder from a narrow base, the square pressed bottles and big square plates, the thrown bottles with the separately added necks, teapots, tea cups, tea bowls, small water jars, the huge thrown bowls, the twelve-inch plate bowls. Brush decorations contrast with pots having freely poured loops or squiggles, interspersed with the famous patterns he has been making fifty years, of bamboo and sugarcane in brown

205

iron oxide on *namijiro* clear, or with enamel pigment, or in wax resist. Prices, varing from one hundred fifty to two thousand dollars, are marked in yen with black ink on little signs beside the pieces.

The use of kaki brown with green enamel lines alone, on clear glazed squares on a square plate is something Hamada wishes to do more of, just the two colors contrasting. He explains this to his old friend Shiko Munakata, the woodblock print artist, as they walk around the pieces together after bowing to each other formally. I remember at Mashiko when Hamada was painting this piece. I noticed its difference and wondered what would happen in the fire: those two colors without the usual accent of the Kutani red enamel, only the clear glaze and the green enamel against the warm tan gray of the body color. Next to the dark iron rich kaki, this gives a very good color quality which is different from the usual flavor. I reflect that it is not often that Hamada produces a new color image, though perhaps this is a growing practice.

People pass around the room in single or double file, slowly, walking around many times, but in this way everyone can see. In the center of the room are several chairs and a low table, where conversation takes place. The room is bare of decoration except for the colors and shapes of the pottery. Black suited men of the department store stand in conspicuous places, silent unless approached. Hamada is near the opening where this room ajoins the outside bustle of the regular gift-wares section of the store, greeting those who know him, and always there is a circle of people around him, waiting.

He no longer looks like the Hamada of Mashiko. The Western suit of the type he has worn since 1920 fits him well but seems incongruous. His appearance is that of everyone else and he has become the business-man tending to chores here that seem unlike him. I am eager to catch a glimpse of the Mashiko Hamada, to see the familiar twinkle in his eye and hear the chuckle of the laugh we heard frequently when he was relaxing at the fire.

His life reflects this apparent dichotomy. The simplicity of his special kind of folk living contrasts with the Hamada who studies, travels, creates museums, and is an authority on archaeology and ancient cultures. He throws himself into his work, says he must always

be working, but spends more than half of his time in other activities away from the clay.

He is aware of money but he does not want to handle it, so others do it for him. He keeps most of his pots for Japan and does not try to sell in America, but he left Japan for a time and endeavored to demonstrate the true way of his work to a university group in Los Angeles. He may give away pots but he also charges as much as several thousand dollars for a bowl. He has always placed a high economic value on his pottery, since he appreciates that materialistic modern society must provide the paths for furthering the values of his world of natural materials and hand labor. So he signs the beautiful wooden boxes containing the pots, but he does not sign the pots; he charges high prices but not the highest prices; he speaks wistfully of days at Mashiko without visitors but personally welcomes them every day; and lives humbly, while his pots are in demand all over the world. His work style has no equal anywhere. Hamada's genius has balanced these contrasting sets of values and has forged a life force that has brought him to fame. Just as the salt glaze and the enamel work processes are opposites, so the traditional pottery techniques and his simple life style contrast with his sophistication. But such "opposites" cannot really be isolated. His force has bound together all the threads of his life—all his work and activities are one.

Each of the eight days in Tokyo I visited the exhibition hoping to have a chance to tell him what I had found and to share some new thought as we might have done in Mashiko at teatime. Each day at the exhibition I watched this round man in his Western suit with the tortoiseshell spectacles on his forehead, bowing politely to all the guests, beaming, rocking in his Western shoes, aware that I am there, and sometimes nodding. But every day was the same: dignitaries, old friends, officials, and the continuous flow of visitors and buyers, and Hamada always busy talking with them. He asked me to join Oka-san to review a television film NHK made of him at Mashiko, but I was never to have the chance to discuss that with him either. Of course he was showing me the film for my study, not his interest. Even though he had told me before we came to the exhibition that there would be luncheons and dinners every day and news conferences and no time

207

even to see his Tokyo family, I had not expected him to be so completely apart. Finally I understand that I have watched him for many months, now it is someone else's turn, and I remember the story at the fireside where the humble farmer had lost his crop and told his wife, "It wasn't our turn to receive it."

Now in Tokyo it is Christmas time. The fantastic department stores are a mixture of images and a multitude of festive toys. The colorful Japanese neons mingle with the Western flavor of tinsel and Christmas tree lights. The store windows are full of American type holiday scenes. Snow falls in soft flurries on the concrete streets.

On my last day Deborah is leaving to join an ashram in India; Shinsaku has gone back to Mashiko. I have spoken early in the morning to Hisako and told her that Hamada has not looked at my photographs, we have not discussed my visits to the publishers that he had recommended, and does she think I will have a chance this day? I know that she will remind her father that I am going.

Late in the afternoon I sit in one of the overstuffed chairs that form the conversation group in the center of the exhibition room, watching the steady stream of visitors moving slowly past the pots. Suddenly Hamada gives a quick turn so no one else can catch him, and comes to stand beside my chair. I rise immediately and he leads us across the room out into the large department store aisle outside this gallery. He is far ahead and I am following, but when he reaches the main part of the store he slows enough for me to catch up to walk beside him. I remember that in my country we could always walk together, but that here in Japan only on certain occasions could he slow his step enough for me to know he was walking with me, not in front.

Hurrying up the stairs, we arrive on the next floor at the dining room done Western style with tables set with linen, roses, and silver. Hamada orders from the waitress. He smiles, and for a moment even in his English suit, the warmth of his Mashiko presence returns as bright as the day we left that village. But for purposes of this city exhibition he is the modern Japanese man pursuing activities in the modern world, which are necessary to nuture his work and his life in the traditional world. Hamada here in Tokyo and the Mashiko Hamada are the same man. It becomes fascinating to me to superimpose the images.

We ate the strawberry sundaes he ordered with large scoops of ice cream topped in Japanese fashion with the perfect slices of carefully cultivated large red berries, covered with whipped cream in the shape of birds, and we drank the coffee demitasse. I tried to tell him of my visits to the publishers. I brought out a series of photographs for his suggestions, but I could see that his interests were elsewhere.

His concern was that America had just given Okinawa back to Japan, that he must get a major museum there and amass a collection for it. He would be going there as soon as this exhibition was over to begin the task. The commitment he was voicing echoed all I had been watching these months. Hamada, so endowed with length and breadth that he could see the larger endless vista, was going to make a preservation once more, for those generations to come. For Okinawa he would now make another collection of folk art that man has made over all time. At this moment it was the most important thing on his mind. My side of the work was ended. His slight gesture toward posterity, of a book about his work, was finished.

Hamada has lived and worked a life. It is not finished. Already he is a recognized Japanese national treasure. There are professionals and students following his way, some without knowing that he led the way, and others searching for the way he has proven. Because of Hamada's own dedication and desire to show the way many will find it. Few, if any, could ever again achieve it on such a scale.

I have watched the inner core of this work, the days of routine that produced this exhibition, these pieces that are typical of all the pieces. The showing in Tokyo is similar to the showing of visitors around the Mashiko pottery, except that it is a beginning as well as an end, for it will bring new guests to the spring. My opportunity was rare, the months of time in a living study. Now Hamada is showing me how it ends but does not end, how the exhibition is part of the cycle and part of the teaching and the regeneration.

Suddenly he leaves the table to go back to the exhibition. His commitment, made when he was twenty-seven, is not finished and he has much to do and too little time. For men like Hamada, for men whose life force springs from underground wells, final goals are never reached.

Appendix

Hamada's Glazes

Essentially Hamada uses five materials for his glaze: wood ash or *dobai*; ground stone called *sekkai*, which is lime; *terayama*, which he says is probably feldspathic quartz, a bad quality quartz; the ground volcanic stone that makes the *kaki*; and rice husk ash. As Hamada says, to use these natural materials is complicated rather than simple, "For I am using nature's mixtures, which are infinitely more complicated."

The natural wood ash glaze, called *namijiro*, is a more or less clear transparent glaze made from *dobai* and *terayama* stone in 70–30 or 80–20 proportions, depending on the tests of the ash, and sometimes with some reed ash added for a more translucent glaze.

Seiji is a turquoise green glaze made by adding six percent copper oxide to *namijiro* base. (At the *kumiai* this glaze is made by adding more copper to ground up glass saké bottles.)

A limestone transparent glaze called *sekkai namijiro* is the only glaze not made at Hamada's workshop. This limestone glaze is prepared at the *kumiai*, the ceramic cooperative in the village, and is used under the *kaki* glaze in a method Hamada devised to keep the kaki from having too metallic a surface. The word *kaki*, means persimmon and also the color when the fruit is ripest; this time varies according to the area of Japan, and in the Mashiko area it is the color of the persimmons on November 24. *Kaki* is a traditional Mashiko glaze, but Hamada has changed it a little to use in his own way and helped it by combining it with *sekkai*.

Kaki, the famous glaze of Mashiko, is a tenmoku type, saturated-iron glaze made from a very hard volcanic stone from a neighboring village. The stone is ground by machine at the *kumiai* to fine powder and calcined by the potters in their own bisque firings. Then it is laboriously mixed with water and screened of impurities. The raw glaze must

213

be chopped up and stirred continously when in use. *Kaki* has color variations from orange to red brown to black. Hamada calls it "the specialty of the house."

A rich opaque black glaze is made by combining *kaki* and *dobai*, and is called *kuro-gusuri*.

Nuka, the creamy white glaze from rice husk ash, is very difficult to make. The black husk of the rice kernal is burned in the field in large mounds, beginning at one end of the mound and burning slow to the middle, by Hamada's farmer. Because the resulting ash is so hard, it is then taken to the *kumiai* for grinding in the ball mill. Later it is screened and washed in Hamada's workshop many times. A base combination of one part husk ash (*nuka-bai*) and three *terayama* is made wet, and ten parts of *dobai* are added. This may not fire properly, so much being dependent on the composition and quality of each batch of rice ash or wood ash. Consequently the base batch is tested in a regular firing; if it is bluish it is right, if it looks too yellow then it must be changed by addition of ten to twenty percent *choseki* (a kind of feldspar from Nagoya) or by adding ten to twenty percent wet *namijiro dobai*.

Generally, enough glaze is mixed at one time for three kiln firings, with tests going on in these kilns for the next batches.

Ash from the robata is kept more or less constant in content, since care is taken to burn only pine, chestnut, and cedar. Only the white ash is really good, coming from hard wood, and all wood ash must be washed many times, screened through a very fine mesh, like silk, before it is used as glaze.

Wood ash contains the same chemical elements found in such mineral glaze ingredients as feldspar, whiting, dolomite, talc, borax, etc., i.e., sodium, calcium, potassium, magnesium, and silica. Plant life contains these things from the soil as well as producing them with its own chemistry, but of course the amounts in plants are much less than in rock form, hence a great deal more ash is needed to do the same thing.

The pigment for painting overglaze patterns that Hamada most prefers is ground iron or magnetic iron, obtained from a blacksmith. When this is not available, he uses a mixture of iron and manganese oxides and some clay.

214

When small amounts of glaze are put into the smaller buckets for ladle-pouring designs, the glaze is screened twice through about 40–60 mesh and then 100 mesh, into a stoneware pot. Brushes are often washed and then put back into the glaze, after they have been standing a time in that glaze. Great care is taken to have the consistency of the glaze or the engobe like smooth liquid cream. Even in cold weather the hands as well as the shovel are used constantly to undo the settling of the ash glazes.

Mixing of two glazes to make different colors is done by pouring measured quantities in liquid condition from the basic glazes, which are stored in the wooden barrels outside the workshop. Most combinations are prepared up there and brought down to the kiln. New batches of ash and combinations of colors are sometimes test-run in series variations in a small electric kiln before being tested in the five-chamber kiln.

Hamada's Hand Wheel

Hamada's hand wheel is different from anything used by Western potters today. Its origin is similar to man's first wheels used in the early cultures of Egypt, Greece, and Mesopotamia. Those wheels consisted of a disk mounted on a shaft or a stone in the ground and were turned by means of a long stick or by hand. The potter could stand or stoop to the clay wobbling in the center of the disk while he worked alternately at trueing up the mound and revolving the wheel.

Hamada's wheel is a thick, wide circle of chestnut wood precisely mounted on a shaft and situated in a hole surrounded by a platform on which he sits cross-legged slightly above the level of the wheel head. In the top of the wooden wheel are four equally spaced brass-lined holes. An old Mashiko pot of traditional style at his left is kept full of steaming hot water all day and nearly all night, so that whenever Hamada has a minute for working, his wheel is ready for use. The stick for turning the wheel rests on top of the waterpot, clay bungs have been wedged and are kept moist for throwing under plastic, and his tools are at the side. A flat, square pillow covered with traditional warp-and-weft dyed indigo and white cotton is placed on the finely polished wood of the platform.

He sits quietly before he starts to work, with his hands in repose, dropped from the wrists, fingertips touching the wheel wood. Slowly he rubs his two hands together in a quiet rhythm, limbering his fingers. It is a familiar gesture one notices him using at other times too. He begins the wheel movement with his left hand, fingers together and flat, starting the motion clockwise. His right hand picks up the wood stick. He fits this into one of the holes in the wheel and begins to turn the head vigorously with a large, strong movement of his arm and shoulder. His back and the center of his body are held rigid, giving

216

stability and power to his arm for turning the heavy wheel. This is taxing work, to say the least, a point that is hard to appreciate unless one has tried it.

Turning the wheel very fast five or six times, he drops the stick quickly and moves to clutch the clay. Several revolutions is all the wheel can maintain against the pressure of his hands as he squeezes and shapes the clay. As the wheel slows he takes the stick again, deftly finds one of the holes, and swings his arm very fast to speed the wheel. As soon as the motion is fast, the stick drops and his hands go immediately to the clay for two or three more rounds. The process is repeated over and over in the making of one piece. Demanding as this obviously is, Hamada says he has not time to learn to use a different wheel. He has always used the hand wheel. It is his traditional way, and the fact that it is the hardest way to throw a pot keeps the challenge alive and new for him.

Because of the nature of the hand wheel and its problems, large pieces or complicated shapes are made by luting coils to previously thrown leather-hard bases. Too much clay on the wheel at once makes it impossible to turn, nor can the speed ever go fast enough to handle a large bulk. The few revolutions possible give insufficient time for the arduous hand pressure necessary to shape large, monolithic forms. Adding clay on and working a little at a time is the ideal method for this wheel. This process suits Hamada too, because it allows him more freedom in the design of the profile line of the pot. Sometimes he constructs large forms in three pieces: coils of wet clay are added to the beginning of the form, which has been allowed to stiffen about a day, and he throws the belly of the shape; when this clay is stiff, a few more coils can be luted on, and the culminating neck of the jar or bottle is thrown. Hamada makes small forms such as jars and lids, teapot parts, and tea ceremony bowls off one hump of clay, centering one piece that is enough for several pots.

The quiet of this wheel moving in perfect balance and Hamada's quiet as he sits at work is contrasted with the intense physical effort necessary to throw in this manner. There is tremendous challenge in the split second timing of finding the hole to rotate the wheel with, in getting the last second of turn while working on the clay and releasing pressure just before it stops, of pulling a form up with minimal yet

sufficient movements and light enough touch for maximum use of the short time the wheel turns. This again embodies Hamada's zest for continuous adventure and insures a new spontaneity for each piece. No other wheel would do for him.

Technique Notes to the Plates

9. Jar, nuka and black glazes, double dipped, brush-painted sugarcane pattern in iron.

10. Press-molded jar, black glaze, kaki ladle pour.

11. Press-molded bottle, clear wood ash glaze, white ladle pours, brush-painted sugarcane pattern in iron.

12. Press-molded bottle, sekkai clear, kaki, overglaze enamel. For enamel painting on the Mashiko clay, which fires quite gray—a green gray under the clear ash glaze—Hamada takes advantage of this dark background by giving the most emphasis to kaki and least to clear. Here enamels are copper green, iron amber, and Kutani red.

13. Tea ceremony bowl, Okinawan red clay, cream-colored slip, Okinawan cobalt brush-painted underglaze pattern and iron on rim, coral clear glaze; enamel painting done in Mashiko.
 Hamada makes some pots every year in Okinawa. The clay body is very plastic and fine grained and fires a rather dark claret brown. He covers this with a local white clay slip and a clear glaze made of rice husk ash and coral (pure calcium) and what Hamada calls a "weak spar."
 In contrast to the darkness of the Mashiko stoneware pots he enamels, Hamada leaves the Okinawan pots mostly clear—the coral glaze when thick is quite yellow over the light slip, with the added warmth of a small craze matrix. On some pots he uses accents of a mild cobalt, with iron and manganese impurities making a soft blue gray, and an iron brown that runs slightly under this glaze. With enamels, the whole effect is bright and lively.

14. Plate, thin kaki, black and white ladle pours.

15. Large bowl, nuka white, black ladle pour.

16. Large bowl (detail), brush-painted sugarcane pattern in iron, sekkai clear, resist waxed, kaki dipped.

17. Press-molded square plate (detail), namijiro clear, overglaze enamel.

219

18. Large bowl (detail), kaki with black ladle pours.

46. Raw clay is collected from the hillside at Kitagoya; the different types are sorted by hand and dried in the sun before blending.

47. The slip is mixed with a wooden oar in a settling tank in the ground. It is stirred and screened several days. The families living by the Kitagoya clay source have been doing this work several generations.

48. The fine clay slurry is ladled into a shallow trough to thicken. Later it is scraped into bats for hardening to the plastic stage; in a few days it can be delivered to the Mashiko potteries.

49. Clay preparation in Hamada's workshop includes breaking clay off from the storage mound and piling it up in the center of the studio. Uma-san foot-wedges each layer as it is added to the pile, which grows until he is standing with his head in the rafters.

50. Clay may be put into a homemade pug mill for further refining.

51–59. Shinsaku begins wedging the clay by squeezing and kneading it in small amounts. Gradually he adds more clay to the initial mass, and a series of palm-down and hand-up motions is employed until the clay is formed into a long roll, sometimes weighing as much as one hundred pounds.

This long roll is kneaded, twisted, and folded over and kneaded again for about one hour. If there is too much clay for one person to handle, another worker joins the wedging process. Chunks of the well-worked clay are broken off and prepared for separate wedging in amounts suitable for the potter's wheel; these are spiral or "chrysanthemum" wedged into cone-shaped bungs. Hundreds of hours are spent in the hand-preparation of the clay, from the time it is gathered on the Kitagoya hillside until it is used on the wheel.

60–64. Hamada sits cross-legged in front of his wheel. There are four holes in the top of the wooden head, into one of which he puts the rounded end of a stick to revolve the wheel. The wheel does not go very fast or stay in motion very long; the vigorous stick-turning is necessary at short intervals.

The wheel does not have the torque to accept one large lump of clay at one time, so, when necessary, Hamada centers a small mass then adds another on the first and forms both into a single, large mound.

Hamada pushes the mound down with steady hands and squeezes it up between his palms, repeating the squeezing up and down to further condition the clay and to "feel" it. This method centers it and makes it ready for throwing. This size chunk will yield a number of small pots, such as tea bowls, cups, or little jars and lids.

65–70. A bite is taken from the top of the centered clay mound. Hamada

opens the ball with his left thumb. One lift brings the shape taller. The edge of the bowl is finished by holding his fingers flat at the lip.

Several tea bowls can be thrown from the initial centered mound of clay. Hamada opens another shape on the lower mound. He pulls up on the left side of the clay because the wheel moves clockwise.

71–76. The first lift is almost straight up. Then the fingers of the right hand push out from the inside against the flat side of the left fingers, to round the form. Sometimes a wooden rib is also used to shape the inside.

Thumb and fingers overlap the edge to smooth the lip. A finger indentation is made at the foot in order to lift the bowl off the hump, and the base is then severed with a silk cord.

80–84. One leather-hard bowl is inverted and used underneath as a chuck for trimming other bowls. Hamada shaves the bowl profile, then the foot rim, alternately, until he achieves the desired proportions and relationship.

The foot rim of the bottom bowl that served as chuck for the others is begun. The way the trimming tool is held and the amount of pressure on it determine the cut and thus the shape of the foot rim.

Hamada taps the clay at the foot. The sound tells him how thick the cross section is and whether he needs to trim away more. Usually it is just right.

89–94. Throwing a cylindrical shape. After centering and forming the clay, as shown in Plates 60–64, Hamada opens the mound and draws the wall up. He uses his left fingers outside, flat against the clay, and moves directly up, holding the fingers of one hand exactly opposite those of the other hand.

He squeezes the cylinder up with the palms of both hands, pushing in and lifting up to narrow and raise the form.

Steady and firm, Hamada's fingers straighten and form the lip. The wheel is turned slowly by the young helper.

The inside hand pushes out and lifts up to round the form. Note the use of the left hand fingers in a flat position against the clay. The lip must be straightened between each lift and between each profile shaping.

The finished form is cut off the wheel with a silk cord. Hamada lifts the pot off by means of the two bamboo splints held to form a cradle.

95–99. A large coil-and-throw jar. The bottom half of this jar was previously thrown. Now the leather-hard form is recentered on the wheel, tacked down with clay, and its lip is moistened and beveled.

Next a coil of clay is attached to the moistened lip. Hamada's young helper turns the wheel slowly with his hand, concentrating on the work and knowing when more speed is needed without being told.

More clay is added to build the shape up. These coils are joined together by finger pinching the layers in opposite directions.

221

The coils are moistened inside and outside and thrown together as the wheel moves. This shaping continues as if the whole form had come from one lump of clay.

The form is rounded more by pushing with the inside fingers outward against a wooden rib.

100–105. Coil-and-throw tall forms: jar and bottle. A tall jar is made in sections by attaching coils to a cylindrical shape and throwing them together. The lip is smoothed with a chamois.

Hamada's large pots are made in sections with the add-on coil method because the wheel does not go fast enough to support the weight of much clay added at once. Hamada also feels that it is the proper method for producing the specific shape he wants for a complex form.

A bottle form (Pls. 102–105) is made by the same method. The neck, shaped after adding on the coils, requires more squeezing in and lifting up. He alternates these movements several times, lifting and squeezing in, to form the narrow neck. Hamada uses an *egote*, a spoon-shaped wooden rib, to refine the curve of the neck and the shoulder.

106–111. Hamada often paddles thrown shapes into oval or angular forms. The clay must be just hard enough to allow a successful paddling—if too wet, the paddle will stick; if too dry, the form will crack. Here he has recentered the leather-hard jar on the wheel and is moistening the lip for connecting the coils.

Coils are luted (with a small amount of water, not slip) to the leather-hard jar. The added coils are thrown together, using a chamois for smoothing.

Hamada draws the neck up taller and thinner, using his fingers exactly opposite each other on both sides of the clay wall. A rolled lip is begun by flaring the top.

He then completes the thickened edge form he desires. He rolls the clay over by turning the flared lip down and flattening it against the body of the pot with his thumbs.

He finishes the form by adding two decorative handles, which he has made by rolling and shaping bits of clay between his palms. The small handles are pressed onto the jar with his fingers.

112–116. A leather-hard teapot body and basic shapes for the spout, lid, and handle are ready for refinement and attachment. After Hamada has faceted the teapot with his Okinawan fish knife (see Note 121–126), he cuts small holes where the spout will be attached. The spout base is cut to fit the pot body. Each edge is moistened, and the spout is pressed into the body of the pot with a wooden tool.

Hamada checks the handle for size and shape before he joins it to the teapot.

222

A knob is formed on the lid shape by trimming it from the basic thrown form shown in Plate 112.

117–119. Hamada flattens sides of certain shapes by paddling the slightly stiffened clay with the smooth side of a plaster mold. Some shapes are changed more subtly by patting them with the flat palm of the hand.

120. Incised textures, when desired, are added with quick, spontaneous movements of his sharp metal trimming tool.

121–126. Hamada uses a sharp fish knife from Okinawa to cut facets on a jar. He holds the knife at right angles to the axis of the pot and pushes the blade straight down to the foot in one or two strokes.

He shapes the foot of this jar by hand with the same knife.

To trim the foot of a jar or bottle, Hamada centers and trues a leather-hard clay chuck, which he previously made. He inverts another jar, already faceted, in the chuck on the wheel and fastens it in place with coils of clay.

A foot rim is trimmed from the rotating leather-hard jar with a metal trimming tool. This tool was shaped by Hamada, and the blade has worn down with use so that it is especially fine for cutting clay feet.

127. Calipers and rules.

128. Wooden ribs and shaping sticks, cutting cord, metal trimming tool, handled needle, bamboo splints used as a lifting cradle, cloths.

129. *Tombo* ("dragonfly") measuring tools for height and width; used for making cups of uniform size. The background is a pillow covering of *kasuri*, warp-and-weft dyed indigo and white cotton.

130. Various Okinawan fish knives used for cutting and shaping.

131. Carved wooden paddles for pressing, paddling, or texturing clay.

132. Hamada's own brushes, which he has made from animal hair and rush, and the compass-brush he uses for wax.

133–137. Square, rectangular, and multiangular forms are slab-pressed in plaster molds. Hamada himself made all the molds, but the workers press the forms. Clay is wedged and pounded into a large, rectangular block. It is sliced horizontally into slabs with a wire held between two vertical sticks.

Clay slabs are pressed into the individual pieces of the mold. Most molds are three pieces: two sides and a foot. Masao-san is particularly adept at pressing the bottle forms. Here, he presses a slab into the mold of half the shape. A coil of clay is added at the open edge to join the next half.

Fastening the two mold halves together with a tight rubber band, Masao-san adds a joining coil of clay for attaching the foot piece of the mold.

Clay is pressed in the foot mold, which is then fastened to the bottle body mold. The entire mold is then put on a wheel, a coil added to the neck opening, and a lip thrown.

When the clay hardens and shrinks in the plaster, the molds are taken apart, the pots removed, and the seam marks trimmed away.

138–141. Sometimes the neck of a bottle form is not included in the mold. Here the bottle and neck have been pressed in separate molds.

With a sharp tool, the hole is cut where the neck will be attached. Slip is applied, and the neck and bottle joint is firmly squeezed together to form a tight lute. The joint is smoothed with the fingers. Great care is taken to form tight joints.

142–147. Fumi-yan adds clay by hand to a small molded dish to thicken the form. He straightens the edge of the clay shape in the plaster mold with a tool. This is one of the pieces of Hamada's ordinary tableware, some of which goes into each kiln.

Mitsuko prepares a clay slab for pressing into an oval dish mold, also one of the forms of the ordinary tableware production.

The two halves of a plaster mold for a hexagonal jar have been pressed with clay slabs and are being squeezed together.

Mitsuko trims the inside of a square bowl shape into which extra coils have been pressed to thicken the shape.

148–159. Preparing to make the largest bowl produced in the Hamada workshop, Shinsaku rolls out fat clay coils. First he puts clay on the wheel head to hold a wooden bat for working. Turning the wheel slowly, he makes an indentation in a large chunk of clay with his fist and hands then spreads this out to begin the bowl.

Fat coils are added one by one and joined together with finger pressure. When the coils are attached, they are trued and centered as the wheel moves faster.

The clay is moistened and the normal throwing method is begun for raising the cylinder and thinning the wall. Shinsaku's Korean type kick wheel moves counterclockwise. He rolls over the lip of the cylinder to strengthen the edge before bowing out the form.

After the cylinder is drawn up, pressure is applied with the fingers moving out and up to form the bowl profile. The diameter is gradually extended in several pulls after the lip has been set.

Pressure must be even inside and out as the bowl form is rounded and widened. The wheel moves slowly. The inside of the bowl is smoothed with a wooden rib, then the shape is lowered and widened with gentle pressure. The diameter and form are rounded and completed, and the lip is finished.

224

160–162. Atsuya throws a series of cups off one lump of clay and measures them. He attaches a lump of clay to the leather-hard cup and pulls a strip handle, after which he attaches the moistened base of the handle to the cup body.

163–165. Uma-san begins the basic plate shape of the workshop by opening the clay mound in a low, wide form on the kick wheel. He pulls up to thin the wall and pulls out to extend the form. When the plate is leather hard, he inverts it on a clay chuck and trims a foot rim.

166–170. A large mound of well-wedged clay is placed on the kick wheel for throwing a number of cups. Centering is accomplished by squeezing the clay up and down between the hands as the wheel turns.

A small opening is made at the top of the mound to begin the first cup. The clay is lifted and thinned as the hands move up in a steady shaping motion. The lip is strengthened for the cup shape by reinforcing the edge, then the profile is flared.

Each cup is measured for height and width. A finished cup is cut off the mound and the next one thrown. Later the foot rims will be cut when the clay has stiffened.

171–173. In good weather Hamada sits outside on his porch surrounded by glaze-fired pots that are to be enameled. He uses the traditional enamel colors of green, amber, and Kutani red to paint on top of the fired stoneware glaze. He has prepared open patterns on some of the forms to act as frames for the enamel decorations. The brushstrokes are strong and deliberate; one enamel color must dry before the next can be painted on.

When all colors have been applied and dried, the pieces will be fired again at 1470°F. (800°C.) to fuse the enamel.

174–178. The firing of the overglaze enamel is accomplished in a few hours in a cylindrical updraft wood-burning kiln. Masao-san loads pots from the top. When the kiln is loaded, the inverted bisqued bowl (Pl. 175) is placed on top to form the kiln roof. The hole is the flue.

Old-man sits in his auto seat in front of the enamel kiln, stoking the firebox continuously with red pine until the desired heat is achieved.

Test tiles, shards with enamel pigments painted on them, are pulled from the fire periodically and brought to Hamada until he approves of the color and the surface. Hamada always inspects each pot from every kiln.

185–191. Powdered volcanic rock is mixed with hot water for the famous Mashiko kaki glaze. Kaki glaze is difficult to keep in suspension; it must be mixed continuously when it is being used.

Hamada's glazes, made from impure natural materials, are generally applied

very thickly to the bisque ware, though some pots may be dipped or rolled quickly in the glaze for a smooth coating and some glazes are poured unevenly for a subtle variation in thickness and overlap. After the workers have applied the base glaze, each pot is generally decorated by Hamada.

192–195. Workers scrape the foot of each pot clean of glaze and examine to see if the piece needs touching up. The reason Hamada's team does not wax pot bottoms before glazing, as Westerners might, is that waxed feet get dirty, picking up crumbs from the ware boards and necessitating sponging of the feet anyway. When dipping, sometimes the foot is wiped partly clean of the wet glaze by the dipper, and later the foot is sponged along that line.

Alumina is painted on the foot rim so the piece will not stick to the kiln shelf during firing (Pl. 193).

The plates in Plate 194 were glazed all over in sekkai clear. Then Hamada paints a pattern of sugarcane with wax, which resists the kaki glaze in which the plates are shown being dipped. Plates are stacked in individual saggers to keep impurities from accumulating on their surfaces during firing.

196–203. Hamada pours a ladle pattern on a bowl glazed in two contrasting colors (finished piece, Pl. 253) In Plate 202 he has waxed a check pattern on a light glaze, over which he is ladling a dark glaze coating.

On the large bowl of Plate 203, Hamada has pulled a finger pattern through the first application of thick wet glaze and then ladle poured a pattern of darker glaze.

Hamada uses many variations of wax resist technique: in Plate 196 a compass is attached to his brush; in Plates 198 and 199 he brushes iron pigment over another glaze and wax decoration; in Plate 197, over a light glaze he has brush painted his sugarcane pattern in iron, waxed circles were then added, and the bowl was coated with a darker glaze.

The foot rims of the large bowls are scraped clean after glazing.

204–207. Bisque pots are lined up on the hillside by the kiln. The workers and Hamada sit together and work as a team. The insides of most shapes are glazed before dipping or pouring the outside surfaces. Jobs are exchanged, the spirit is free, and the work efficient.

Painting resist patterns (Pl. 206) with wax on one glaze and dipping the piece in a second glaze is one of Hamada's chief methods of decoration. Note the extreme thickness of application (Pl. 207) necessary for these ash glazes.

208–212. The viscous ash glazes of varying colors are ladle poured over base glazes of contrasting color. The edges of the design may soften in the fire, but the pattern will hold.

Hamada moves his arm and wrist with deft strokes, causing the glaze to flow from the ladle onto the pot in a long, thin stream. The ladle is raised or

226

lowered over the pot to get different effects—the glaze may catch in thick pools or swirl in thin lines, depending on Hamada's movements.

213–215. Often Hamada is alone in the evening and at night, painting his pots under one light bulb after the workers have gone.

His own bamboo and sugarcane patterns seem to develop without effort when his special handmade brush drops down to the pot. A mixture of iron earth oxide and clay is used to paint this pattern. The color will be brown black when fired.

216–220. Hamada paints an iron oxide sugarcane pattern over a glazed dish that has a ladle-poured edge. At night the light is harsh and casts strong shadows. Using a brush on his compass, he waxes resist circles on a jar. In Plate 219 he paints an iron-manganese slip on a bisque tea bowl, which will be dipped in glaze later. In Plate 220, he pours ochre slip, made from clay as it occurs at Kitagoya, on a leather-hard tea bowl.

221. Hamada states that his brush patterns have not changed in fifty years. Yanagi said, "There's Hamada, painting the same simple painting over and over and over exactly the same year after year. Can't he think of anything else? Really he cannot help it. The painting has become part of his hand."

222–226. The ware is handed up the hill beside the kiln and in to the persons who stack the shelves. Hamada now uses carborundum slabs in the kiln for stacking the ware. Shelves and supports are cleaned before each firing, made steady with clay pads, and dusted with kaolin to prevent them from being glazed by the wood ash during the firing.

Saggers full of plates are stacked up in front of the ware decks, leaving room to throw in logs.

Chamber openings are bricked up when each one has been filled with pots. Bricked doors are sealed over with a mixture of water and very fine sifted sand.

227–233. Wood from forty-year-old pine trees, aged two years, is stacked above the hill kiln by each chamber, ready for stoking. All the wood will be used.

Old-man begins the warming fire at the mouth of the kiln. He is surrounded by a fort of big logs to be used for stoking the fire mouth.

After long hours of stoking the fire mouth, Hamada checks the look of the pots in the first chamber. He wants to see if the glaze has begun to melt and if it is time to stoke this chamber to completion, 2300°F. (1260°C.).

The stoking ports in each sealed door have removable plugs. A worker throws about forty logs at a stoke, throwing the first ones into the center of the chamber and dropping the last one just inside the sealed chamber opening. Stoking takes place simultaneously on both sides of a chamber. The workers stoke in

227

unison, which is very important to maintain the even temperature of the kiln, but they cannot see each other.

234–237. Fire pours from the portholes along the chambers as the wood is thrown in. The kiln is an updraft type; atmosphere and temperature changes occur by regulating openings during the firing.

Test tiles placed inside each chamber are pulled out at different times during the firing to check the development of glaze. Uma-san brings one hot tile from the kiln to Hamada for inspection. A socket made in the clay test tile will receive the end of the poker used to lift it out of the fire. The tiles are glazed with the most crucial glazes used on pots stacked in each chamber.

Hamada, Oka-san, and Uma-san discuss the appearance of the glaze on a test tile. The men will decide whether more temperature is necessary to develop the glaze. If more heat is needed, the fire will be stoked longer and another test tile will be pulled.

244–249. Slip-decorated, unfired clay pots are handed in to be stacked in the salt glaze kiln. Pots are placed on shelves that are heavily dusted with kaolin. Pads of clay with clam shell stilts are placed under each pot; this prevents the pot sticking to the kiln shelf during the salting and leaves a textured mark on the foot.

The two-chamber salt glaze climbing kiln is stacked with about three hundred pots. Hamada says the salt kiln is old now and "makes many mistakes."

The warming fire uses charcoal for fuel and is heated slowly because the pots inside have not been bisque fired.

When the kiln has achieved about 2300° F. (1260° C.), rock salt bundled in newspaper is heaved into the chambers at the maturing temperature of the clay. The salt vaporization forms a special kind of glaze on the pots. Two hundred pounds of salt were all that were necessary for this firing because the kiln is so old and a residue of salt remains from the many firings.

250. Press-molded jar, nuka and black glaze dipped, finger patterns.

251. Jar, black lip under nuka, iron-manganese variation of sugarcane pattern.

252. Bottle, black and nuka dipped.

253. Large (30–inch) bowl, seiji turquoise and nuka ladle pours over a background of amber robata ash glaze and kaki (see Pl. 201).

254. Press-molded bottle, sand-colored body, clear glaze, iron-manganese sugarcane pattern, nuka ladle pours.

228

255. Press-molded bottle, nuka, black ladle pours.

256. Pitcher, nuka, iron sugarcane pattern.

257. Bottle, hakeme, iron sugarcane pattern, salt glazed.

258. Group of pots, sekkai clear and kaki; some are decorated with wax resist, others with iron brush-painted patterns. Kaki over sekkai clear is the glaze combination that Hamada calls the "specialty of the house."

259. Plate, white, iron-manganese sugarcane and line pattern. It is interesting to note the different effects on the same shape given by Hamada's handling of various patterns. Compare this piece with Plate 14.

261. Jar, black and nuka dipped, iron sugarcane pattern. Where the dipped nuka and black meet, the glaze color becomes greenish.

262. Jar, hakeme, namijiro clear, iron sugarcane pattern. Hamada's variations of the sugarcane pattern seem almost endless.

263. Bottle, incised patterns, amber robata ash glaze.

264–266. Tea ceremony bowls, Okinawan red clay, cream-colored slip, coral clear glaze, overglaze enamels (see Note 13).

267. Bowl (detail), finger pulls made quickly while the black glaze is still wet.

268. Bowl (detail), black ladle pours over nuka.

269. Square bowl (detail), sekkai clear, kaki, sugarcane pattern.

270. Bowl (detail), rich surface variations result from thick ladle pours over a kaki and robata ash glaze background.

271. Press-molded bottle (detail), black ladle pour over nuka.

A Hamada Chronology

1894 Born in Tokyo, December 9. Family residence at Akefune-cho, Shiba, Tokyo.

1898 Afflicted by diphtheria.

1908 Enters Tokyo First Middle School.

1909 Inspired by the writings of Renoir, decides to become an artist producing things for practical use.

1910 Determines to study at the Tokyo Technical College under the potter Hazan Itaya.

1911 Greatly impressed by the works of Bernard Leach and Kenkichi Tomimoto at the Mikasa Gallery.

1913 Enters ceramic section of Tokyo Technical College and studies under Hazan Itaya. Comes to know Kanjiro Kawai, his senior at the school. Commutes to the Hakuba Institute to learn drawing.

1914 Impressed by landscape decorated teapot of Mashiko seen at Hazan's home.

1915 During summer vacation visits kilns at Mino, Seto, Iga, Kyoto, Kanazawa (Kutani), etc. Also visits Kawai at the Kyoto Ceramic Testing Institute and decides to enter the institute after graduation.

1916 Graduates and enters Kyoto Ceramic Testing Institute. Becomes acquainted with Tomimoto. Starts series of 10,000 glaze experiments with Kawai.

1918 Meets Leach for first time at exhibit in December.

1919 In May goes to meet Leach at his kiln in Abiko, Soetsu Yanagi's home. Also meets Yanagi and Naoya Shiga for first time. Frequently corresponds with Leach. Makes trip to Korea and Manchuria with Kawai.

1920 Goes to England with Leach; builds a climbing kiln at St. Ives, Cornwall; tries Japanese raku and stoneware techniques.

1921 Visits Mrs. Ethel Mairet and Eric Gill in Ditchling.

1923 Holds his first one-man show in spring and a second show in December at Paterson Gallery, London. At end of year leaves London and returns home via France, Italy, Crete, and Egypt.

1924 Arrives in Japan at end of March; goes directly from Kobe to Kawai's Kyoto home and stays two months. Moves to Mashiko in Tochigi Prefecture. Marries Kazue Kimura in December and goes to Okinawa on honeymoon.

1925 Makes pottery in Okinawa (Tsuboya) until spring. Holds first Japanese one-man show in December at Kyukyodo, Tokyo. Since then has exhibited annually in Tokyo and Osaka.

1929 Becomes member of Kokugakai art group. Travels through Europe with Yanagi, visits Leach, and exhibits at Paterson Gallery, London. Purchases English furniture (by request) and exhibits it at Kyukyodo upon return.

1930 Moves a farmhouse from a nearby village and rebuilds it as his own home in Mashiko. Next year builds three-chamber climbing kiln.

1934 Moves and rebuilds gate house. Leach comes to Japan for over one-year stay and makes pots with Hamada, Kawai, Tomimoto, etc.

1936 Japan Folkcraft Museum opened; founded on endowment of Magosaburo Ohara. Organized by Soetsu Yanagi, Hamada, Kawai, etc.

1936–37 Travels throughout Korea with Yanagi and Kawai, collecting old and new folkcrafts.

1939–40 Visits Okinawa with Japan folkcraft movement members, collecting, making pots, photographing.

1941–43 In and out of Japan many times, traveling to Korea, Manchuria, and North China. Builds eight-chamber climbing kiln and moves and rebuilds various farm buildings on his land.

1949 Receives the first Tochigi Prefecture Culture Award.

1952 Travels around Europe with Naoya Shiga and Yanagi as cultural emissaries of the *Mainichi Shimbun* (newspaper) then attends international craft conference at Dartington Hall, England, with Yanagi and Leach. The three travel to and give demonstration workshops throughout the U.S.A. and return to Japan the next year.

1953 Receives the annual Minister of Education Award for Art.

1955 Receives designation as Holder of an Important Intangible Cultural Property (popularly known as a "Living National Treasure") at its inaugural presentation.

1956 Builds small salt glaze kiln.

1957 Becomes member of Council for the Protection of Cultural Properties.

1959 Goes to Okinawa to help build a monument to the poet Sonosuke Sato.

1961 Soetsu Yanagi dies in May. *Asahi Shimbun* (newspaper) publishes *Shoji Hamada Collected Works*, edited by Soetsu Yanagi.

1962 Succeeds Soetsu Yanagi as Director of the Japan Folkcraft Museum.

1963 With second son Shinsaku holds workshops and exhibitions in many parts of U.S.A.; goes to Washington, D.C., as representative to Japan-America Conference on Cultural Education. Also visits Mexico and Spain, collecting folkcrafts.

1964 Returns to Japan and holds exhibit of folk objects collected. Receives Shiju Hosho (Purple Ribbon) cultural award.

1965 Invited to New Zealand and Australia with third son Atsuya for workshops and exhibitions. Returns home via Europe.

1966 Tours the U.S.A. and Europe with Mrs. Hamada and daughter Hisako, who had just finished education in California.

1967 Invited to 50th anniversary of Michigan University; receives honorary LLD degree and exhibits work.

1968 Holds exhibit in Copenhagen and visits Leach in St. Ives with Mrs. Hamada and daughter Hisako. Presented Okinawa Times Award. Receives Order of Culture from emperor.

1969 Visits Taiwan then meets Bernard and Janet Leach in Hong Kong and tours Okinawa with them. Designated Honorary Citizen of Mashiko. *The Works of Shoji Hamada* published by *Asahi Shimbun*.

1970 Completes Osaka Folkcraft Museum for Expo '70 and starts Okinawa Folkcraft Museum.

1972 Publishes *77 Teabowls*.

1973 Receives honorary Doctor of Art from Royal College of Art, London.

1974 Completes museum for own collection, Mashiko.

Household Members and Workers, 1970

Family at the Mashiko residence
 Shoji Hamada
 Mrs. Kazue Hamada
 Shinsaku (second son)
 Teruko (Shinsaku's wife)
 Yuichi and Tomoo (sons of Shinsaku and Teruko)
 Atsuya (third son)
 Hisako (second daughter)
Workers in the studio
 Minekichi Kurausu ("Old-man")
 Umakichi Shinozaki, 31 years in the workshop, since he was 15 years old
 (Uma-san)
 Masao Toyoda (Masao-san), 28 years in the workshop
 Sakura Oka (Oka-san), deshi eleven years
 Mitsuko Takanezawa (Mit-chan), about 10 years in the workshop
 Shosaku Akashi (Sho-chan), has been working for Hamada off and on
 for 5 years, not present in autumn 1970
 Fumio Usune (Fumi-yan), young boy, Hamada's helper for 2 years
 Yoshibumi Kurusu (Yotchi-san), helps in workshop
 Fukiji Kamija (Fuka-san), works for Hamada regularly, comes at glazing
 time
 Mitsue Otsuka, just comes when needed
Housemaids
 Mitsue Irie (Mitsue-san)
 Kyoko Maehara (Kyoko-chan)
 Sachiko Sukegawa (Sat-chan)

 Kanshiro Koguchi (gardener)

Glossary-Index

teppo-gama	"rifle kiln," another name for a type of early hill kiln without chambers
te-rokuro	hand wheel (or stick wheel), 39–41, 83, 89
tokonoma	alcove for display in Japanese room
tokkuri	saké bottle
tokkuri-gama	bottle kiln
Tomimoto, Kenkichi	28, 166
tsubo	jar, pot
tsuchi	clay or earth, refers to clay in dry condition, natural or man-mixed
tsuchi-momi	wedging, kneading clay
uwa-e	overglaze enamel painting (literally, "over pictures")
warabai	rice straw ash
wax resist	86, 90, 91, 157, 158, 177, 206
wheels, potter's	39–41, 45, 46, 50, 58, 64, 83, 89
Yanagi, Soetsu	25, 33, 56, 59, 82, 84, 92, 164–166, 171, 183, 192, 194
Yayoi	the name for Bronze Age Japan (ca. 250 B.C.–200 A.D.) identified by wheel thrown earthenware simple and elegant in form and without surface designs, 61
yubi-gaki	finger painting; finger wipe design technique
yunomi	tea cup

Note: Not all the entries in this glossary appear in the text; many terms have been included just for interest.